Groundtruth

All photos and Text by Ben Barber
Preface by Andrew Natsios

Art Direction and Graphic Design by de.MO
Edited by Ben Barber, Giorgio Baravalle and Elizabeth Logan Baravalle

www.benabarber.com

Published in 2014 by
de.MO design Ltd.
123 Nine Partners Lane
Millbrook New York 12545

books@de-mo.org

www.de-mo.org

First Edition.
ISBN 978-0-9825908-7-4

Groundtruth

Work, Play
and
Conflict
in the
Third World

by
Ben Barber

Preface

by Andrew Natsios

Far too many people in wealthy western countries view the developing world as mired in hunger, poverty, violence, and despair.

This portrayal is both inaccurate and counter-productive because it encourages isolationist sentiments among the public that limits America's engagement with the developing world.

While there is poverty and violence in every country—including in some that are highly developed—many developing countries have made remarkable progress over the past half century. Some in East Asia such as South Korea, Taiwan, Malaysia, Thailand, Hong Kong, Singapore, and China have become economic powerhouses; they have driven down the number of people below the poverty line to a greater degree than at any time in recorded history.

Seventeen African democracies, few of which have oil wealth, have sustained an average annual increase in per capita growth of 2%—a respectable rate—since 1995. Since 1950, literacy rates and life expectancy in most poor countries have skyrocketed. Sixty years ago only 40% of the population in industrialized countries had a high school education. Today, 50% of the people in developing countries have them.

The death rates of children under five in poor countries today are equal to what these same rates were sixty years ago in wealthy western countries. Ben Barber, a photojournalist and author of this book, presents a history of his travels in the developing world over thirty years which tracks this progress through some remarkable and poignant photographs.

In 2002 I asked Ben to join the U.S. Agency for International Development (USAID) after I became Administrator of the Agency in 2001, to use his skills as a journalist and photographer to record the Agency's work around the world which is not well known in the United States. He eventually became the editor of Frontlines, the monthly newspaper of USAID which was started in 1961 when President John F. Kennedy formally created the Agency. Kennedy merged three federal foreign assistance agencies created to manage the Marshall Plan and the aid effort to contain Communist expansionism during the early years of the Cold War.

Ben served in USAID between 2002-2010 under four Administrators through tumultuous times in American foreign policy where the Agency worked in the front lines of humanitarian assistance and international development.

This book is about work, life, play, conflict, crisis, and reconstruction in developing countries. Most people, where ever they may live, have little interest in grand strategy of the Great Powers, or in international politics, but focus their energies on feeding, educating, and sheltering their families, and wish more than anything to be left alone to live their lives in peace. When they feel empowered and given the freedom to pursue their own happiness, they can be very innovative in supporting themselves and improving the prospects for their children's future. When they are given the tools of development they can accomplish astonishing things.

Ben Barber captures people at work and play, in crisis and recovery where they tell their own stories in a way which begins to correct the distorted images of life in the developing world. He has done a great service through his book.

-

Andrew Natsios,
Administrator, U.S. Agency for International Development, 2001-2006.
Distinguished Professor, Georgetown University, 2007-2010.
Currently Executive Professor at the Bush School of Government and Public Service

Introduction

by
Ben Barber

When intelligence officials speak of "groundtruth," they mean the day-to-day feeling of a place found when an agent actually walks in the markets and villages, rubs shoulders with ordinary men and women, and hears their gripes, praise, hopes and fears.

This book presents the groundtruth I found in nearly 40 years of travel and work in the Third World as a journalist and photographer.

In the world drama of TV and newspapers, the Third World is miscast – painted as a stereotype, a cliché. Economists began using the term Third World in the 1950s for the poor countries of Asia, Africa and Latin America. The rich West plus Japan was the First World. The centrally-planned communist bloc was the Second World.

But we became so uncomfortable with our label for the poverty and ancient ways of life in the Third World that we began calling it the "underdeveloped world." That soon was given more positive spin as the "developing world." But we all know what it is when we see it on TV. Unfortunately, what we see is a narrow slice of the reality that is found on the ground.

The Third World only reaches the "first draft of history" that we call journalism by its excess. War, terrorism, hunger, floods, tsunamis, AIDS, and injustice. Poverty, suffering, refugees, ethnic conflict. Religious violence, tribal conflict, repression of women.I know. I served that appetite for front-page

news for 25 years in Cambodia, Afghanistan, Vietnam, Laos and Thailand. In Kashmir, Israel, Iran, Sri Lanka, Colombia, Haiti and Nicaragua. Morocco, Algeria, Pakistan, India, Bangladesh, China, Egypt. Every trip I ended up at least once staring into the barrel of a gun.

But there is a sweet side to the Third World. An Iranian family in a village gave me their one room mud home for the night and in the morning I found them asleep outside the door, hugging each other to keep warm.

I think that for every trouble making gunman you find in the turbulent corners of the Third World, you find a million decent hard-working men and women raising their children with eyes full of sunshine and hope.

This is the real Third World that few Westerners get to see. Instead, every day our newspapers and televisions show us frightening bombers in the Middle East, starving Ethiopians and snake charmers in India.

I've seen a different reality. To me the Third World is a sea of mostly shining faces: decent people, struggling parents and eager children.

Poverty beyond imagination still envelops about three billion of the planet's seven billion people. Each day the population continues to climb towards 10 or possibly 15 billion people by the year 2100. Almost all the growth is in the poorest countries,

where the good land is already taken up. I've shared bread with people in their shelters in the streets of Bombay and Calcutta. Walked with them on trails in Pakistan's Hindu Kush Mountains.

The photos in this book aim to share the bigger truth of the Third World – the one I was rarely asked to write about in the newspapers and magazines I wrote for.

"DBW," Dull But Worthy, said one blunt foreign editor at the Washington Times when I proposed stories about what is good in Asia and the Middle East. I faced the same attitude at other papers I wrote for as a freelancer – USA TODAY, the London Observer, the Christian Science Monitor, Newsday, the San Francisco Examiner and the Toronto Globe and Mail. When I proposed stories on explosive economic growth in Thailand, miracle seeds for wheat and rice, appropriate technology, free universities, textile jobs and mini-paddy plows, my fellow reporters smiled indulgently and said the editors back home only want elephants, prostitutes, opium, refugees and war, war, war. Bad news is news. Good news is boring. They were right. I had to fight to get the occasional good-news story into print.

This book shows the real Third World that only those of us who have been there have seen. It's not the Third World of five star hotels and diplomatic meetings I saw when I flew as a reporter with Secretary of State Colin Powell or with President Bill Clinton on trips to Africa, the Middle East and Europe. Many of the photos I took when I was a free-lance writer, traveling cheaply for weeks on a slim expense check from a newspaper. But even the cheap hotels and bumpy rides on local trains and buses were a world above my early years after college, exploring the Third World on $1,000 for a whole year's travels. Third class trains and sleeping in temples or train stations.

And those hardships were minor compared to the people around me. They lived in flimsy shelters when the storms hit, searching to provide food for hungry children and chopping at the parched earth, hoping for a break, for rain and a lenient landlord.

When I first visited the Third World after college, I was swept away by the beauty. Sari-clad women hauled brass pots of water on their hips along earthen dikes as the men urged huge white cows to turn a few more furrows before the golden twilight vanished into the darkening sky.

But when I returned as a journalist, I learned about the dark side of life that I had not seen at first. I learned about the corruption, the caste system, the repression of women, the lack of education, the lack of basic medicine, the hatred for the next village or the next religion or the next country.

Despite that, the people continue to smile, to radiate their gratitude for every glass of water, for every mouthful of food, for the warm sun in winter and the cool breeze in summer.

We have so much in America and Europe yet often we are no happier than those with nothing. I still think we have something to learn from our brothers and sisters in the Third World. I always believed that if they could get our organization, medicine, science and technology, and we could get their humility and spirituality, it would make a better world for all.

And now the Third World is coming to us – Al Qaeda, Iraq, Afghanistan, China, AIDS, Mexican immigration.

The groundtruths these pictures and captions contain bring each reader a bit closer to a wider and deeper understanding of the Third World that is to be so important in our future.

Groundtruth

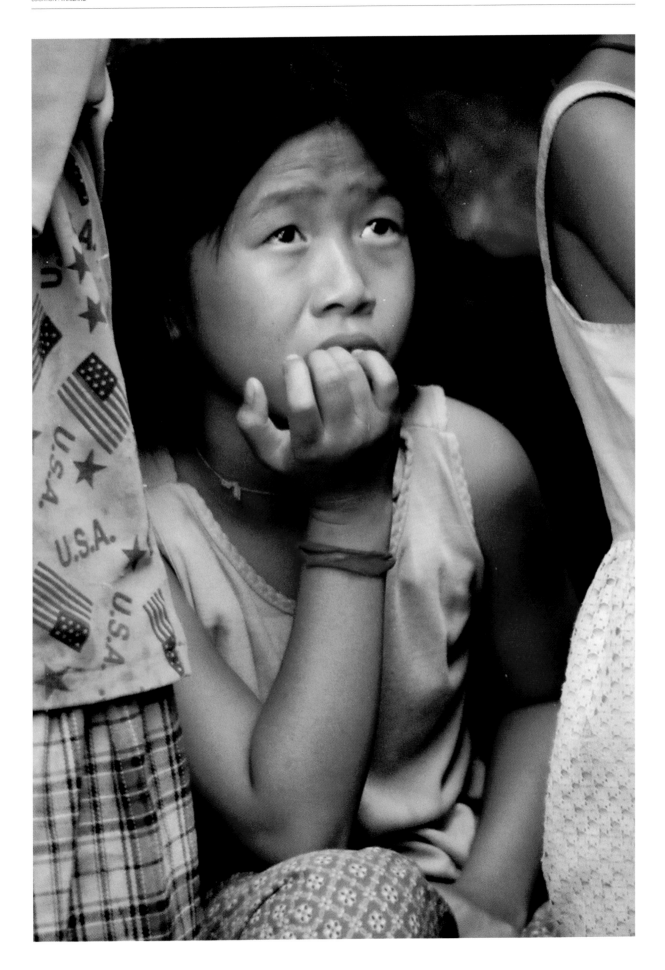

1.
Hmong Refugee Girl

Staring out from her cousins and friends packed like
sardines in a thatched hut, this Laotian Hmong girl
had known only refugee camps when I met her in 1995.
But still she dreamed.

"I want to become a doctor," she said shyly but firmly.

She lived with 10,000 Hmong refugees in the Buddhist
temple of Tham Krabok in Thailand, fearing that the
Thai government might send them back to Laos.

While she spoke, we heard the dull crump of
explosions from a quarry where her father blasted
rocks for a dollar a day.

About 100,000 Hmong fled across the Mekong River
into Thailand in 1975 after communists seized
power in Laos.The CIA had formed a secret Hmong
army which fought against the red Pathet Lao.

Most Hmong refugees languished in Thai camps for
years before immigrating to the United States where
they clustered around clan leaders in Fresno, CA or
St. Paul, Minn. I sometimes wonder if this girl is in a
community college here now, studying pre-med.

2.
Bengali Kitchen

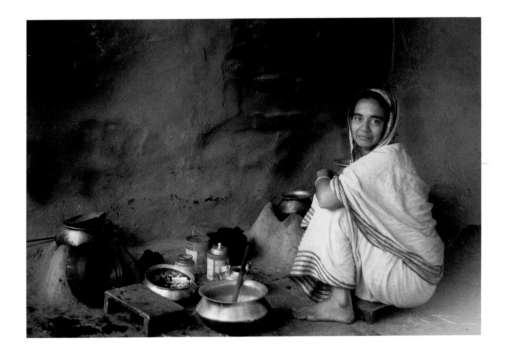

This Bengali woman sat on a low wooden bench in her traditional Indian kitchen which has changed little in thousands of years. The pots are now aluminum instead of brass or clay but their shape allows them to balance nicely on mud ovens or over three rocks. Dried cow dung and wood still provide the main cooking fuel.

Her face is an icon of India's ancient and deep culture. It is full of wisdom, compassion and beauty. This is the face of the real Third World — mothers and fathers nurturing their children and living in peace and humility far from the angry crowds shaking fists that the television seems to adore.

Her white sari tells all – despite the earthen floor, the ashes from the fireplace and the lack of tables and furniture, she keeps her garment clean. This is a Herculean task when there is no running water, soap is costly, and the wind blows dust and dirt everywhere.

I went to her village with Assad Latif, an editor at the Statesman, Calcutta's oldest newspaper. Assad was helping me interview pavement dwellers in Calcutta – we might mistakenly call them the homeless but, in fact, they have their homes, be it so humble as a shack or a place on a sidewalk.

Assad invited me to his family's ancestral village where I saw the timeless pattern of Indian life. And it helped me understand that whether people live in the cities and work on a modern newspaper or still harvest wheat with a sickle, they share common roots. Lives revolve over providing our families with food, medicine, education and love.

In 2008, the world reached a tipping point when as many people lived in cities as in the countryside, the UN reported. And by 2050, the world population will grow from 6.7 billion to 9.2 billion. All that growth will be in cities – mainly those of the world's least developed countries.

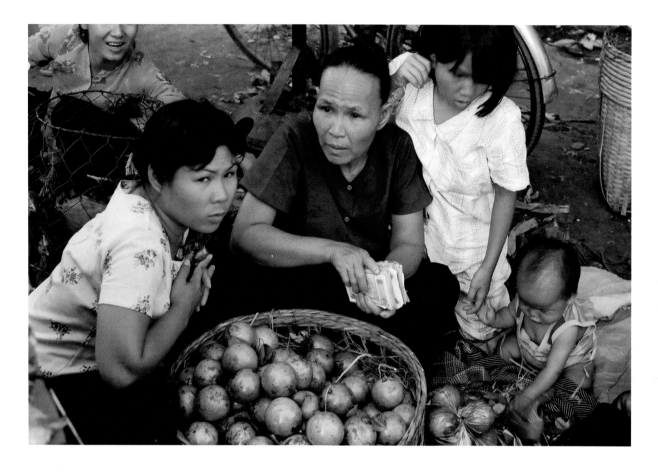

3.
Worried Saigon Market Woman

Now Vietnam's trade with the United States is booming and U.S. investors are flooding in. Presidents Clinton and Bush have visited. The communists won the war but U.S.-style capitalism won the peace.

I call it Reverse Domino Theory. Instead of communism spreading from Indo China across Southeast Asia, free markets of Thailand, Malaysia and Singapore flooded Vietnam with smuggled consumer goods. Eventually, the communist leaders got it. But they're still working on the democracy and freedom thing.

According to a forecast in December 2005 by Goldman-Sachs, the Vietnamese economy will become the 17th largest economy in the world with nominal GDP per capita of $4,400 by 2025.

4.
Tea Below, Tobacco Above in Calcutta

In perhaps the most crowded city in the world, a small piece of valuable urban real estate near the central Chowringee Road houses a tea shop down below and a tobacco shop above.

The tobacco merchant sits holding a cup of tea from the chai wallah – the tea shop owner – who sits below. They all wear dhoti skirts and one wears a thread over his shoulder marking his caste as Brahmin. He delivers tea to the nearby shops.

As I sipped a cup of piping hot, sweet, milky chai, the tea and tobacco sellers told me they had inherited their businesses from their fathers and grandfathers. I think their children and grandchildren may still be doing business there.

I bought one Charminar cigarette for a few paisa, worth about a half cent, and lit it from a small kerosene lamp to save the match. It went well with the hot chai.

As much as 60 percent of the economy in developing countries is in the Informal Economy which pays no taxes and is not monitored by the government. The influential economist Hernando de Soto, author of The Other Path, hailed the entrepreneurial spirit of the informal economy and blamed its limited success in ending poverty on excessive regulations against new businesses.

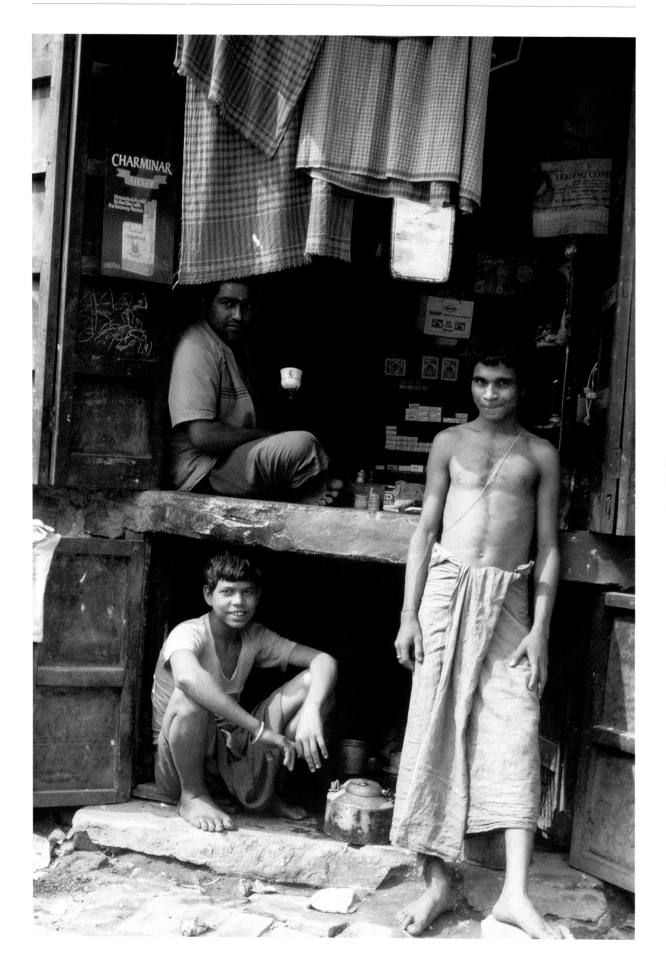

5.
Bengali Village

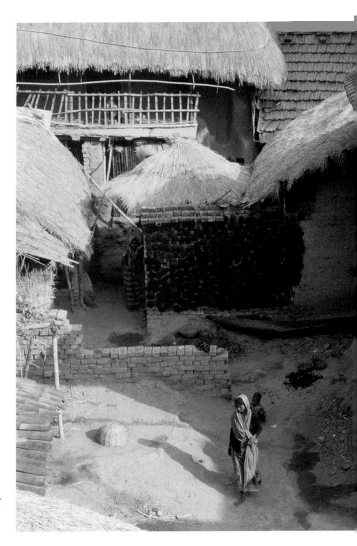

Just an hour by bus from the trams and factories of Calcutta are thousands of villages such as this one, entirely built of natural materials. Barefoot, the people walk its paths of packed earth. The houses are of baked brick covered by mud. Railings and roof beams are wood, and roofs are straw or clay tiles.

On the wall behind the woman, dozens of dark cow dung patties are drying so they can be used as fuel for cooking fires.

Nearly everything in this picture might have existed 500 or 1,000 years ago. Only the thoughts of its inhabitants have changed. Many can read a newspaper. Some have a radio or television hooked to a car battery. People discuss politics. They voted in the world's only elected communist government in West Bengal. The farmers even walk through their mustard and cabbage fields spraying insecticide to improve yields.

But the limits of the land and the village and custom preserve their style of housing and clothing. The space they utilize defines their lives into a dance with nature and time. This dance they know as Shiva's, the God who creates the world through dance.

This is the place of the inner frontier. Indians cannot find the open space that gave Americans their taste for freedom. Instead, their Hindu faith teaches acceptance and meditation to know inner freedom.

6.
Bombing of Barikot, Afghanistan

let me go. Hekmatyar has come back since the U.S. ouster of the Taliban in 2001 and in my last Afghan visit in 2006, he was attacking American and Afghan troops around Barikot.

In the Afghan-Soviet War — between 1979 and 1989 — 200,000 Afghan Mujahideen fighters died along with 14,000 Soviet troops. Estimated Afghan civilian deaths ranged from 700,000 to 2 million.

The United States and the Gulf Arab states each donated about $600 million a year to the Mujahideen, wrote Gilles Kepel in Jihad, Belknap, (2002). But when the Soviets withdrew in 1989, factional Afghan fighting further destroyed the country and led to a Pakistan-backed takeover by the extremist Islamic Taliban faction in 1996.

We felt the shock waves from the bombs as we walked across a suspension bridge, a few miles away – a light fluttering on our cheeks. When we reached the town, it was in ruins. This Afghan mujahideen fighter scanned the sky for returning Russian planes. Under the burning ruins behind him, four of his friends lay buried.

It was summer of 1988. Barikot was the first town abandoned to the U.S.-backed "muj" as the Soviets began to pull out.

"Come and stay here with us here in liberated Afghanistan," said the man in the photo. It looked like a very bad idea, especially as a tiny silver jet crossed the sky, high above the range of Stinger missiles, looking down on us to see if it was worth wasting more explosives.

As I headed back towards the Pakistani border, some fighters leveled their AK-47s at me and accused me of being a Zionist spy. They were with Islamic extremist Gulbuddin Hekmatyar. Fortunately, I had gotten a note from his office in Peshawar, Pakistan introducing me as a responsible journalist. So they

photo on following page

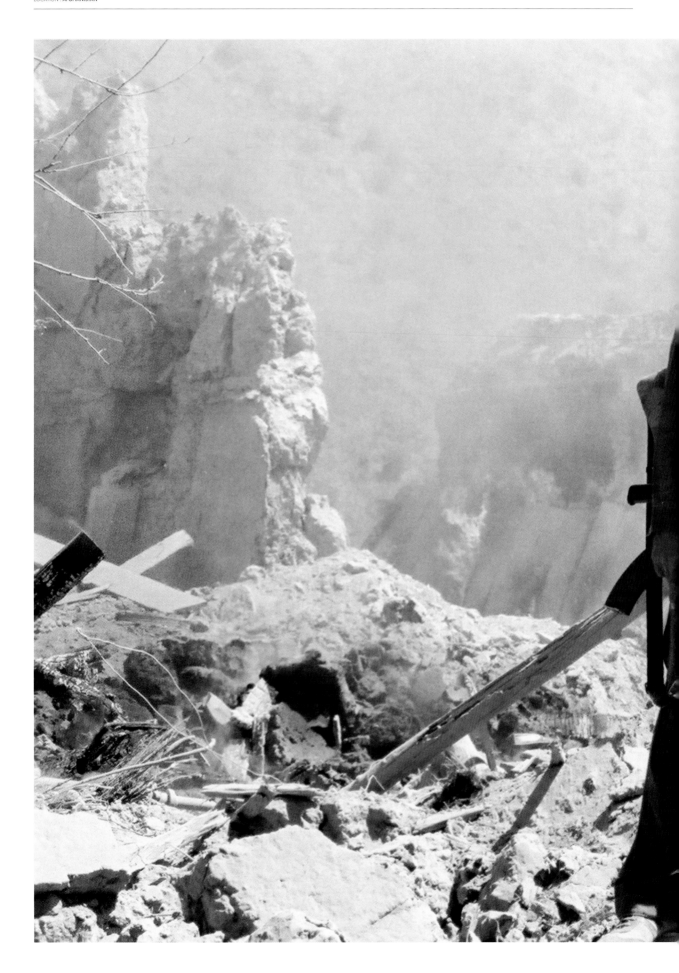

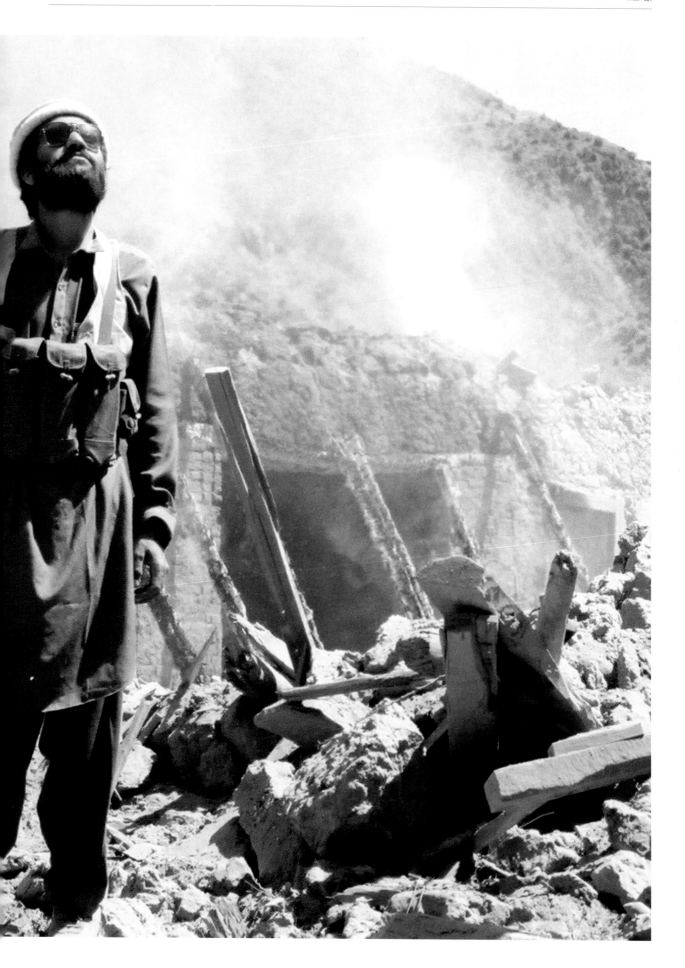

6.1
Guarding the Bridge from Pakistan to Afghanistan

remains of two Soviet helicopters in the fields alongside the dirt road. They looked like giant locusts with their rusting metal skeletons and shattered rotor blades.

The fields are full of mines warned my guide. They tell me the muj has lost 24 people in the past few days from the mines.

After the attack by Al Qaeda on New York and Washington Sept. 11, 2001, The United States launched Operation Enduring Freedom in Afghanistan and by 2011 had spent $443 billion. The Obama administration requested an additional $113 billion in its proposed 2012 budget. (Congressional Research Service).

On the human plane, U.S. military deaths in the Afghan War, from 2001 to May 17, 2011 reached 1,579. Another 888 troops from Britain and other coalition partners also died. (source: icasualties.org)

Civilian Afghan deaths were not well documented before 2007, but since then about 9,000 died and 7,000 were wounded as of 2011. Although U.S. and other foreign forces have surged in the last year to reach 150,000 troops, violence across Afghanistan in 2010 reached the highest levels since the Taliban were overthrown in late 2001.

The bridge from the Pakistan side of the river was hung from steel cables strung over two brick towers. At the far end, these two mujahideen fighters were perched in a rocky cleft with a perfect field of fire overlooking the bridge.

I walked straight towards them and resisted the urge to offer a friendly salute and nod of my head. I was dressed in Afghan clothing and my cover story worked out with my Afghan guide was that I was to pretending to be a mute. Wisdom told me to say nothing, indicate nothing and show no expression at all on my face. Frankly, the fighters I was with must have sensed I was a Western visitor to the war.

I shuffled past the guards with the dozen or so mujahideen who had been riding with me in the pickup truck from the Pakistan refugee camp.

But not before I pulled out my camera and got off a shot.

Walking deeper into Afghan territory I saw the

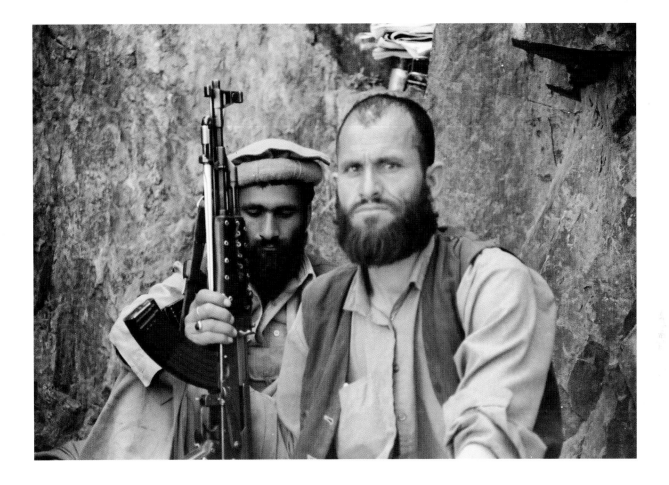

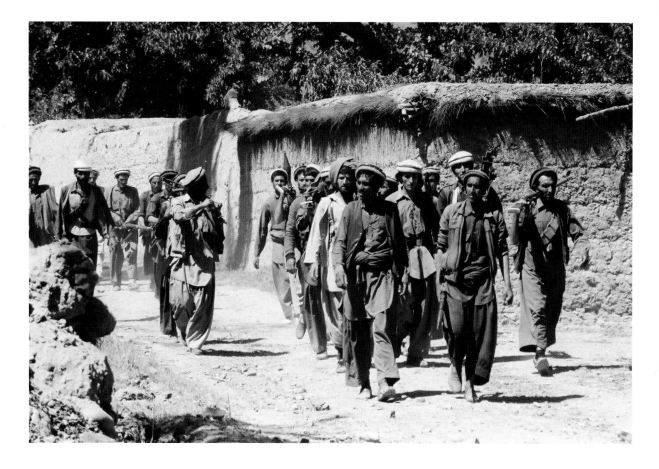

6.2 Afghan Fighters on the Move

These are some of the fighters who poured into Barikot as the Soviet-backed Afghan army withdrew in 1988.

Their clothing and appearance show them to be Tajiks, possibly aligned with the great guerrilla fighter Ahmad Shah Masood, who later became defense minister and finally was assassinated by Al Qaeda operatives just two days prior to the 9/11 attacks on America.

The fighters walked in a rough military formation, carrying assault rifles and rocket propelled grenades – scant weaponry against the fighter jets, tanks and artillery the Soviets had given their Afghan allies in Kabul.

The fact that they had left the mountain trails and caves to march as a military unit in the open country was a sign that the end of the Soviet war was drawing close.

7.
Teaching to Kill for Islam

"Most kids here go for jihad, and I will too, God willing," said 14-year-old Obeidulla Anwer, seated, at the Khuddamuddin madrassah school in Lahore, Pakistan. "Jihad is to fight for Islam and the pride of Islam. We go to fight in Kashmir, Chechnya, Palestine, Afghanistan."

The boys are very poor, sent to the madrassah because they get food and clothing there. Like little soldiers they have nothing but a bedroll and spend their days memorizing the Koran in Arabic – which they do not understand.

The head of the school raised money in America from Muslim communities and mosques.

I asked Obeidulla how he will know who is an enemy of Islam. "If I say 'Salam Aleikum' and they don't know to reply with 'Aleikum Salem," he said.

But most Americans don't understand what that means. Does that mean they are all enemies, I asked. His teachers gathered around to hear his reply. He looked up at me.

"No. They are not enemies of Islam."

About 15 percent of the 1 million Pakistani children in madrassas are in schools that preach violence or militancy. U.S. assistance goes to secular schools and not to Pakistan's 20,000 madrassas, said Doug Johnston, CEO of the International Center for Religion and Diplomacy. His group has worked for five years training more than 2,200 madrassa leaders and senior faculty from some 1,450 madrassas, including a sizable number in the more radical areas of the country. The training emphasizes critical thinking skills, religious tolerance and human rights — especially women's.

photo on following page

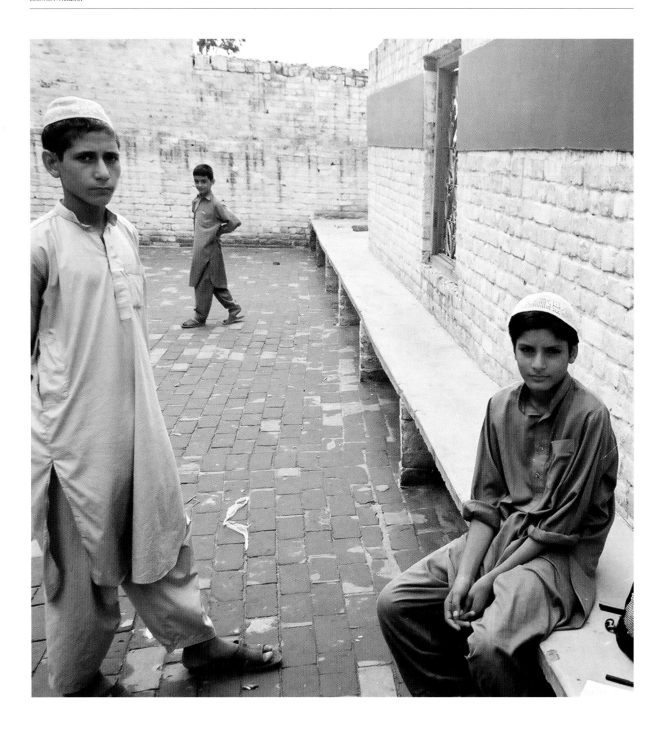

7.1 Madrassah in Old Lahore

This madrassah in the old city of Lahore is typical of many of the older buildings that made the city of 10 million a center for academics, culture, publishing and other arts. For at least 1,000 years, Lahore was the intellectual capital of North-West India. It is Pakistan's second largest city after the commercial capital Karachi.

Lahore is predominantly Punjabi in language and culture. Punjabi officers form the backbone of Pakistan's military. But in recent years, Lahore and the wider Punjab province have been the sites of terrorist attacks, including more than one blast at the city's great shrine to a mystical Sufi poet — Data Durbar.

When I once walked in the old city a merchant asked me to take tea with him and his fellow shopkeepers. It was the time that Mike Dukakis was running against Vice-President George H.W. Bush for president in America.

"We believe that the Republicans like Pakistan but the Democrats like India," said the merchant. I was taken aback and did not know what to say. Later I learned that in fact Republicans had highly valued U.S.-Pakistani military ties, and that Democrats had seen India – despite its quasi socialist economy – as a valuable Third World leader and potential ally in global diplomacy.

Since then, India dropped its socialism and the Soviet Union collapsed. India developed expertise in high technology (in India as well as in Silicon Valley) and opened up to American investment. Pakistan has been jealous and felt betrayed at the U.S. tilt towards India.

As a reporter in the 1990s in Washington, I detected and reported on the U.S. tilt towards India. As a result, the Pakistani Ambassador in Washington Maleeha Lodhi considered me to be pro Indian and denied me a visa. I've been told I'm the only U.S. journalist to have ever been denied a visa by Pakistan.

However I was able to get an introduction to the Pakistan foreign minister and his home phone number. So I called and told him I was denied a visa and wanted to come to Pakistan to report on Kashmir, madrassas, the economy, militant groups and other topics. He told me to go to the nearest Pakistani Embassy – I was in Nepal at the time – and the visa would be given to me. I did and it was.

photo on following page

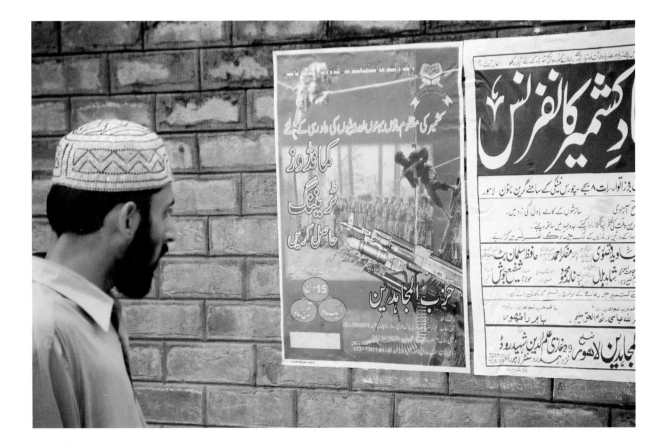

8.
Join the Fight

This Pakistani man reads the fine print on a poster recruiting volunteers to fight the Indian army in Kashmir. The poster offers training and says volunteers can fight for three months of longer.

The poster was hung outside the headquarters of Pakistan's largest Islamic party – Jamaat-i-Islami, near Lahore. It uses the latest techniques found in Western marketing: showing guerrilla fighters are heroes rapelling down walls and carrying weapons on ropes. The row of bullets in the foreground makes clear this is about bloodshed.

Each year thousands of militants cross the border into Indian-held portions of Kashmir to attack Indian troops and also kill Kashmiri Muslim civilians seen as not supporting the Islamic guerrillas. Indian troops respond with brutal force. Some 60,000 have died since fighting began in 1989.

Pakistan denies that guerrillas are recruited, trained, equipped and then sent over the border from its territory.

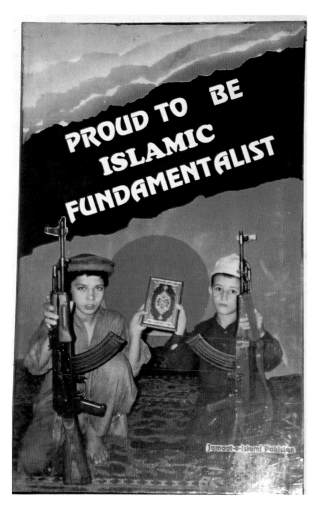

8.1 Child Fighters

This poster shows children holding weapons and a Koran. It was put out by Jamaat-i-Islami, Pakistan's largest Islamic political party – one that has won from two percent of seats in parliament up to 20 percent in 2002. It has remained on the fringe of political power but it is able to put tens of thousands of demonstrators into the streets and intimidate critics.

A strong supporter of efforts to oust India from Kashmir, Jamaat's leader once rushed back from a trip abroad to stop peace talks that proposed ending the guerrilla conflict through negotiations. He put a quick stop to those talks, and the guerrilla war goes on 10 years later. The group has sponsored huge demonstrations opposed to U.S. intervention in Afghanistan and efforts to attack terrorists inside Pakistan.

Jamaat operates out of a sprawling campus a half hour drive from Lahore.

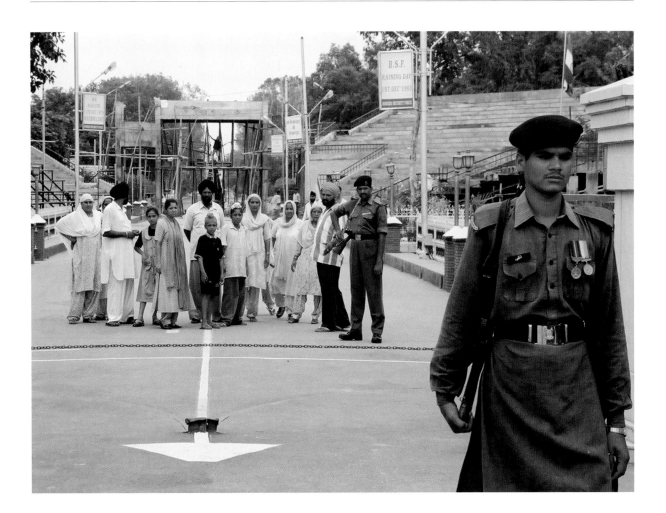

9.
Indians View Pakistan Across Chain Border

As a tall Pakistani border guard marches back and forth, an Indian family stares across from its side at the enemy.

This is Wagah – the only crossing point on the 1,500 mile India-Pakistan frontier. Most Indians and Pakistanis cannot cross. Even foreigners can only cross on the one day per week it is open.

Although many of the 187 million Pakistanis and 1.2 billion Indians speak the same language – Urdu or Hindi – and they like the same curries and films and music, they fought three wars since partition into the two states in 1947. In 1998, both tested nuclear weapons.

Since 9/11, the United States gave Pakistan $20 billion in aid – mostly for its military – to fight terrorism.

Instead of using the money to hunt for Osama Bin Laden (found hiding May 2, 2011 in a villa less than a mile from Pakistan's military academy in Abbottabad), or to catch militant fighters of the Taliban and other groups slipping into Afghanistan to kill Americans and Afghans, Pakistan used the U.S. aid to buy weapons to fight India.

The Indian sub-continent's culture began in Pakistan's Indus River Valley 3,500 years ago and spread East and South into what is now India. India is expected to pass China in the coming years to become the world's most populous nation. While it still has the largest number of the world's malnourished children and vast regions of dire poverty, it has made economic progress, including exports and service center jobs answering phone calls from Americans seeking to call their banks. Literacy is 61 percent and the gross domestic product per capita is $3,400.

Pakistan's literacy rate is 50 percent and GDP per capita is $2,400.

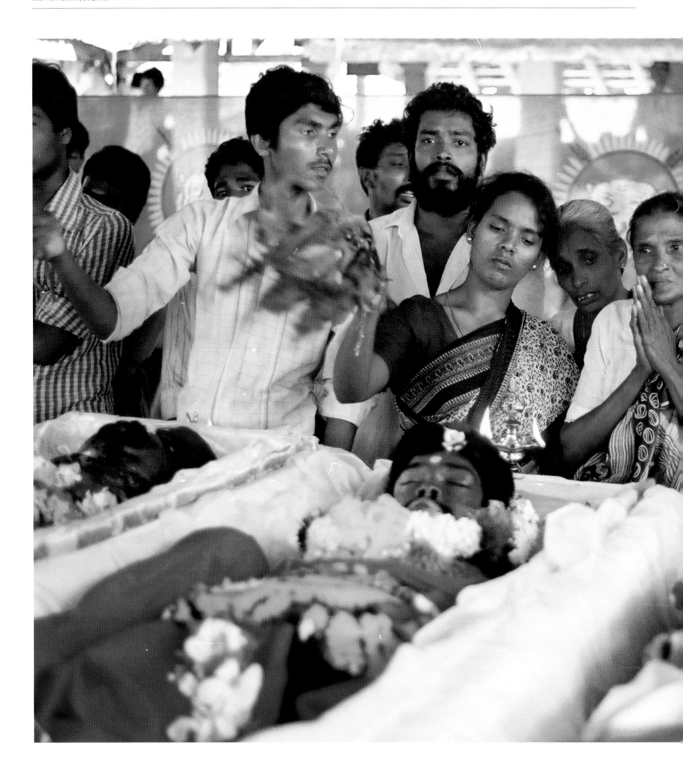

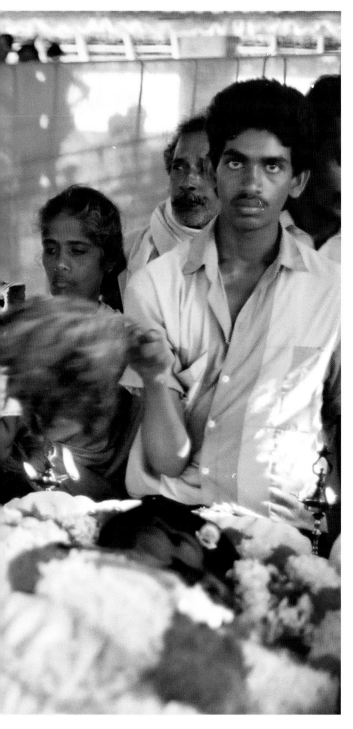

10.
Tiger
Suicides

Quite by chance, I stumbled onto a large crowd in northern Sri Lanka and found myself the only reporter at the funeral of 12 Tamil Tiger fighters who bit cyanide capsules after being captured.

It was 1987 and the separatist war had already killed about 50,000 people. In 2006, thousands more died as the guerrilla war flared anew.

All the Tiger fighters wear cyanide capsules and are taught to commit suicide rather than face possible torture under interrogation.

But pity for the suicidal Tiger is blunted by their atrocities. I saw mass killings, places where buses were halted and Hindu Tamils allowed to live while all the Buddhist Sinhalese were gunned down.

"You want to see Sinhalese burning," a Tamil man on a motorbike asked me next day in Jaffna. I could already smell it. Four men had been captured and shot – a television crew from Colombo.

That was October. Next month India would send 50,000 peacekeeping troops to try and stop the bloodshed. They failed and went home with 1,500 dead.

I had the feeling the Tamil Tigers were never more than a small group who imposed their will on their own people first and then pushed for a separate state they would control.

10.1 Wounded Tiger

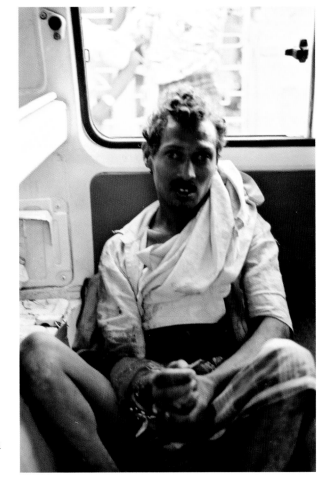

A wounded Tamil fighter clutches a bloody cloth over his bleeding arm as his comrades rush him to a hospital in the Jaffna Peninsula of Sri Lanka.

Helicopters of the Sri Lankan Army and the Indian Peace Keeping Force patrolled the skies as we raced at up to 100 miles an hour along deserted roads.

In the hospital, among several other wounded Tamil fighters, one of them was delirious, mumbling "there were so many Indians, so many of them."

The Indian military help in 1988 only pushed the Liberation Tigers of Tamil Eelam into remote jungles. But the rebellion lasted another 20 years.

In 2009, the Sri Lanka army used massive force to drive the Tigers from jungle hideouts and destroy them on a northeastern sandbar despite the presence of tens of thousands of Tamil civilians the Tigers had brought with them as the human shields.

Scandinavian peace negotiators and human rights activists blamed the Sri Lankan army for killing civilians during their final push to end the Tiger rebellion. But the Tigers had played the European sympathy card for many years. This time, the Sri Lankan army probably decided to ignore the human rights appeals and push on to totally eliminate the Tiger movement which had killed so many thousands of people, forced families to send children to be used as suicide bombers and devastated the beautiful island once known as Ceylon.

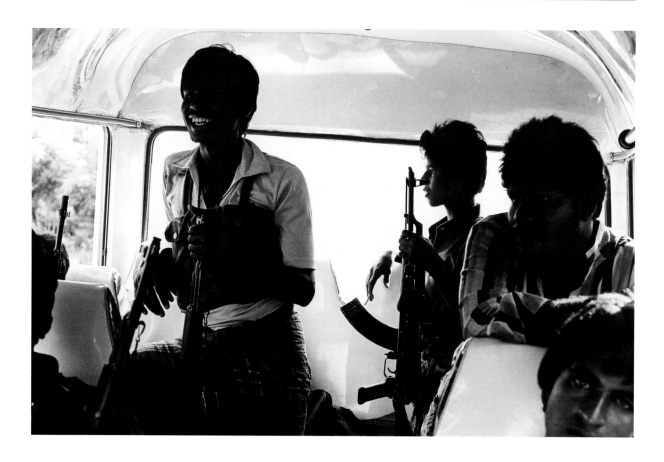

10.2 Light Moment Before Battle

A dozen Tamil Tiger fighters hold their weapons and laugh as they are shifted from one encounter with the Sri Lankan or Indian troops to another.

They had no uniforms but wore cloth lungi skirts and flip flops.

One Indian military officer who met with the Tigers before the Indians tried to intervene in 1987, remarked that they look boys but what they held in their hands told another story. The weapons were oiled and lovingly maintained. The only ornaments they wore were additional ammunition pouches and cyanide capsules.

10.3
Ready
for
More

A young Tamil fighter holds his rifle at the ready as he moves with his squad from one encounter with enemy troops to the next. The tough and resourceful Tigers, controlled and inspired by their leader, proved elusive for the conventional army of Sri Lanka and the Indian troops sent to help end the rebellion.

In the end, after 28 years of fighting, 60,000 to 100,000 lay dead on the tropical island paradise, including the Tamil Tiger leaders and many of their followers.

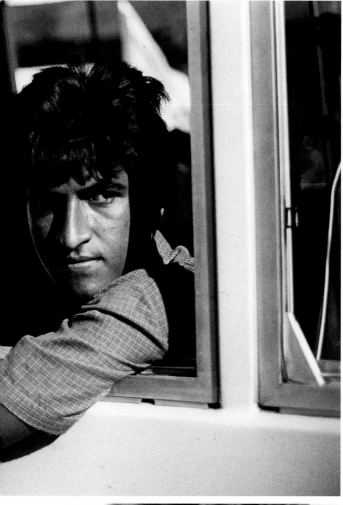

10.4 Cyanide Capsule Promises Death

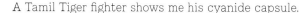

A Tamil Tiger fighter shows me his cyanide capsule.

I could not tell if it was glass or plastic – I did not want to tap it very hard to find out.

The white crystals inside assure the fighters that they will not be able to reveal any secrets if they are captured and tortured. The Tiger leaders insist all fighters wear their capsules and bite down on them if they are about to be captured. Death will come in minutes.

10.5 Wounded Civilians at Jaffna Hospital

The Tigers had been telling me and other reporters that Sri Lankan troops killed Tamil doctors and nurses in Jaffna hospital when they captured it. So when the Sri Lankan army invited about 30 journalists to fly by helicopter into Jaffna in 1987 to witness their victory over the Tigers, we asked to see the hospital.

Sniper and machine gun fire echoed through the air. But no one was visible on the streets as our military convoy wound its way through Jaffna to the hospital.

Here you see an old man with a wounded child who came out to meet with us outside a ward. But he was too frightened to speak to us and explain anything.

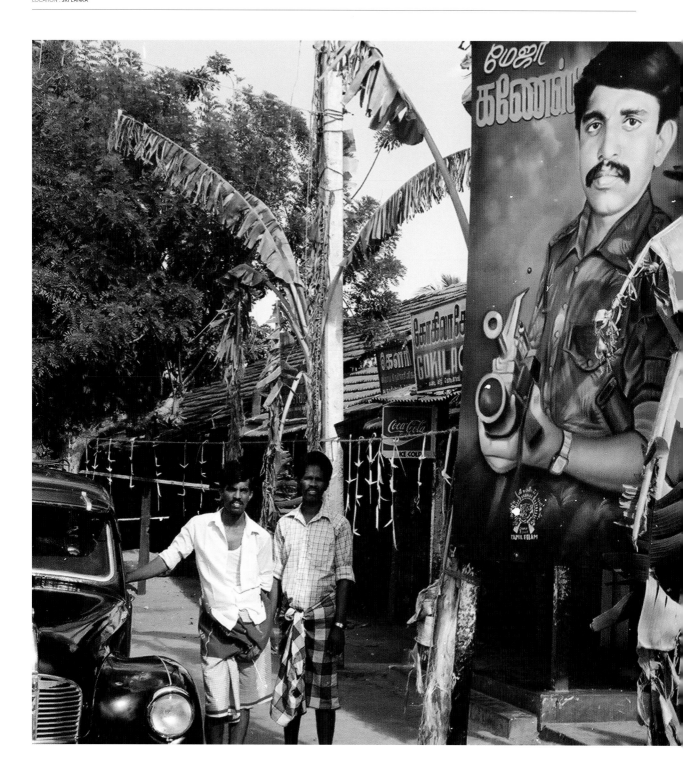

10.6 Rambo Pose

Young Tamils in Jaffna stand beside a larger than life-sized poster of a heroic Tiger fighter in a Rambo pose with his weapon facing forward. During two visits I made to Jaffna while it was under control of the Tigers, I saw many of these giant posters glorifying dead fighters or simply aiming to inspire people to support the cause.

When I asked people in shops or in the street if they support the Tiger's fight to create a separate Tamil state, they were all terrified to respond. That indicated they were against the Tamil Tiger movement. If they supported the struggle, they would not have been afraid to say so.

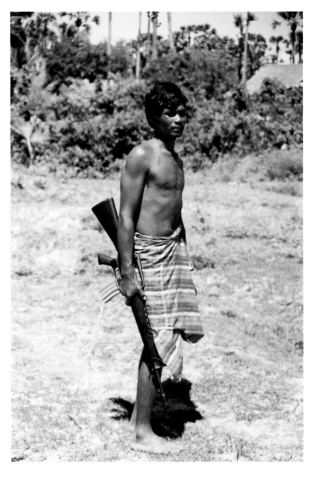

10.7
Is This
How You
Dress for
War?

A Tamil Tiger fighter shows what is essential in dressing for combat. He has only a single cloth tied around his waist and does not even have shoes.

But his weapon appears ready for use with a magazine locked into place.

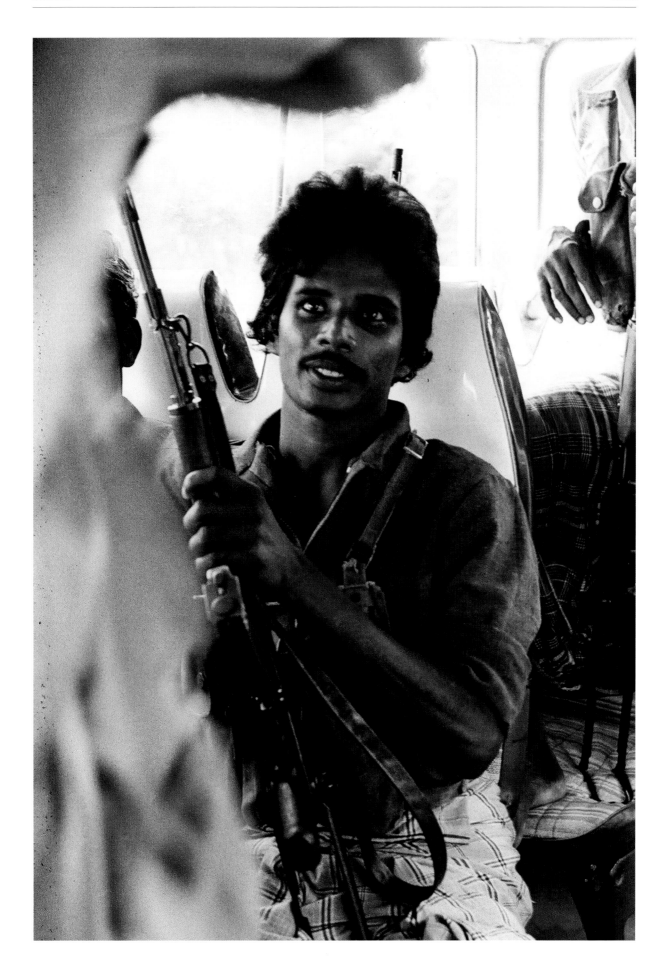

11.
After the
Battle

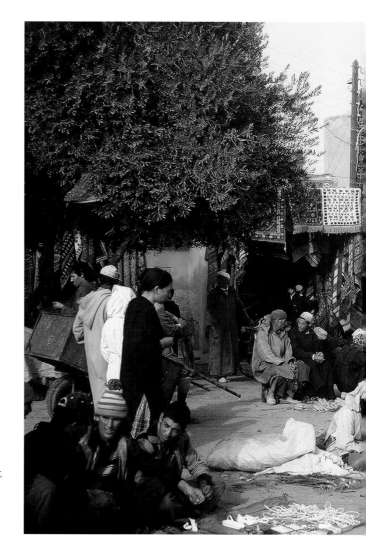

A Tamil Tiger fighter holds his weapon moments after a battle with Indian Peacekeeping Forces in northern Sri Lanka. His face reveals the excitement of the battle. Death had taken some friends, some enemies. He has survived, so far. Although he's wearing a cloth skirt or lungy and flip flop sandals, he's got a reliable AK-47 assault rifle and rides in a bus with a dozen other fighters.

From the Indian army helicopters patrolling the skies, it looks like a civilian bus so it's not attacked. When I stick my head out of the window to see the helicopter, they pull me back inside. Don't attract attention, I'm told.

Sri Lanka's terrible guerrilla war was marked by suicide capsules and by suicide bombs. Colombo the capital was torn apart by huge bombs long before Al Qaeda, Hamas and other Muslim groups adopted the technique.

A female Tamil Tiger assassinated Indian Prime Minister Rajiv Gandhi in May, 1991 with a suicide bomb.

photo on previous page

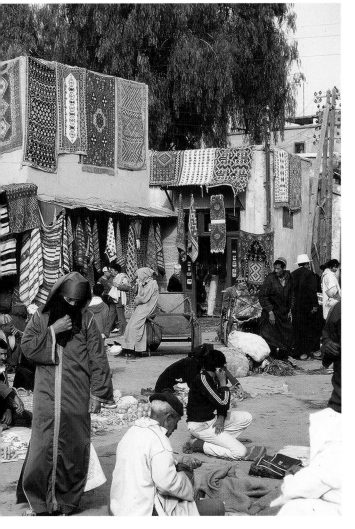

12. Marakesh Carpet Market

You come to this open market square by following a labyrinth of nameless alleys through the Medina – the Arab city inside the ochre walls built 500 years ago. I'd lived six months in the city in 1969 and only found this place years later, by chance.

This scene is filled with life. People are selling plastic sandals, rope, vegetables and –most important of all – Moroccan hand woven carpets. The men wear gelabas, the hooded robes of traditional Morocco.

In many Third World countries such as Algeria, European colonial rule undermined the sense of pride in ones own, ancient culture.

Because the French ruled Morocco as a protectorate, allowing the local people to run courts, police and village government, people kept their sense of pride in who they are. They showed me a million kindnesses without the confused inferiority-superiority complex one finds in many developing countries.

For this reason, the scene in this photo is a miracle. These people are at home – chez eux in French. The woman in the center wears a veil but as she looks at the merchandise on sale, her posture is not subservient. Everyone in this scene seems relaxed, animated, comfortable. And their carpets are magnificent. Unfortunately, many are woven by very young girls who sacrifice their education, their eyesight and their childhood to make them and to bring income to their families.

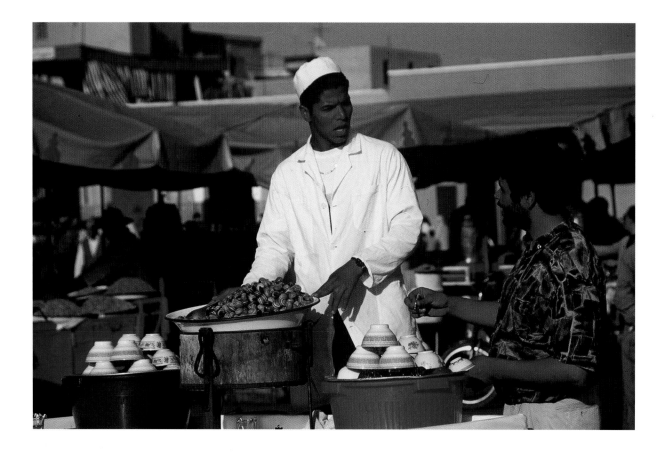

12.1
The Place
Djemaa El
Fna

A Moroccan man sells snails to a customer in the giant outdoor market in Marrakesh, the Djemaa El Fna. Every day thousands of villagers descend from Atlas mountain towns around Marrakesh to sell their wares, buy their household and farming needs and listen to stories told by poets and singers.

I spent six months one winter in the old city of Marrakesh, living in a rented house behind a high wall and heavy wooden door. Every day we went through the dusty, crowded streets to the "Place" to wander among the crowds who wore different tribal garb. We'd watch the snake charmers and story tellers singing their epic tales handed down from father to son over the generations. I'd meet with people from all over Morocco and visitors from Europe and Africa.

In April, 2011, a huge blast hit a café overlooking the Place, killing 16 people including many foreign visitors. I think it must have been the café where I so often drank thick milky café au lait or else super sweet mint tea.

From the second floor café balcony we could not only look over the thousands of people in the square, and the horse carriages trotting back from the French Quarter. We also saw the snow atop the High Atlas Mountains as it turned orange and red in the setting sun.

At night, the magicians and water sellers are replaced by dozens of food stalls running electric lights from

generators and cooking everything from traditional cous-cous and tagine stews to kebabs and the snails pictured here.

The largest traditional market or souk in Morocco and perhaps all of Africa, the Place is a gateway to a series of circular passages leading deep into the ancient city whose walls are plastered with red clay. Next to the booths selling sheepskin clothing and pottery one finds a scarcely-noticeable opening into a covered alley where hundreds of shops fan out selling horn-handled knives, carpets, silver jewelry, spices, flat buzzing hand drums, flutes, Berber dresses and – finally at the end of this chain of goods — the tethered lambs and sheep ready to be slaughtered, cooked, skinned and rendered into yellow slippers, vests and other useful items.

You also find woodcraft and textiles and knives from Nigeria on sale. They come across the Sahara Desert. One day I borrowed a car and crossed the Atlas Mountains. On the other side I drove down into the sand dunes of the Sahara, stopping for an uncomfortable night in the fly-blown village of Ouarzazate. From here, travel was mainly by camel caravans of the Berbers dressed in blue clothing; or else in convoys of trucks carrying oil and cargo heading for Mali, Niger and Kano, Nigeria – the vast ancient market city of Northern Nigeria that lies at the opposite end of the Sahara from Marrakesh.

Morocco lies at the Western edge of Islam. It has 31 million people. King Mohammed VI has promised to yield some of his absolute power to an elected parliament and prime minister, but pro-democracy protests of the Arab spring continued to erupt in June 2011. The World Bank reports that the average income was $2,770 in 2009. Poverty fell in a decade from 16 percent to nine percent of the population, life expectancy was 72, but literacy was only 56 percent.

13. Hmong Girl Carrying Baby

The umbrella staves off the hot sun of lowland Laos as this young Hmong girl carries a child on her back.

Her face and her glance show the natural beauty and strength of the Hmong people, struggling with the elements in a hostile landscape.

She lives in a resettlement village. Her family and hundreds more escaped to Thailand in 1975 by crossing the Mekong River after the communists took power. But Thailand grew weary of the refugees and those who were not accepted by the United States were sent back to Laos around 1995.

But instead of moving back up to their mountain villages, where they might grow opium or cut down the forests to grow corn, they were given rice land in the plains. Adapting to the heat and the new life has not been easy. But after 20 years in refugee camps, the rhythm of the new life was taking root.

photo on following page

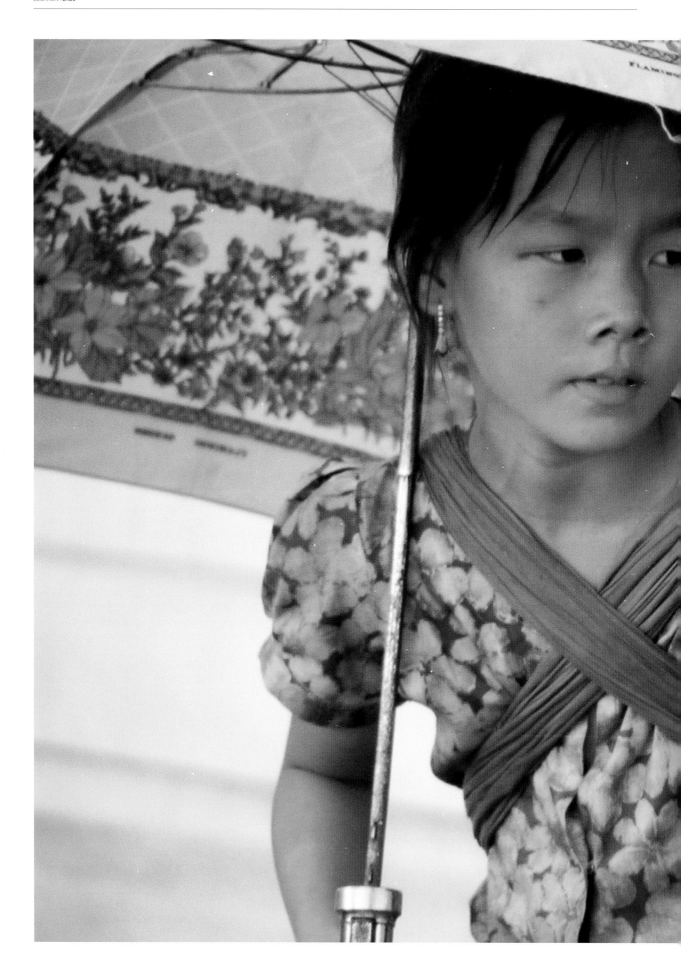

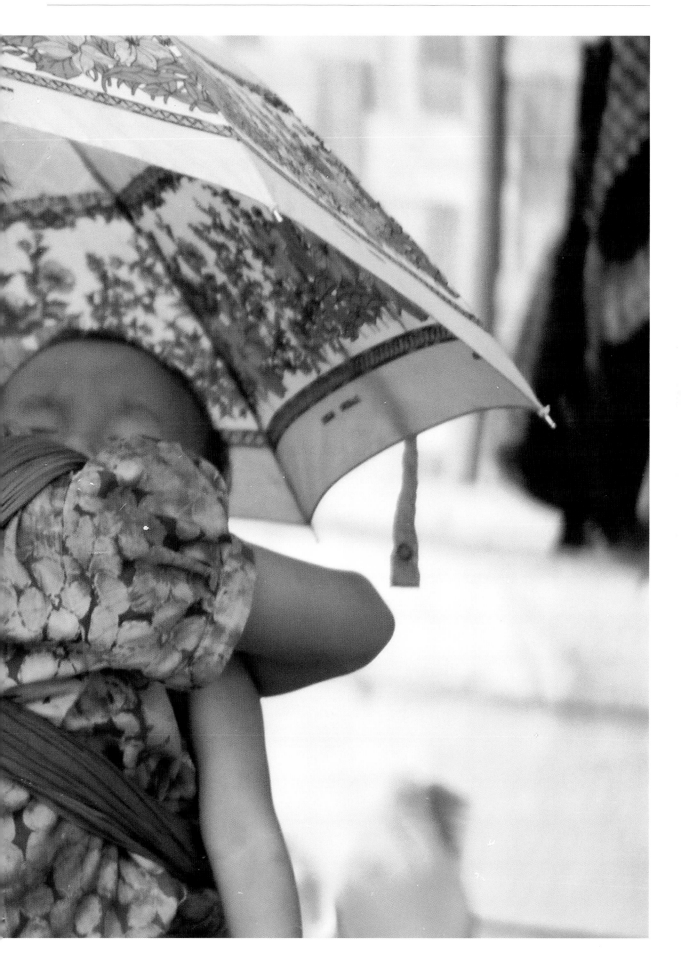

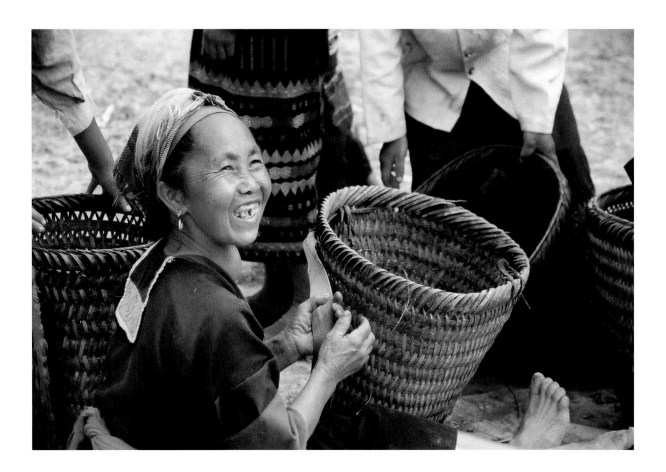

13.1
Hmong
Basket
Woman in
Laos

This smiling Hmong woman was sitting at a road crossing in central Laos.

She was preparing the straps on her basket, ready to haul a load of anything from textiles to wood to grain from the town to her home village many miles up and down the rugged hills of Xieng Khouang Province. During the Vietnam War, the region made history by becoming the most heavily bombed place in the world. And all that bombing did not prevent the communists from winning the war. But it seeded the landscape with millions of deadly unexploded ordinance that still kills farmers and children each year.

Her smile seems to eclipse the long years of war and privation that afflicted the Hmong over the years. As an American reporter I always find it surprising and reassuring to find people such as this woman, a survivor of bombing, landmines, the Vietnam War, communist rule, poverty, prejudice against Hmong, and the endless struggle to feed herself and her family. She is not morose and gloomy. She does not put out her hand for money. She does not appear to resent someone who travels in a car, albeit a dilapidated Russian jeep without shock absorbers that bounced me around so much that half the numbers on my watch came loose.

The scene is full of authenticity. Her dress is a traditional design and made of locally made cloth and embroidery on the back collar. The baskets are all hand made from locally grown materials and extremely sturdy. Americans once knew how to make such baskets 200 years ago but now have lost all memory of the craft.

Next to her stands a woman wearing a colorful traditional cloth skirt. The designs are similar to cloth woven throughout Southeast Asian hill tribes living in the highlands of Burma, Thailand, Laos, Cambodia and Vietnam.

The women will walk together along the unpaved roads to share company and protection.

At first when I printed out this photo, I focused on her teeth, and I felt sorry that she had no way to fix or replace the teeth she had lost. I also wondered if she had pain from infected teeth. But later on I saw the brilliant smile and the spirit of this woman.

There are about five million people in the world who speak Hmong languages. Three million live in China, 800,000 in Vietnam, 500,000 in Laos, 150,000 in Thailand, and 180,000 in the United States.

U.S. relations with Laos, broken during the Vietnam War, improved in recent years, especially as opium production – much of it cultivated by the Hmong — was slashed by 95 percent between 1998 and 2007. U.S. foreign aid was $11million in 2010, focused on clearing unexploded munitions, counternarcotics, health, food, trade and governance, according to the State Department.

After years during which U.S. conservatives and some Lao refugees helped block trade with Laos – believing isolation might bring down the communist rulers – in 2004, trade relations were normalized. However trade remains small.

One area where trade is brisk is seen in the post office in the capital of Xieng Khouang Province. Dozens of Hmong families were sending parcels off to the two centers of the Hmong refugee community in America — St. Paul and Fresno. The parcels contained fancy embroidered traditional dresses to be sold to Hmong refugees in America seeking to keep their culture alive.

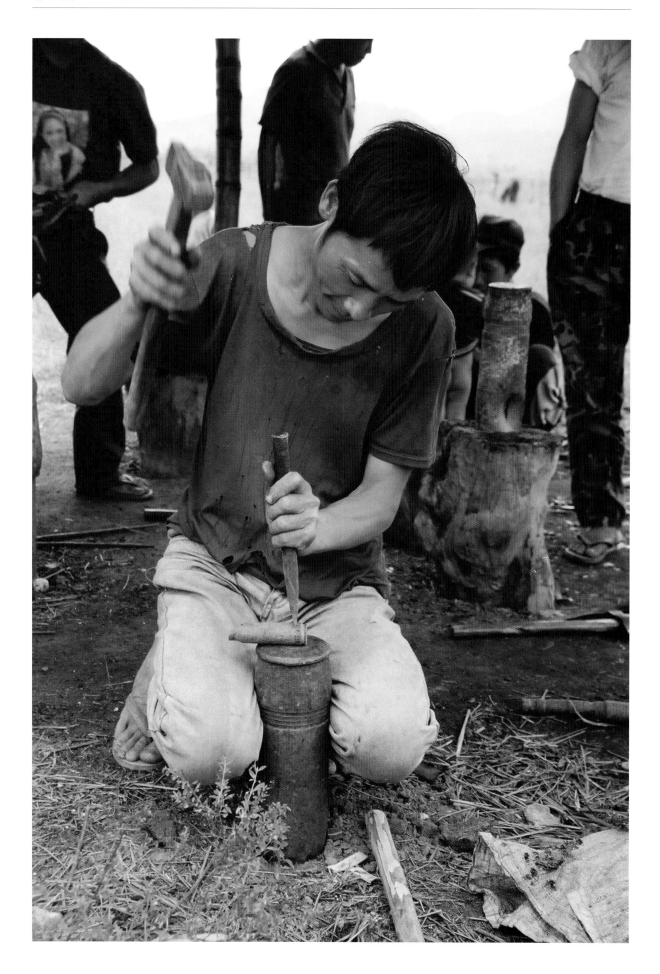

13.2 Explosive Anvil

When I saw what this Laotian gunsmith was doing, I was afraid to stand too close.

He was using an old artillery shell as an anvil.

I assumed it must not be explosive any more. But I was not entirely convinced.

With a handmade chisel and hammer he was trying to dissect a smaller cartridge, either to rescue some of the explosives inside or to use the brass case.

He was making a muzzle-loading musket to hunt birds. He shook out into his hand the small lead balls he would pour into the barrel of the gun he had made. Then he raised the wooden stock to his shoulder and fired into the sky above a vacant field.

It seemed strange to be cutting up the artillery and war tools of the 20th century – even using some of them as an anvil — and use them to re-create hunting firearms of the 18th century.

It was also uncomfortable to think that these old artillery shells and bullets might have been rained down upon this tribal, undeveloped people from American B-52 bombers, fighter planes or artillery. Of course, the munitions could have also been fired by North Vietnamese guns.

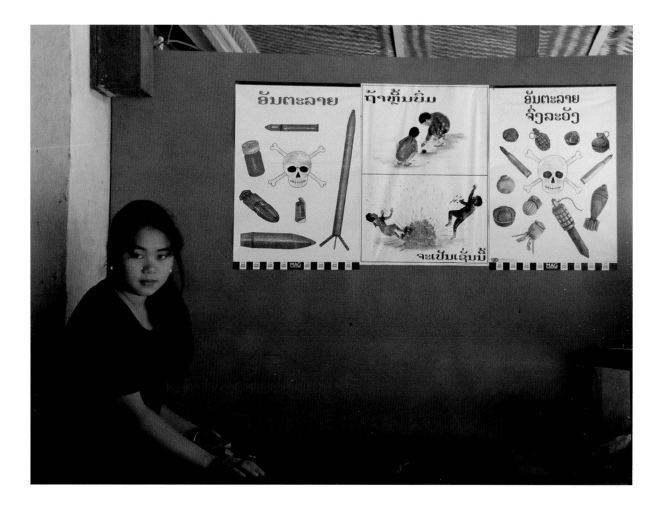

13.3 Unexploded Bombs Continue to Kill Long After Vietnam War

This young woman sits in front of posters warning of deadly unexploded ordinance (UXO) that still remain ready to blow up when struck or even moved by a shovel or a child's inquisitive hand in central Laos.

The poster shows a varied assortment of U.S. and Soviet Bloc munitions left behind by the Vietnam War.

Large portions of the Laos highlands were heavily bombed by the United States in a futile effort to block the advance of North Vietnamese troops who helped overthrow in 1975 the Royal Lao government. The king, Savang Vatthana, died of neglect, chained to a tree in a re-education camp for years after his government fell, sources told me in Bangkok years later.

To reduce the effects of accidental blasts from UXO, U.S. aid teams gave out American-style shovels to replace the traditional heavy hoe which tends to direct a blast back at the farmer. The U.S. spades direct the explosion away from the farmer.

The aim of the posters is to teach children about these devices so that they will know to keep away from them and keep small children away as well.

Laos is the most heavily bombed country, per capita, in history, according to UXO Lao, the Lao National Unexploded Ordinance Program, a group that seeks to clear and eliminate such weapons.

Approximately 25% of villages are contaminated with UXO left over from 580,000 bombing missions that dropped 2 million tons of ordnance between 1964 and 1973. The most common UXO remaining are cluster bomblets – some 270 million of them were dropped on Laos and 30 percent failed to detonate, leaving 80 million unexploded bombies in Laos after the war.

All 17 provinces of Laos suffer from UXO contamination.

Over 50,000 people were killed or injured by UXO accidents from 1964 to 2008. Some 20,000 of them were hurt or killed after the war ended.

UXO Lao says it needs about $6.5 million for operations. It employs over 1,000 people.

13.4 Hmong Laotian Girl

This Hmong Laotian girl was standing by the trail as I walked among the villages of central Laos in 1997, researching a series of articles for The Washington Times on the fate of the Hmong after the war.

She seemed supremely at ease and comfortable talking to a foreign reporter through an interpreter.

General Vang Pao, leader of the CIA's secret Hmong army in Laos from 1964 to 1975, told me in an interview in Fresno, Calif. in 1997 that the communist Laotian government was persecuting the Hmong who stayed behind and did not flee into refugee camps in Thailand and later move to the United States. Vang Pao and other Hmong and American activists lobbied Congress to keep Laos isolated and cut off from U.S. trade and aid. My editor sent me to Laos to find out the truth of these allegations. I came back and reported that the Hmong in Laos were actually doing all right and did not face the sort of brutal persecution alleged by the activists.

The majority ethnic Lao live in the lowlands and control the government, military and economy. They see the Hmong as rude, ignorant, dirty and non-Buddhist hill tribe people – sort of the hillbillies of Laos. But the Lao do not go out of their way to persecute the Hmong, I was told by the Hmong themselves.

The biggest fear the Hmong had was that they would be prevented from using their traditional "swidden" form of agriculture – they would burn a patch of jungle in the mountains and grow crops for five or 10 years until the fertility was exhausted. Then they burn a new patch. Environmentalists – especially from Europe – pressured Laos to stop this system and even urged that Hmong be forced to move to the lowlands to protect the nation's watershed which the government wanted to tap for hydro power projects.

Children such as this girl may be the last to grow up in the cool hills and forests of their ancient culture, far from the prejudice shown by the majority Lao towards their hill tribe in the steamy lowlands.

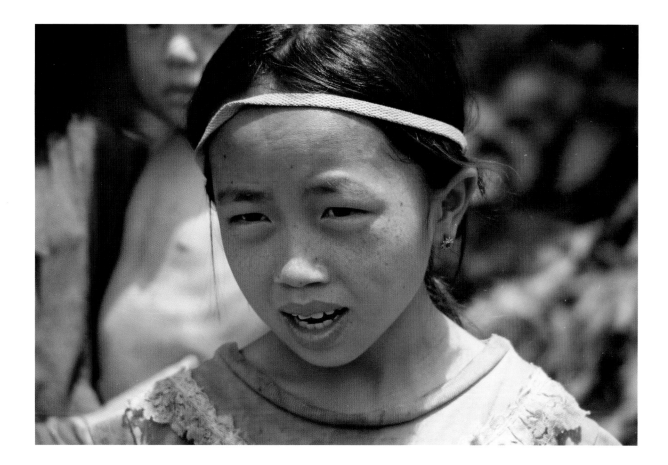

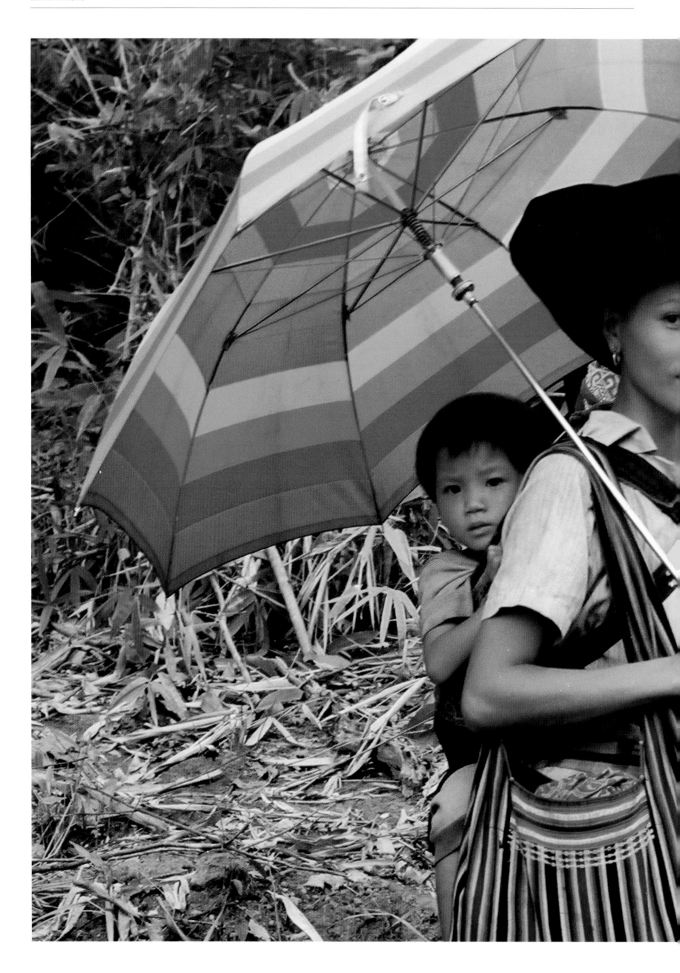

13.5
Woman with Child in Northern Thailand

In Northern Thailand near the border of Laos live five hill tribes: the Hmong, the Akka, the Karen, the Yao and the Lahu. This woman with her child is typical of these hill tribe people: clinging to their traditional clothing but smart and open enough to use an umbrella to shelter herself and baby from the steamy sunshine.

These hill people proved to be the barrier that stopped the spread of communism at the end of the Vietnam War.

After U.S.-backed governments were overthrown in South Vietnam, Laos and Cambodia, communists began trying to make Thailand the next domino to fall. They began recruiting among the Thai hill tribes, reasoning that these people were ignored and neglected by the Thai government so would be ripe for a change.

U.S. advisors offered to help the Thai seek a military solution to the communist groups, which were backed by China. But the Thai government saw the frightening collapse of adjacent governments allied to the United States. They watched films of people fighting for seats on the last helicopters out of Saigon, Phnom Penh and Vientiane. So the Thais asked the United States to go home — withdraw U.S. troops and aircraft. Thanks but no thanks.

Instead the Thai King Bhumibol Adulyadej and the Thai government decided to embrace the hill tribes. They built roads so that –for the first time – hill tribe children could get to school, people could go to clinics, and farmers could market their cabbages in major Thai cities. In a few years, helped by a large U.S. aid program, the hill tribes accelerated into the 20th century. And the communists seemed to be an anachronism of the soon-to-end cold war.

The King also offered amnesty to the communist guerrilla fighters – the Thai government bought their weapons and granted them small parcels of land to raise crops and livestock. A few days before encountering this woman on a mountain trail I had flown to Chiang Rai with the former Army Supreme Commander General Saiyud Kerdphol. He was the architect of the civil-political-military strategy that replaced the U.S. offer to launch a new Southeast Asian war.

Together we went to visit a former communist guerrilla who now ran a small pig farm. The two old men – former enemies — sat on a wooden bench under a woven thatched awning and reminisced about the years when they fought each other.

"This is better," said the former guerrilla.
"Peace is better."

photo on previous page

13.6
Hill Tribe Man with Muzzle-Loading Gun

This young hill tribe man was walking along the trail in northern Thailand when we met. I asked to photograph him with his gun – apparently a muzzle-loading musket with small BB sized pellets used to hunt birds and other small animals.

He carries the ubiquitous striped colorful shoulder bag one sees from Morocco to Vietnam, from Tibet to Burma. They can carry up to 40 pounds of grain, tools and other goods although they seem rather flimsy at first glance.

And he wears flip-flops, shaming those of us who spend $100 and more on hiking shoes for our trekking. And he wears a watch. I have yet to figure out why one pant leg is rolled up – is it a fashion statement or just happenstance?

His face is what is most intriguing. It's a picture of serenity, of confidence, of relaxed alertness.
It speaks to me as belonging to someone who must remain alert and wary as he walks remote mountain trails, either to bring down game or to avoid nasty people, who exist all over the world. Yet when approached with a friendly face and a straightforward request to document his rifle and himself through a photograph, he agrees.

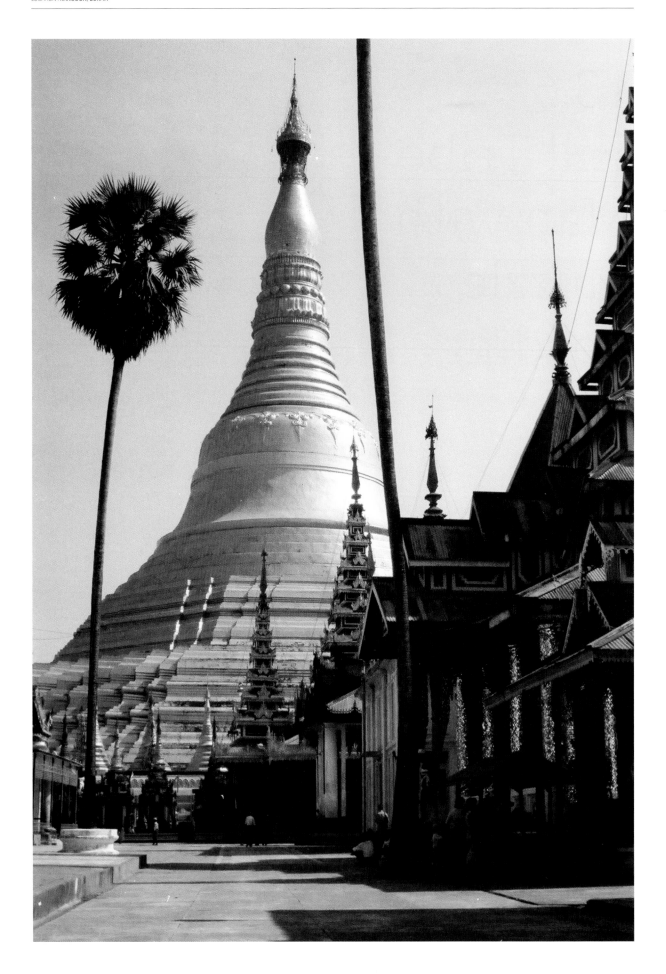

13.7 The Shwedagon Pagoda in Rangoon

The incredible Shwedagon Pagoda in Rangoon soars 32 stories above the temple platform. It is one of the world's greatest religious monuments. Thousands of Buddhist pilgrims were wandering around the temple when I visited and the overwhelming feeling was one of awe.

How had ancient architects and builders raised that 322 foot spire, coated with thin sheets of gold? How had they placed at the peak more than 5,000 diamonds and rubies, including a 76 carat diamond?

All around the foot of the pagoda, Buddhist monks in red robes along with thousands of ordinary Burmese worshipped at dozens of smaller shrines and temples, packed with statues of Buddha mediating, standing, lying down and holding his hands in the mudras or poses that indicate various states of being.

Not far from the Shwedagon Pagoda, the ruling military junta would shoot down 3,000 protesting students in 1988. Instead of coming to the Pagoda for protection, the students came to the front of the U.S. Embassy in the mistaken belief that the United States would protect them. After all, U.S. speakers on the Voice of America Burmese service often spoke about U.S. support for democracy around the world. But the dy I took this photo it was 1982 and the fear of the army, its spies and its torture cells in Insein Prison was so great that no one spoke out loud about democracy.

After shooting the democracy protestors in 1988, the junta changed the names of the capital city from Rangoon to Yangon, and the name of the country from Burma to Myanmar.

It was hard to equate the graceful and powerful spire of the Shwedagon Pagoda with the cruel military, hunting down the students in the jungles near the Thai border, systematically raping Karen and other ethnic women, and forcing thousands of men to serve as porters in malarial jungles. Was this great beauty and great ugliness produced by the same nation?

Because journalists were banned, I went as a tourist and was very careful to interview people out of sight of possible government spies. And I never used the names of my sources in my articles.

Some visitors say that because of the isolation imposed by the military dictatorship Burma is one of the most authentic, traditional and exotic countries on earth. That may be so. But I could not get the sense of fear out of my mind every moment I spent in the country.

The Burmese military has controlled the country for nearly the entire period since independence from Britain in 1948. The army is dominated by and defends the ethnic Burmans who live in the center of the country. It has subjugated the many ethnic minorities living in the periphery near the borders of Thailand, China and Bangladesh: the Karen, Kachin, Shan, Arakan, Mon, Wa and others.

The army allowed elections in 1990 which the National League for Democracy led by Nobel Peace Laureate Aung San Suu Kyi won by a landslide. But then the government refused to recognize the results. Instead, it placed Aung San Suu Kyi under house arrest for most of the next 20 years.

Burma was hit in May, 2008, by Cyclone Nargis which killed 138,000 people, yet the military rulers refused to allow large scale U.S. and other relief into the country.

When I first visited the country in 1982, Burmese seethed with anger over the military decision to replace overnight the 50 kyat bill with new 45 kyat bills. Suddenly, all the money people had saved was valueless – they could not change it for new currency at the banks. One friend said he used the old bills to light the burner on his stove. Of course the military leaders, aware of the impending move, all changed their 50 kyat notes before they were devalued.

In 2010, Aung Sang Suu Kyi was released from house arrest and the military rulers eased their grip on society.

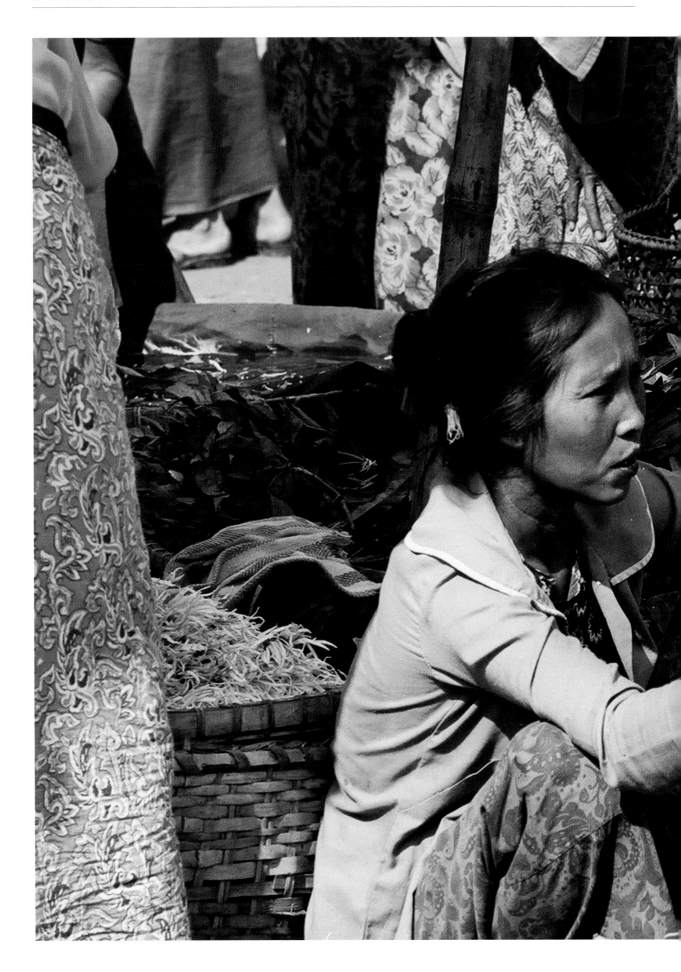

13.8 Burmese Woman Smoking a Cheroot

In the market I saw this woman squatting comfortably on the ground near her produce.

How do they manage to squat for long periods in apparent comfort? I could barely squat for a couple of minutes before my legs burned with pain and I had to sit back on my bottom and stretch my legs out.

The Muslims too around the world are able to kneel during prayers and then sit back on their legs, resting their weight on their feet. Aside from the pain that causes me, I immediately get cramps as well.

Indians too are able to sit comfortable for many minutes while cross legged at ashrams or temples. Not me. Maybe I've spent too many years with chairs to be able to revert to these ancient ways of sitting.

This woman is also smoking a cheroot, a hand-rolled cigar, which is common in this country. This habit was immortalized by Rudyard Kipling in his 1892 work, "On the Road to Mandalay":

'Er petticoat was yaller an' 'er little cap was green,

An' 'er name was Supi-yaw-lat — jes' the same as Theebaw's Queen,
An' I seed her first a-smokin' of a whackin' white cheroot,
An' a-wastin' Christian kisses on an 'eathen idol's foot:

Burma has 50 million people. Under the British it was the rice basket of Asia, exporting large volumes of food to India and other countries. These days it is impoverished and annual average income is $1,400.

According to the CIA World Fact Book: "Burma, a resource-rich country, suffers from pervasive government controls, inefficient economic policies, corruption, and rural poverty. Despite Burma's emergence as a natural gas exporter, socio-economic conditions have deteriorated under the regime's mismanagement, leaving most of the public in poverty, while military leaders and their business cronies exploit the country's ample natural resources."

photo on previous page

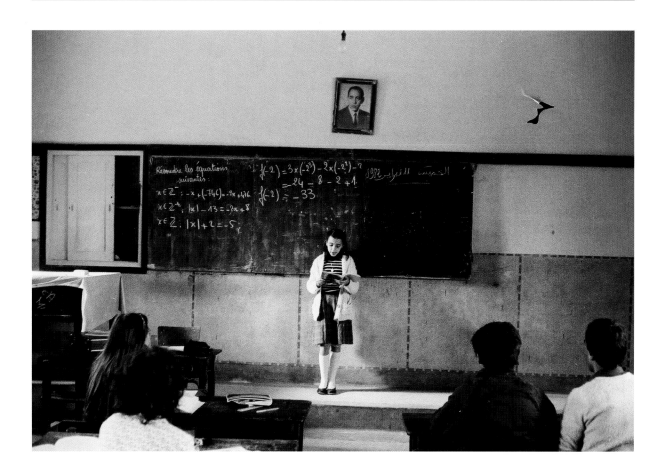

14. Moroccan Jewish School

The dwindling Jewish community in Morocco still ran a few schools in 1982. Here a young girl reads aloud from her notebook to the class. Above the blackboard covered with algebra equations, is a photo of King Hassan II.

Jews lived among Morocco's native Berber people as early as the 2nd century AD – some 500 years before Islam was born and Arab immigrants brought it to Morocco. Under French rule in the 19th and 20th centuries, many Jews adopted European dress and lifestyle. Even after Israel defeated seven invading Arab armies in the 1948 War of Independence, King Hassan protected the 300,000 Moroccan Jews from any backlash. But rising anti-Jewish sentiment among the people led to an exodus, and by 1982, 90 percent of the Jews had left or were about to leave for France and then to Israel. They left by night in small boats off the northern, Mediterranean coast, leaving behind their homes, land, businesses, synagogues, schools, graves, and memories.

This class may have been one of the last for the Jewish children of Morocco, ending nearly 2,000 years of mostly peaceful life among the Moroccan majority.

15.
Magic
Tiger
Tattoo

This workman is taking a break from painting a shop in downtown Vientianne, the sleepy, decaying capital of Laos, some 20 years after the communists took over.

His body is covered in magic tattoos with numerical and religious symbols aimed at fending off the evil spirits that Lao and Thai Buddhists fear so much.

His face is serene and confident, his eyes and mouth smiling. Perhaps he thought it funny that I took his picture — that a working stiff like himself taking a break from painting interested a foreign visitor.

Maybe he was just a self-confident guy, protected by magic tattoos, expecting a paycheck at the end of the day and enjoying a smoke. His indifference to the paint on his body and the attention of the camera show what one rarely sees in American newspapers: a happy, confident man in one of the poorest countries on earth.

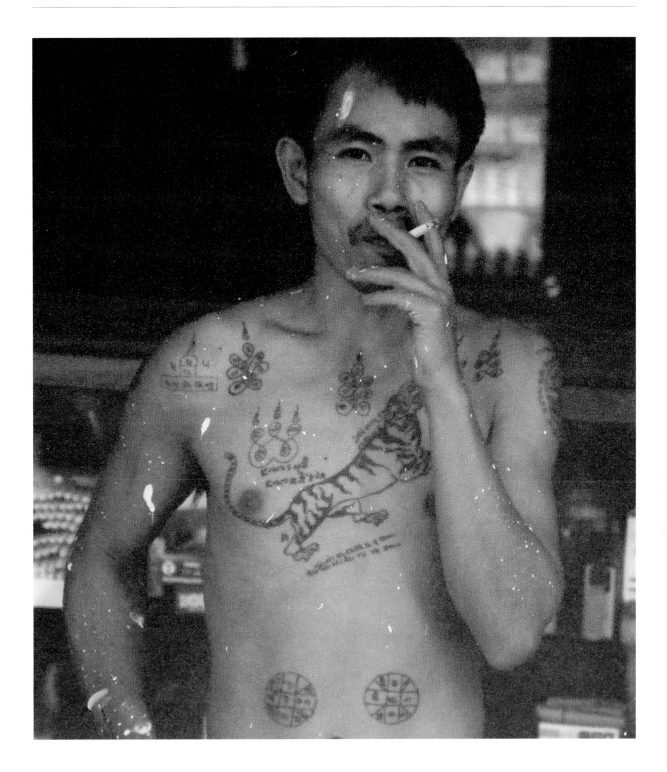

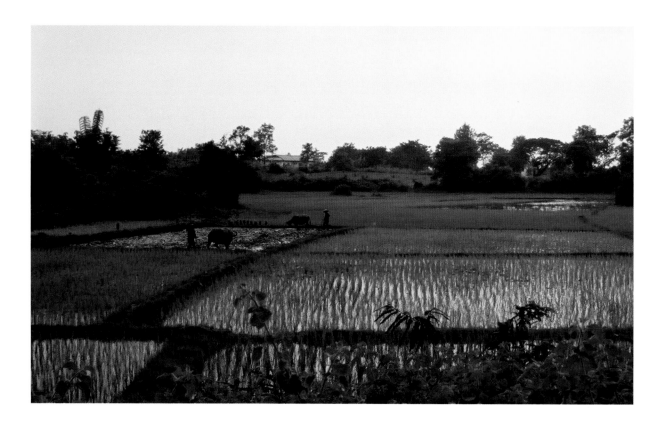

16.
Laos Rice
Paddies

Two farmers plod behind their buffaloes, guiding their plows as they turn over the thick mud of their rice paddies. It is the Laotian lowlands where monsoon rains have collected in the flooded fields. Each one is surrounded by a three-foot tall earthen dike, pressed flat at the top by the feet of villagers navigating across the fields from village to village.

In the heat of the day, the buffalo must rest in the shade. As evening approaches, the farmers urge the huge beasts on to complete another field.

The paddies already planted with rice shoots reflect the sky. They are golden as the sun sets. They were blue in the morning.

When the new paddy is ready, villagers transplant seedlings from the nursery into the mud. Then they flood the field.

The timeless scene could be Laos, Vietnam, Cambodia, Thailand, India, the Philippines or China.

With a simple diesel pump, farmers can now easily refill the paddies after the harvest, raising water from ponds and canals. This gives them a second crop, doubling their income. They also use the new high-yielding rice bred by plan scientists.

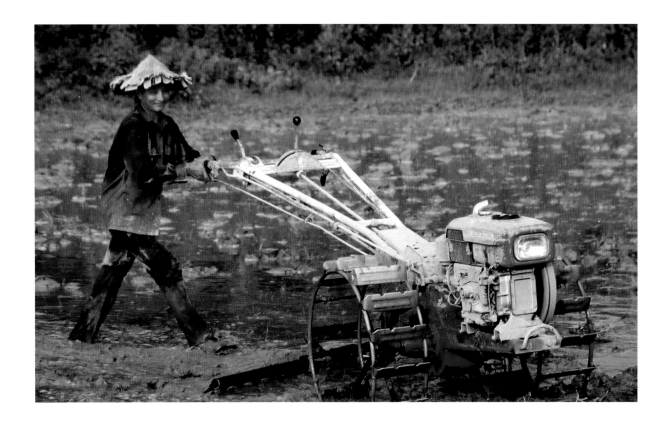

17.
The Iron Buffalo

This machine has changed the face of Asia. The Thai farmer uses his Kwai Lek or Iron Buffalo in a rice paddy. It was introduced in the 1980s and can plow seven times the area that buffalos do per day–without resting in the heat.

"I am sad and miss my buffalo," Chamlong Elam U Lai, a farmer, told me, standing in his rice field. "But no one wants to go back to them. Too slow. I plant two crops a year now in this field."

I met the Iron Buffalo's inventor in 1982 — Mom Teparit, a Thai prince and agricultural engineer. He got the idea from watching how the hoofs of horses

and buffalo spread in the mud and helped them keep on top of muddy fields. The paddle wheels act like the hoofs.

To keep costs low, Thai officials initially allowed duty free imports of the Japanese engines; wheels and body were built in Thailand. By selling two buffalo and taking out a loan, farmers could step up to the new machine. Hundreds of thousands did so.

After a few years, the Japanese Yanmar and Kubota firms were told to assemble engines in Thailand; then, to make the parts in country as well.

King Bhumibol Adulyadej started a Buffalo Bank, buying unwanted animals to lend to poor farmers.

The Iron Buffalo is easily adapted to pump water up from canals, harvest ripe grain and pull carts.

It remains perhaps the most outstanding example of appropriate technology. It let small rice farms make Thailand the world's largest rice exporter.

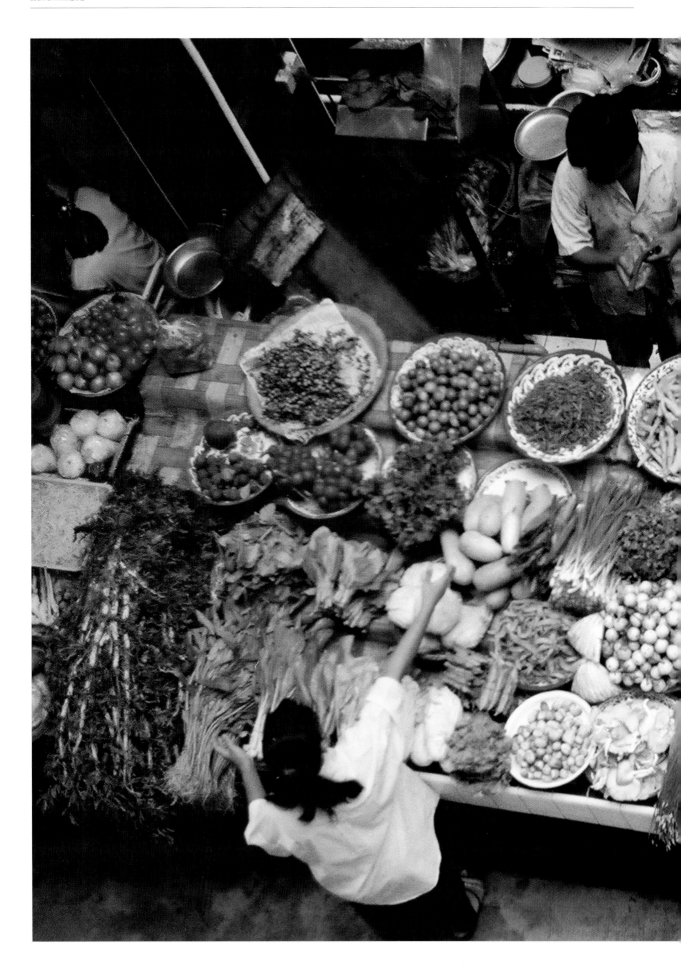

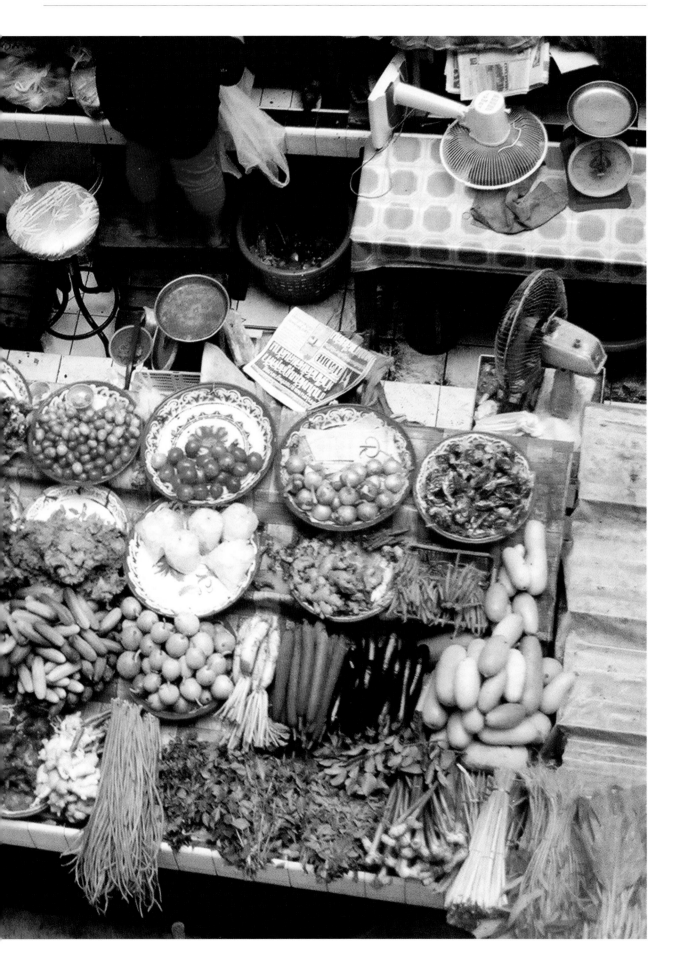

17.1
Thai
Vegetable
Cornucopia

I took this shot from a balcony above a vegetable market in Bangkok. Many of the items on sale were unknown to me before traveling to Asia. Later I would encounter them on my plate and discover how interesting they could be.

Among the items on sale here and in other vegetable markets are:

Lotus root, pak choi, green papaya, pea aubergines, dried mushrooms, spring onions, sugar pea, swamp cabbage, sweet chilli, eggplant, taro, tomato, twisted cluster bean, wax gourd, winged bean, yard long bean, apple aubergines, asparagus, baby corn, bamboo shoot, banana blossom, bean sprout, bell chilli, bitter melon, broccoli, carrot, cauliflower, Chinese broccoli or kale, Chinese cabbage, Chinese chives, Chinese mustard green, Chinese radish, and cucumber.

As you can tell, several of the vegetables have a Chinese origin, brought by the many generations of traders who came from Southern China to Thailand since the 10th century and earlier and settled among the local people. However Thai food benefits from another culinary source– India. Since the first century Indian traders and travelers brought not only food but art and religion. The mixture of Indian and Chinese cuisine — curry and coconut — along with local foods grown in the verdant flood plain of the Mekong River Valley as well as the fruit orchards of the southeast near Cambodia, made Thai food legendary in Asia and, in recent years, America.

Indeed, you cannot go far in any mid-sized American city without stumbling on a Thai restaurant whose customers are not expatriate Thais looking for a taste of home. They are Americans of every social level who have come to love the exciting taste of Thai cuisine.

photo on previous page

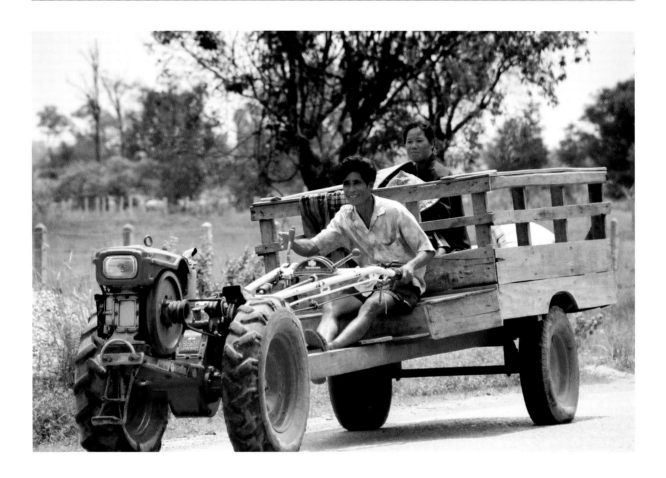

18.
Iron Buffalo
Cart

In Laos, a young man enjoys driving his cart, powered by an Iron Buffalo. The iron paddle wheels that enable it to work in muddy rice fields have been switched to rubber wheels for the paved roads.

For the first time in their history, villagers no longer trudge along the trails bearing the heavy loads of grain, firewood, cooking oil and other produce to and from the markets. Children can get to schools more quickly. And even the sick can get to a clinic without being carried on someone's back.

The cart goes about 12 miles per hour – four times as fast as a man walks – and can haul 15 people and goods.

19.
Haiti Cart Hauler

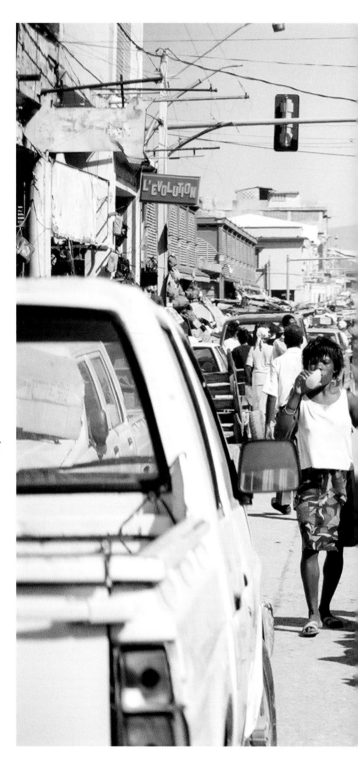

It is the Boulevard J.J. Dessalines, the main street of Haiti's capital Port-au-Prince.

This barefoot man hauls a heavy cart, aided by two women who push from behind. A red sign at left hopefully says "L'Evolution" but there is little evidence of this. The traffic lights are blank. The biggest and best buildings lining the busy shopping street were constructed during French colonial rule or shortly after it ended in 1804 when the black slaves rose up and defeated the army of Napolean.

In the distance, brown mountains begin, their slopes long stripped of trees to make charcoal.

The pride of the Haitian people is still to be seen — their fierce pride and independence. Also, the artistic magic they brought with them from Africa, alongside their Voodoo religion, is seen in their painting, their Compas music and the way they turn a badly-eroded island into a home.

But from the terror under the Duvalier dictators, to the military rulers in the early 1990s, and to the chaos of mobs in recent years, the Haitian people are still waiting for their saviour.

When Jean-Claude "Baby Doc" Duvalier fled Haiti in 1986 during riots, many people hoped for an end to fear, poverty and dictatorship. But a series of military dictators took power. When the Catholic priest Jean-Bertrand Aristide won Haiti's first real election to become president in 1989, the army threw him out. By 1994 military killings drove U.S.

President Bill Clinton to send in troops and restore Aristide. Although much loved by the people, he proved unable to lead Haiti to overcome its poverty, crime and underdevelopment. He was re-elected but pushed out of power by an insurrection. UN peacekeeping troops maintain order and in view of the devastating earthquake in January, 2010, which killed perhaps 300,000 people and destroyed the presidential palace and most government ministries, Haiti remained in need of international aid.

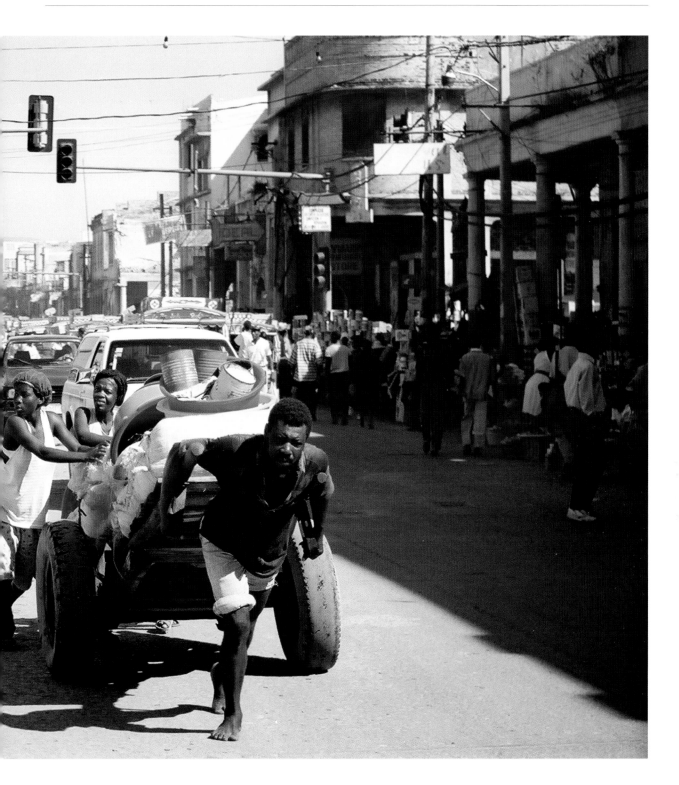

20. Haitian Macoute Hiding at Home

Oreste M. Theodore was wearing his dressing gown and was now afraid to leave his own courtyard.

He was one of the dreaded Tonton Macoutes militia, enforcers of the Haitian dictators: Francois "Papa Doc" Duvalier (1957-1971) and his son Jean-Claude "Baby Doc" (1971-1986). The Macoutes tortured, they killed, they spread absolute terror. No one was safe.

A shopkeeper in the Fort National area of Port au Prince said Theodore "was bad but not too bad. He took things from the shops without paying and pushed people around." But he was not a killer.

In 1986, Baby Doc fled to France before a popular uprising. Theodore lost all his power. "Anyone in the street can shout 'he is a Macoute' and kill me," he said.

Tonton Macoute means Uncle Bag – he is the monster of Haitian culture and is believed to stuff bad children in his bag and drag them away to be eaten.

Near Theodore's house was a burned voodoo temple where a sorcerer, Joseph Joliesien, "buried people alive," said one man. I saw a hole filled with rubble and bones.

Theodore had 14 children and now that he lost his job as a Macoute he was broke.

Three years later, I returned to look for him. He'd lost his home and lived lower down the hill in a crowded, unhealthy maze of houses. He had two stark, sweaty rooms with only a bed, a chair and a kerosene lamp. He was very thin and coughed.

In January, 2012, the UN High Commission for Human Rights objected strongly to the decision by Haitian authorities not to prosecute former dictator Jean Claude "Baby Doc" Duvalier who had recently returned to Haiti after 25 years in exile in France.

A UN spokesman was quoted as saying "Very serious human rights violations including torture, rape and extrajudicial killings have been extensively documented by Haitian and international human rights organizations to have occurred in Haiti during the regime of Duvalier."

Some estimated that 30,000 Haitians were murdered by the regime of the father "Papa Doc" and the son. Yet the son returned to live a wealthy lifestyle without being prosecuted for crimes under his rule. Relatives of his victims could see him driving to luxury restaurants and mansions of his supporters in the suburb of Petionville.

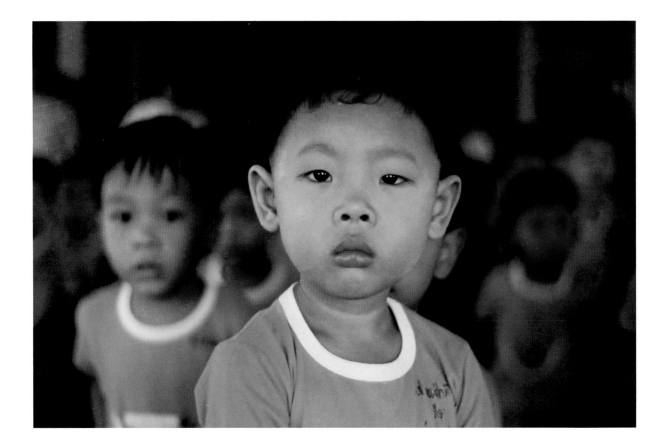

21.
Slum
School

Bangkok's most infamous slum is Klong Toey, where poverty, drugs, prostitution and crime coexist uneasily with thousands of innocent people.

These children around 1982 were in the slum school in Klong Toey run by Father Joe Maier, an American Catholic priest. He came to Thailand in 1967, worked with poor people upcountry, and in 1971 moved into a shack in the slaughterhouse area of Klong Toey.

In 1973 he set up his first school. It grew into an organization of 31 slum schools – the Human Development Center — that by 1998 educated 55,000 children.

The center runs a clinic for the poor and a savings and loan program to help rebuild homes burned down, possibly by landlords seeking to develop the land. His center taught women how to sew and market quilts and other products.

Finally, as HIV/AIDS hit Thailand around 1988, Father Maier offered care for carriers and a hospice so the dying had comfort and dignity in their final days.

See www.fatherjoe.org for more.

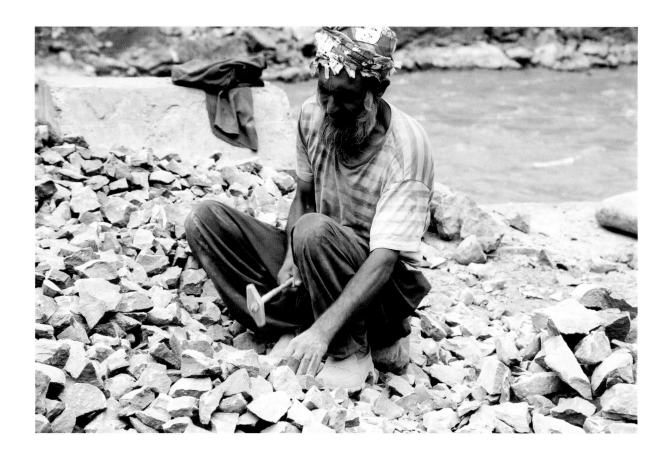

22.
Breaking
Stones

Along a swift river, white with silt from the high snowy peaks of Kashmir, a man is building a road. He breaks the stones with a small hammer, one by one.

To protect his fingers from a slip of the hammer, he has fashioned metal tubes for his fingers.

This work is numbing to the mind and the body, consuming hours, days and years in an effort to build roads on the shifting hillsides. His goal is to fracture the stones into ever smaller pieces. A weeks worth of stones can cover a few dozen yards of road, helping the sturdy trucks of India and Pakistan up into the remote villages.

The roads also carry troops of both countries as they patrol the shaky Line of Control separating Kashmir. Troops and artillery and rockets and bullets.

But in the unstable Himalayas, a mudslide, a rain storm, an earthquake or a shift in the land can send 5,000 feet of earth tumbling down into the river and wash away years worth of the small stones.

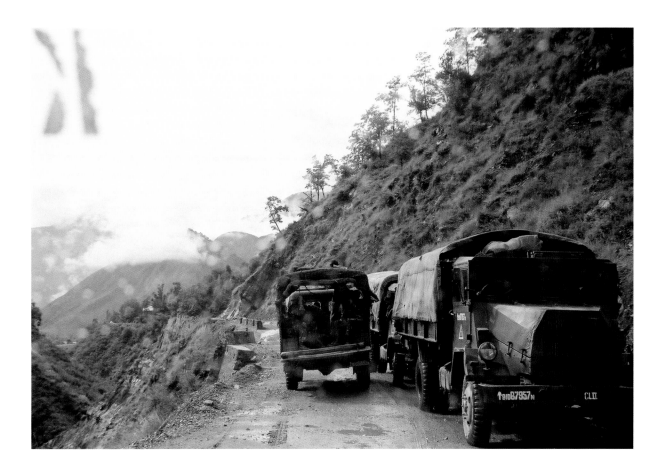

23.
Kashmir
Road

Through a rain-spattered windscreen of an Indian army truck, I see the soggy road climbing up through the steep mountains towards the clouds. A convoy of military transports has pulled to the side of the road to let us pass. This road washed out several times that week, in 1998, as I visited Indian border posts and villages. The following week I'd take a roundabout trip — back down through Delhi, over to Pakistan via Lahore, then to Islamabad and up to Muzaffarabad in what Pakistan calls Azad Kashmir. There a Pakistani military patrol took me over similar steep mountains to the Neelam River Valley where I was a stone's throw away from Indian-held Kashmir where I had been last week.

It was then the Indians shelled us, hurling high explosive mortar rounds a dozen miles to crash with earthshaking explosions a few hundred yards away.

Welcome to the permanent war. Let's just hope they don't use their nukes.

24. Coffee Picker

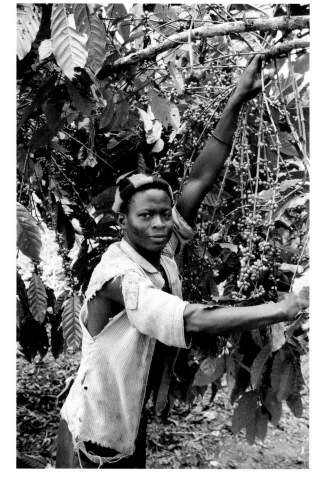

He was a coffee planter in Ivory Coast, collecting the valuable beans that give so many West Africans their income.

His torn clothing showed just how little was the profit he gained from the world's most widely savored brew.

And his worries went far beyond the terrible price that speculators offered for his beans – a price they would increase tenfold as they moved the coffee to the ports and to European cafes and grocery stores.

This young man was a Muslim migrant from neighboring Burkina Faso, one of millions lured to Ivory Coast for work. But in 1986 when I took this photo, the government was whipping up anti-foreign sentiment, a feeling that rapidly spilled over into anti-Muslim bloodletting in many rural riots.

The mainly Christian and animist leaders in the south made "Ivoirite" a condition of employment, residence, and candidacy for office. Taxi drivers in the capital Abidjan were stopped by police and asked to prove their grandparents were born in Ivory Coast – a nation that did not exist until 1960.

Soon the anti-foreign pressure led the north to rebel and left Ivory Coast – France's post-colonial jewel – a divided country that endured two civil wars since 2002 before French and UN troops restored order in 2012.

25.
Cocoa
Beans
Drying

Children in Ivory Coast haul water on their heads as they skirt cocoa beans drying on the road. The cocoa will be bought from local growers by speculators – many of them Lebanese merchants who came to French-speaking West Africa during the 1975-1990 civil war in Beirut. Because the growers have no transport, the speculators offer pennies per pound, knowing the farmers have no other buyers. Then the cocoa is sold to Switzerland or France for huge profits.

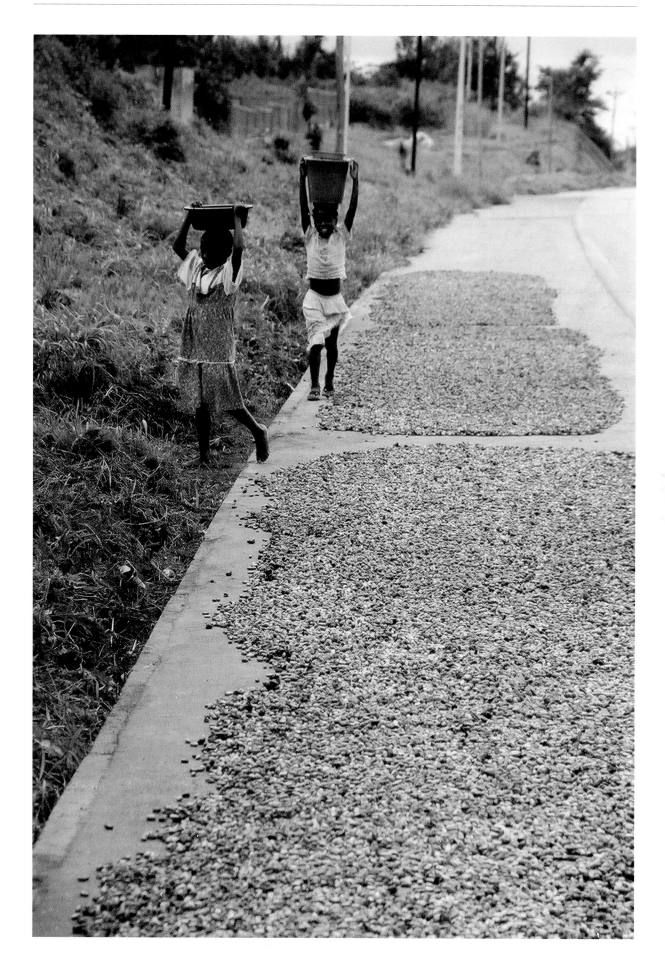

26.
It's a Baby

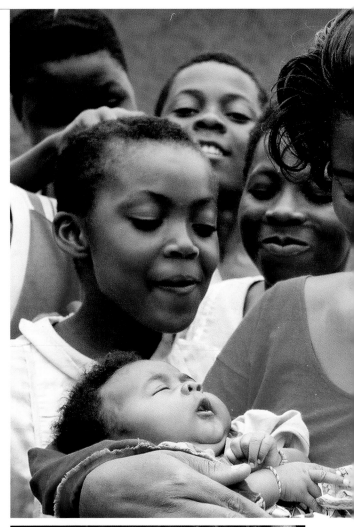

This mother in an Ivory Coast village brought out her baby to show us.

I was traveling with a former television news anchor who was very famous and drew lots of attention. He'd been fired in 1994 because he refused to announce that the head of the parliament was seizing power after the death of President Felix Houphouet Boigny. The head of the supreme court was supposed to take power.

The village we came to was a mix of Ivory Coast's three main tribes: the Christian and animist Baoule and Bete tribes; and Muslim Mandingos. A few weeks before we visited, the three groups had taken up arms against each other and hacked or burned many people to death.

The village was divided into three zones. Each neighborhood was occupied only by one group. The mother and her admiring entourage were from one of the groups.

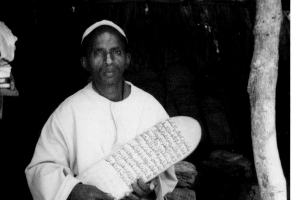

26.1 West African Koran Teacher

I went to West Africa to teach journalism in the 1990s, sent by the U.S. Information Agency which was later absorbed into the State Department.

Because I had learned French at the Sorbonne in Paris and could speak well enough to teach and edit their articles, I was sent to Guinea, Senegal, Ivory Coast, Burkina Faso and Niger. I spent several weeks in each country working with their top reporters and editors to improve their writing.

I also learned from them a lot about their countries – about the culture, the tribes, the religions, the marriage customs, the polygamy, the corruption, the brutality, the lack of security and the poverty.

In each country I'd take a day off to drive with an interpreter into the countryside and interview farmers, shopkeepers, mechanics and others.

This man was sitting by the road in a tent with wooden tablets on which was scrawled Koranic verse. For many children who came to his tent for lessons, this would be their only literacy – reading and writing Arabic, a language they did not understand. Only the lucky ones would go to a state school and learn to read French and possibly to read Wolof, Hausa and other African languages.

These were the heady days after the collapse of communism. Freedom of the press was spreading across regimes that had been repressive for decades that followed independence in the 1960s.

The French had long supported the strongmen of the region, sending experts to prop up the local governments. The French even backed the common currency used by most of West Africa – the CFA franc (CFA means in French: Financial Community of Africa).

In 1989, as the Berlin Wall came down, French President Francois Mitterrand famously told African leaders: "there is no development without democracy," signalling an end to business as usual with dictators.

Since then West Africa has been struggling to achieve both development and democracy. Strongmen continued to rule for many years, wars and ethnic fighting broke out, French advisors continue to manage from behind the scenes, and journalists must write what their publishers tell them to write. Everyone is afraid of crossing the powerful elites.

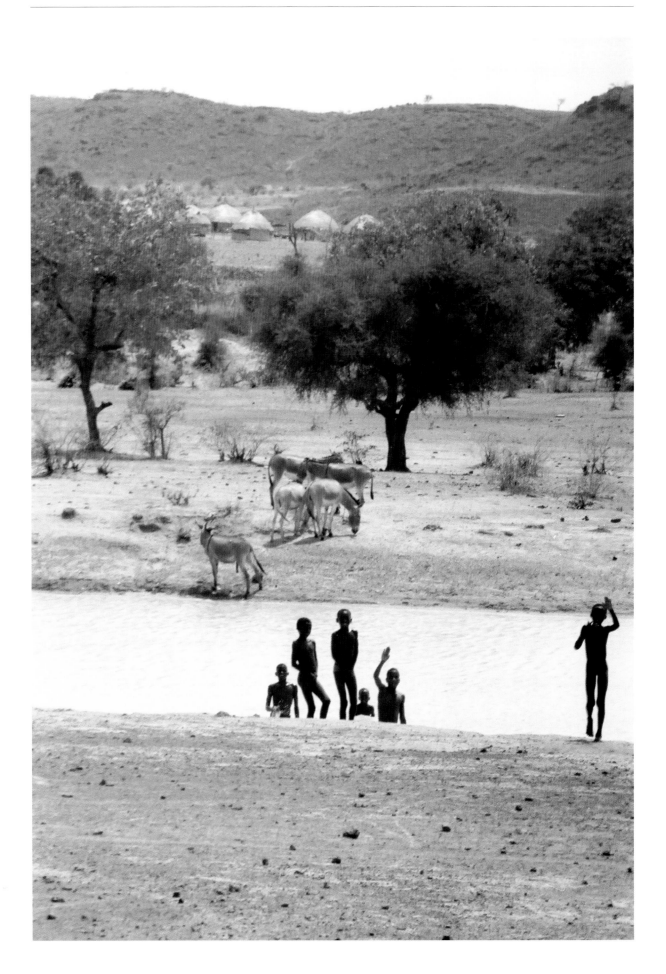

26.2
The Sahel

There are moments in life when you turn towards a scene and suddenly everything drops away and there is nothing but awe.

I had read about the Sahel and seen it in films and on TV. But I never realized its world-swallowing power.

This photo captures that moment. We had driven for several hours north from Niamey, the capital of the African nation of Niger. The landscape was grey-white and the few bushes that grew had tiny leaves and huge thorns. The earth was covered in stones. Huge Baobab trees seemed as if they had stuck their crowns into the earth and stuck their roots into the sky. I thought of the Little Prince, protecting his asteroid from Baobabs.

We saw some children so we stopped. And when I got out, the enormity of the barren landscape swept me away. How could human beings live out here in this hostile wilderness?

The children were very dark and naked – bathing in a pond. Laughing and shouting and jumping into the water like children everywhere.

Beyond them I saw small frisky goats, chewing on thorny bushes, butting heads. And beyond, almost disappearing in the shimmering heat waves rising off the gravel plain, I saw a tight village of little round huts. I was told the huts have sticks woven into floors raised a few inches above the ground, allowing cool winds at night to circulate from underneath.

Further north lies the French-run uranium mine

which President George Bush claimed Saddam Hussein was using to make atom bombs – a false claim that was used to justify the war on Iraq.

Niger is in the Sahel, a 4,500 mile long belt of 10 countries with land south of the Sahara Desert, running from the Atlantic to the Arabian Sea. The others are Senegal, Mauretania, Burkina Faso, Mali, Algeria, Chad, Sudan, Ethiopia and Eritrea.

The populations of these countries are clustered as far away from the Sahara as possible, mainly south of the empty wasteland of the desert. Tuareg tribes still cross the desert on camels, hauling salt, food and other goods. Many of them now use Land Cruisers and trucks, heading north to Morocco, Algeria, Libya and Egypt. In recent years, attacks by Al Qaeda in the Maghreb, a terror group operating across national boundaries in the desert, have made travel dangerous and even cancelled the famous Paris to Dakar endurance auto race.

Niamey was brutally hot, dry and dusty. My first days, I ran about town to set up my journalism seminars, thinking that the people must be very lazy as they walked so slowly in their robes. But as the days went by, and the heat got to me, I too slowed down to their rate – it was the only way to survive in such blistering heat.

Niger is about twice the size of Texas and has 16 million people, according to the World Fact Book. Eighty percent of the land is desert and the rest savannah suitable for herds and some agriculture.

The population growth rate is second highest in the world: 3.6 percent. The birth rate is highest in the world — each woman has on average seven to eight children.

Infant mortality is third highest in the world — 112 deaths per 1,000 live births.

Only 17 percent of the people live in cities.

Most of the people are Muslims from the Hausa ethnic group — which is also the majority group in adjacent northern Nigeria — Africa's most populous nation.

Only 29 percent of people can read and among women it is only 15 percent.

The average annual income is $770, making it 222nd in the world.

26.3
Ivory Coast Market In Marlboro Shadow

I saw the huge Marlboro cowboys on a billboard, sharing a smoke while Africans tended their stalls and travelers stopped for snacks.

This market was at a road junction a few hours' drive from the Ivory Coast commercial capital Abidjan.

You might think it strange to try and sell cigarettes to Africans by using posters of American cowboys. But the romance is there – the Stetson hats, the coiled whip suggesting power, the leather saddle, the horses in the background.

Contrast that dramatic, romantic image with the reality in front of the poster. Garbage litters the road and hand carts await a human being to pull them when the market ends. The brightly dressed market women have little of value to sell other than the ubiquitous bananas, plantains and other local vegetables and fruit.

Behind the neatly painted blue and white picket fence is a small restaurant selling snacks and cold drinks. One suspects that the market women and most of the people who pass by will not have the money to eat and drink there. It's mainly drivers of the buses and trucks, government officials and the occasional foreigner who can do so.

Beyond that junction, the smoothly-paved asphalt road leads for many kilometers but we see hardly any other vehicles as we drive north. Instead, hundreds of people walk, carrying their burdens on their heads. It made me wonder why the roads are so well made if only a few can enjoy them. In

Southeast Asia such roads – even among distant villages—are crowded with motorcycles and small carts powered by agricultural engines. The first step towards development is transport – allowing people to get to schools, clinics and markets.

But there is little here in Ivory Coast, which produces most of the world's cocoa for chocolate but earns only a small percent of the selling price for its farmers. That is in part because only the middlemen have trucks to haul away the harvested cocoa beans. They divide the region and set prices among them. The farmers are at their mercy. The buyers offer whatever price they want to pay. No rival middle man will offer a better price. Then trucks take the cocoa to the port and it heads off to Europe.

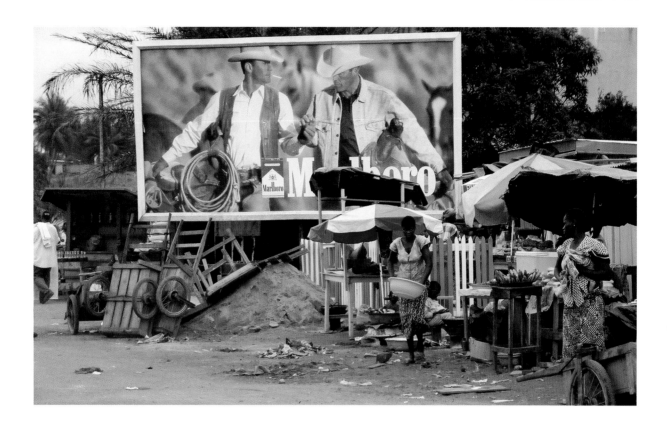

For 33 years since independence in 1960, Ivory
Coast was headed by Felix Houphouet-Boigny—a
dictator. But it benefited from French assistance
which helped build the only highways and high rise
buildings in West Africa.

After the first leader died, there was another strongman,
a coup, and a civil war in 2002 as the mainly Muslim
north separated from the Christian and animist
south. French troops ended the fighting but violence
followed an election in 2010 until the international-
ly-accepted winner, Alassane Ouattara, captured the
defeated former leader Laurent Gbagbo. I inter-
viewed Ouattara in his office at the International
Monetary Fund in Washington and met Gbagbo in
Ivory Coast before he achieved the presidency.

When I went to Ivory Coast in 1996, the country was
about to be torn apart and ethnic hatred was the root
cause. The southerners claimed that Muslims from
Burkina Faso and other countries were immigrating
and taking away jobs. The government, dominated by
southerners, declared that to hold office or even drive
a taxi one had to prove your "Ivorite" or Ivory-ness
by showing that all your grandparents were born in
Ivory Coast — which did not exist as a nation before
1960. "Ivoriness is a catastrophe. It pushes people to
tribalism," Gbagbo told me. Yet he resorted to it to
try and block Ouattara from replacing him.

This spurred ethnic hatred and violence as all
Muslims could be challenged by any thug or
policeman to prove they were not outsiders. Many
fled to the north. And war was the result.

26.4 Magic Hunters Provide Security

This rustic warrior, watching over the modern city in the evening twilight, was the first "dozo" I had ever seen. Suleiman was guarding a hospital in Gagnoa, a few hours drive from Abidjan, Ivory Coast.

The magical amulets hanging by leather thongs from his handmade clothing will protect him from bullets and spears, he believes.

Dozos are a secret society of sacred tribal hunters who guarded villages in Ivory Coast, Mali, and Burkina Faso for centuries. Now that crime has spread, dozos are being hired to protect the cities and towns.

They fear nothing and the people trust in them.

I asked to interview Suleiman and he was gracious, pulling up a chair for me to join him. He said he has been a dozo for 30 years and was recently hired by the hospital to provide security, with his French shotgun, a knife and his scary amulets.

"I am 49 years old and came here from Guinea," he said in French. "I am Muslim but also belong to the secret spiritual world of the dozos."

The dozoton or the society of tribal hunters is open to non-Muslims and Muslims. It dates back to the 13th century and is largely drawn from the culture of the Malinke, also known as the Mande and Mandigo – an ethnic group covering many West African countries.

Suleiman said his father was a famous dozo and killed lions, panthers, buffalo and giraffe using muzzle-loading guns.

Dozos are pledged to secrecy and cannot reveal all their mysterious rituals. However Western researchers say they learn to use medicinal plants that protect them from bullets and snakebites. They use these plants to "wash" their bodies and their weapons. They are barred from adultery. Taboos also bar dozos from touching a menstruating woman. And they learn incantations, sorcery and how to relate to djinns – the forest spirits.

The bottom line is that mystical power and moral fibre are inextricably linked, said American anthropologist Joseph R. Hellweg, a Fullbright scholar who was initiated into the dozo society in 1994.

There may be as many as 23,000 dozos in Ivory Coast.

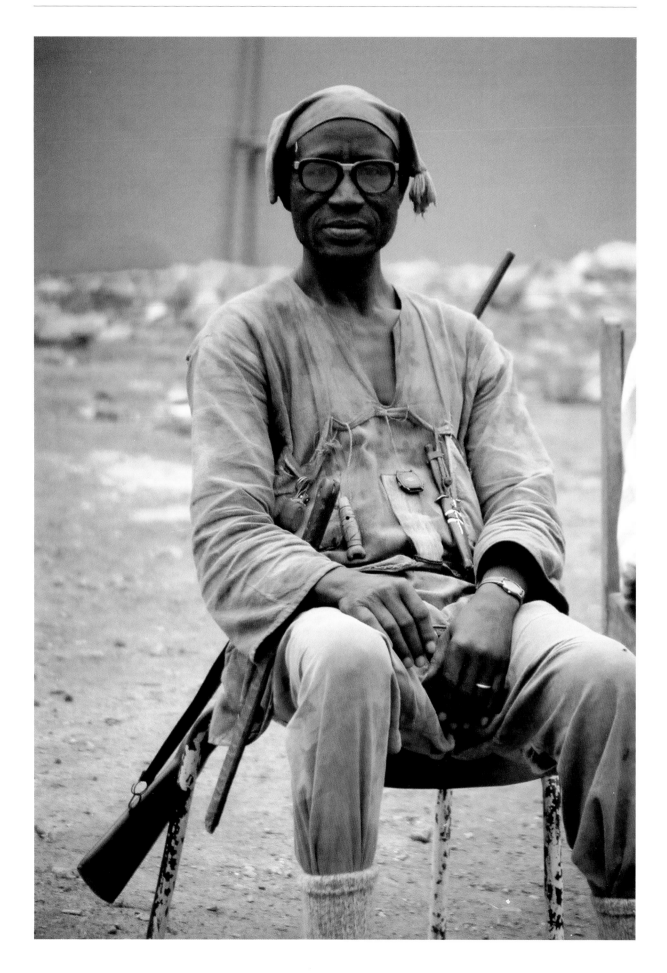

26.5 Children Overcome Ethnic Hate

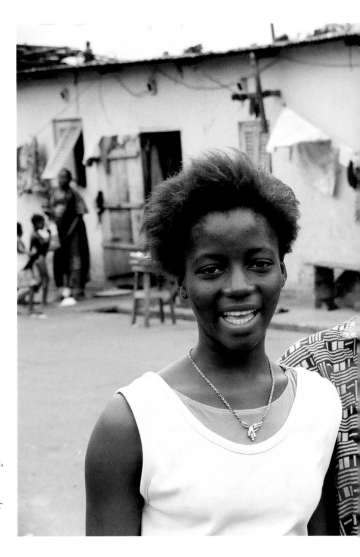

Ivory Coast is a country riven by ethnic hatred that has left tens of thousands dead in civil war, massacres, and mass migration.

But these two happy school children showed a higher way to live.

In the downtown area of Abidjan, the commercial capital, they were strolling along when I asked to interview them for an article I was researching.

They told me that they were best friends. The girl at left is a member of the Baoule ethnic group – a southern tribe that dominates the politics and economics in Abidjan. Her friend is Malinke, the Muslim group largely located in the north of the country.

The Baoule are mainly Christian and have been pitted by their leaders against the Muslim Malinke.

These two girls showed that basic friendship is able to overcome ethnic differences.

Would that they could teach the adults how to behave.

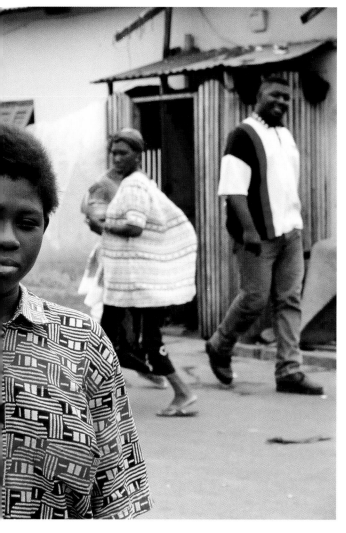

26.6
Praying in
the Street

For Muslims in Africa, Friday is the most important day for them to join with others in prayers. On other days they may pray as individuals on a small carpet in the back of their shop, or go to a local neighborhood mosque.

But Friday is the Muslim Sabbath and they want to be in the most important mosques where preachers are well known for their inspiring sermons.

I was walking around one of Africa's biggest cities, Lagos, when I found the street in front of me packed with people. They were listening to a voice on a loudspeaker from a nearby mosque.

I gestured with my camera to one of the nearest rows of men on the ground, asking permission in pantomime to take a photo.

The men nodded and waved me to go ahead.

I didn't hesitate. Brought up the camera and got off a shot. Then I continued into another street before any-one in the huge crowd could object. I put the camera into a bag and walked quickly and steadily away.

photo on following page

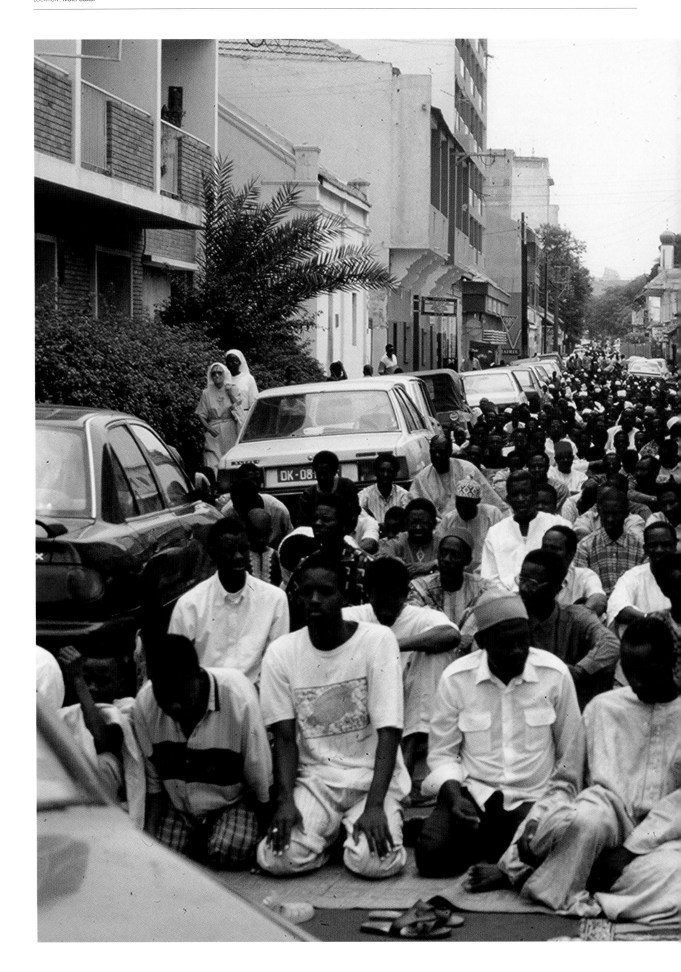

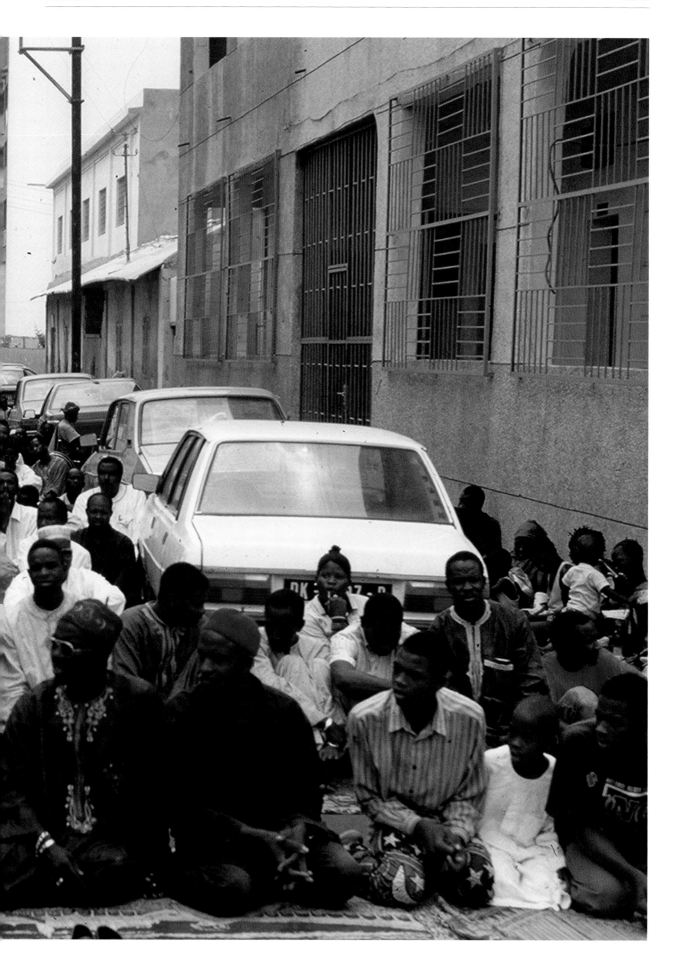

26.7 Mango Lady

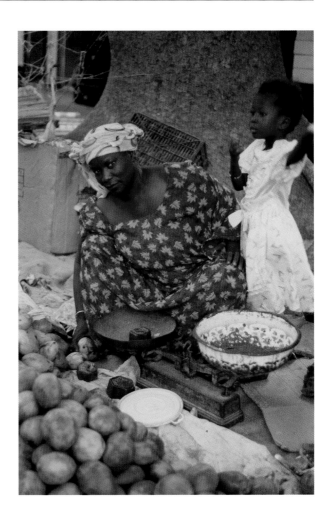

This lady selling green and yellow mangos on the sidewalk of a major West African city, has her spotlessly-dressed daughter with her. Most likely the girl came after school to the market so her mother could keep an eye on her.

The woman looks at the camera with a wary smile just visible on her face.

Many people in West Africa dislike it when foreigners take photos of them. There are four main reasons:

1. "You take my photo for free and then you get paid a lot of money by some magazine in your country," say some people. "So pay me first to take my photo."

2. "You take photos here to show how dirty and poor we are," say some. "Don't take photos here."

3. "Are you a spy? Where is your permission to take photos here?" said some people in the market place in Kano, Nigeria, hardly a location of national security. However they soon brought the cops and we had to squirm before they released our cameras.

4. Magic. Some people believe the camera can steal your soul.

This lady however reveals another truth. She is clearly wary of anyone who might take advantage of her — a necessity for life in the Third World where you often have to provide your own security and vigilance. But her mini-smile shows that like many people in this world, she likes to have her picture taken. She likes to be the center of attention. She likes that someone has recognized her as a fitting subject for a photo.

Her beautiful, clean dress and turban, as well as her beautifully-dressed child, show that she wants to look her best. Maybe it even helps with sales. We all like to buy things from well-dressed people. We assume that those who take good care of their appearance will also take good care of the goods they offer.

And finally, she is a very strong woman. Her expression shows the world not to mess with her.

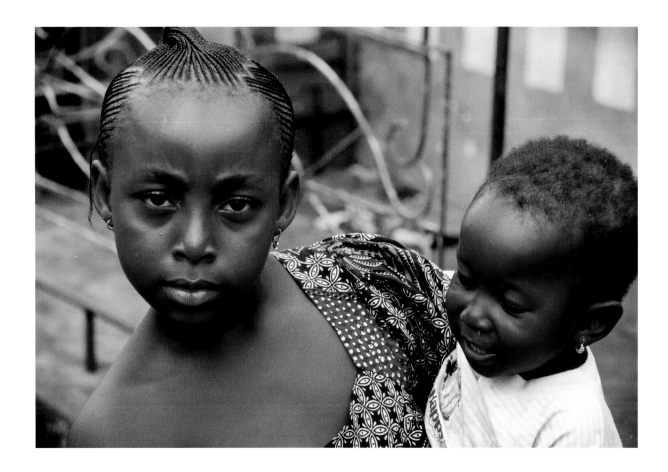

26.8 Minding Baby

This girl carrying a baby appeared in front of me as I shot photos in downtown Abidjan. Her determined face, her neatly formed cornrows and the smiling baby she perched on her hip all won my heart.

I felt this is a girl who I would trust to watch my baby. She has an almost fierce look about her, challenging the camera to take her photo as she has nothing to fear from anyone.

Children grow up quickly in the cities and villages of the Third World. They may not know how to write a term paper or use cell phones and the Internet. But they know human nature. They can tell who is a threat and who is not.

We foolishly tell our children not to speak to strangers – in fact, to fear and avoid strangers. I see many children in the suburbs of Washington DC where I live who turn away in terror if I wave at them or try to say hi. They've learned to categorize all strangers as threatening and hostile.

But in the Third World, children rapidly learn to determine the character of the people they encounter. Sadly, I get many more high-fives and smiles from children in strange lands far from home than in my own country.

27.
My Baby

It was only when I had children that I began to understand the real Third World. At first it, Asia and North Africa appeared to me as a beautiful yet often cruel living museum. It was a trip into the past and the life of my own ancestors 1,000 years ago.

But when I returned to India and Thailand with my own small children, my viewpoint changed. I began to ask people where did they find a doctor, how do they buy medicine, what do they feed their children, where is the school.

This is my daughter Stephanie. In Bangkok she was at home with her mother's Thai family and with the American and Australian families of the other foreign correspondents. When we traveled, people opened their homes and hearts to us because we were no longer just foreigners but we were parents.

And when we struggled to find boiled water, healthy food, a way to keep off mosquitoes or a safe place to play, the problems that plague so many families in the Third World became our own.

It is easy to interview an angry young man in a market, warning of discontent, revolution and violence. Those quotes can get your story on page one. But I find it is better to interview parents — those men and women who have to struggle to feed their children and therefore think of the future. They are the real barometer of the mood in a country.

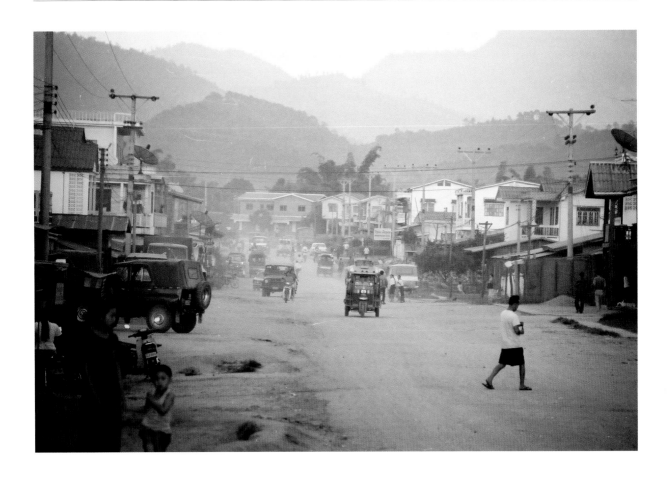

28.
Most
Bombed

This is the main street of Phonsavan, capital of Xiang Khoang province in north central Laos. During the Vietnam War, this was the most heavily bombed province in the country that was the most heavily bombed in history. More bombs fell on Laos than in all of World War II. Unfortunately for Laotians, technology and delivery had vastly improved as far as munitions go.

In 1996, many shops covered the open drains next to the street with metal grilles ripped from strategic short runways laid down by U.S. forces in the 1960s.

The CIA funded and armed a secret army of ethnic Hmong fighters drawn largely from the hills around Phonsavan in a vain attempt to stop the Vietnamese and Laotian communists. Since 1975, the communists have ruled all of Laos. In the hills, Hmong still practice slash and burn agriculture, growing corn and opium in clearings on the slopes. Farmers still tragically uncover unexploded bombs and shells in the fields.

I rode from Phonsawan to the villages in an old Russian jeep whose suspension was so bad that the numbers were shaken loose from the face of my watch. High on the hillside, I looked down at the craters in the valley below, left by the bombing.

But the Laotians, and especially the Hmong, bore America no blame. The war was past. Right now, people needed food, medicine and work.

29.
Bengal
Plow

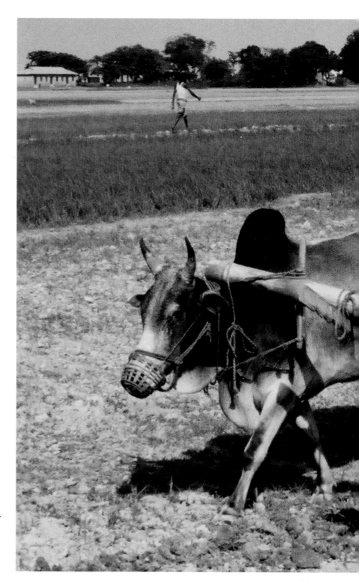

Bangladesh is flat, flat, flat. When the monsoon rains sweep down from the slopes of the Himalaya Mountains in India and China, they pour into the mighty Bramhaputra and Ganges rivers, flooding much of Bangladesh. The floods deposit nutrients good for the soil but drive millions out of their homes.

This farmer walked barefoot, clad only in a lungy loincloth and t-shirt. The cows are masked so they won't eat adjacent fields. The yoke of the plow is bamboo, a flimsy but abundant wood.

Once called the world's basket case by Secretary of State Henry Kissinger, the country has made great progress since it split from Pakistan in 1972. But constant political feuding between two women leading the rival political parties often paralyzes the country.

When one wins power, the other calls hartals, violent stoppages of all work and transport. Even the new textile factories shipping millions of shirts and dresses to U.S. markets have missed key holiday deadlines because of the hartals.

I saw the bloodstained stairway where the founder of Bangladesh was assassinated in Dhaka in 1974. It was 1988 and I went to the house to meet his daughter Sheikh Hasina, who was opposition leader. She lived in the house in devotion to her father Sheikh Mujibur Rachman. She may still live there. But since 2009 she has been prime minister.

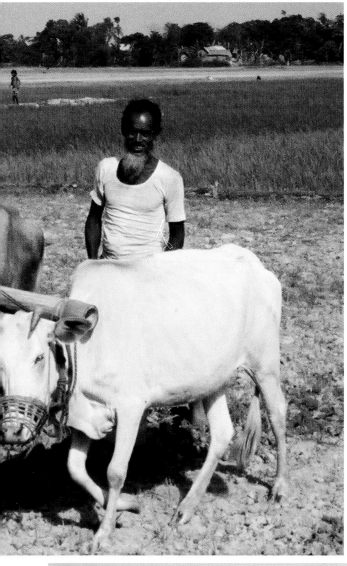

30. Brick Makers

India is full of patterns. Many are woven into the fabric of the universe that is the Indian landscape.

Here in West Bengal province, the brick makers have set up a piazza of drying mud bricks, each spaced so that the hot sun and air will dry them evenly. More bricks have been stacked into walls with space for the air to circulate.

Wearing nothing but a single piece of cloth twisted into a simple knot at the waist, these boys could have lived 2,000 years ago. They work only with their hands and the earth and the sun and water. In the background rises a house made of bricks perhaps fashioned by these boys, or perhaps by boys 100 years earlier.

The Indian village always gives a sense of eternity.

31.
Haitian
Refugee
Boat

When this boat builder in Haiti completes his craft, it will most likely set sail for Miami with 300 impoverished people hoping to find the American dream.

The sturdy construction and design make the boat a good coastal freighter, able to bring charcoal, fruit, timber and other goods to Port-au-Prince from Cap Haitian and other cities.

But on the 600 miles of open Atlantic seas that lead to Miami, the boat will toss and turn and creak while the hundreds of people who sold their land and borrowed money from their parents crowd together in sickness and prayer.

Above all, they pray they will not meet with an American Coast Guard cruiser which will pick them up and return them to Haiti.

There was nothing to keep them there before they left. No land, no credit, no jobs, no medical care. Just hunger and crowding on the eroding land. When the Coast Guard returns them, they will have less than nothing. Only the empty faces of those who sold their land to lend them the money for the passage.

32.
Dung
Patties

Cow dung makes excellent fuel. When dry, it burns with a blue flame.

All over India, women collect cow dung when it's still moist. They slap the dung patties against a mud wall to dry in the sun. A few days or weeks later, they rip off the dried dung to use in their cooking fires.

If they did not burn the dung, they would burn wood or dried corn stalks.

Each morning, as I walked along the roads of India's countryside, the sweet distinctive smell of the dung fires gathered in the hollows with the night mist. As the sun rose it drove both the smoke and the mist into the hazy pale blue sky.

photo on following page

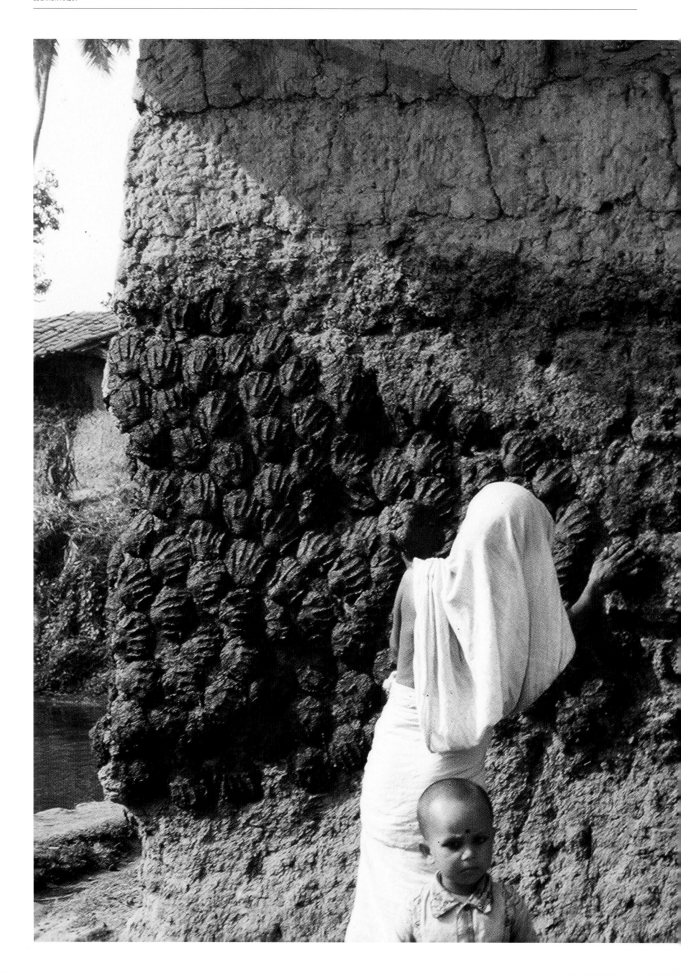

33.
Chai
Master

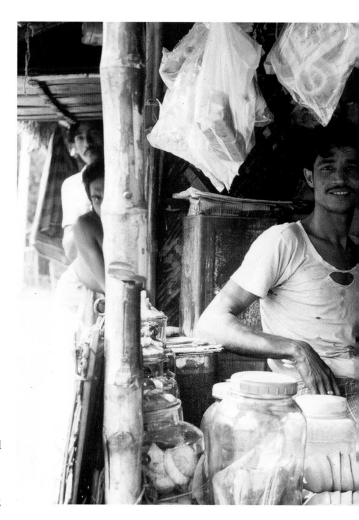

The Indian village tea shop is dominated and serviced by the chai wallah who sits all day on a rickety bamboo bench. His face reveals the compassion of one who doles out small doses of sugar, milk and tea to people who can barely get together 25 pice – about two cents U.S. That's the price of strong, sweet caffeine-rich tea, sipped while they share a bench with the rest of the village. In the tea shop, all are equal.

The tea man's shirt is torn but fairly clean. He looks out with a tremulous eye, ready to fight off a village dog or to prepare a drink for the village elders.

One pot holds yoghurt, another hold boiling water and a third holds hot milk. Each cup of tea gets a measure of milk and a wedge of thick cream floating on top. The jars hold biscuits. Cups hang from a bamboo pole behind which is the inevitable Hindu calendar with the elephant god Ganesh – symbol of prosperity and commerce. Above that a poster appears to show Krishna, the human-like god who spilt the honey as a baby, who frolicked with the milkmaids as a youth and who forced the noble warrior Arjuna to take up the sword in battle even if it meant slaying his own kin – a powerful lesson of duty and fate in the Hindu bible, the Baghavad Gita.

The chai wallah is the gatekeeper to the world of India's people and its villages.

34.
Wood
Workers

The density of Indian life would be unbearable were it not for the gentle spirit that pervades. Here, a man sips his tea, squatting amidst the wood shavings, while his fellow woodworkers hammer together furniture.

Each takes up so little space and material. They are barefoot, with only a dhoti cloth tied around their waists and a cheap undershirt. The smiles are real as they crowd together in the shop, turning out beds and tables with hand tools and techniques used since biblical times.

While America's furniture and other factories use less and less labor, installing better machines to increase individual productivity, India's workshops are a giant employment program, soaking up the tens of millions of hands emerging each year into the labor market seeking work. There are 1.2 billion Indians in a country the size of the United States.

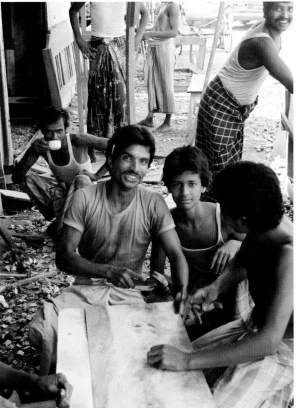

34.1 Fixing Wagon Wheel

This Indian wheelwright is barefoot, squatting in his dhoti skirt on the wheel he is repairing.

He is using only a hammer and chisel, tools that could have been used 1000 years ago in Europe.

The hut behind him has a thatch roof and the walls are made of woven sticks with mud daubed on them. The hammer, chisel, and the single, thin band of iron that will go around the finished wheel are the only pieces of metal in the picture. Everything else is made from the earth and plants that have been cultivated and used by man since prehistory.

The wheel is for a tonga, the horse-drawn carriages that transport so many people in India, Pakistan and Bangladesh. Some use two horses but I have seen one pitiful, skinny horse pulling a tonga with 16 people seated on it.

While many are used in rural areas, you can still see horses pulling tongas amidst the seething traffic of major cities.

Sadly, in some places human-powered vehicles such as bicycle rickshaws, human-pulled rickshaws and hand carts are even cheaper than the tonga. There are just so many people in these countries in need of work and food they will work more cheaply than a horse.

In some areas, the engine-powered three-wheeled rickshaws known as tri-shaws or auto-rickshaws have replaced some of the tongas. They belch smoke from their engines and bounce like crazy on the pot-holed streets but are much faster than the horse carts.

34.2 Washing in the Gutter at Mother Theresa's

I had gone to Mother Theresa's compound in Calcutta in the hope of getting an interview with the renowned saint.

Across the street from her compound I saw these people washing their clothing and their bodies in sewer water running in the gutter.

I still feel a mixture of admiration, shame, and horror as I see this photo.

Admiration because, poor as they are, these people are cleaning their clothing and washing themselves – with soap. They even wash their dhoti cloths and sari while wearing them as it is probably their only piece of clothing. You can be sure they would prefer to use a clean bathroom with clean running water if it was available. Probably they are rural people who came to Calcutta because there is no food or jobs in the countryside.

I also feel shame – who am I to expose to the world this pitiful existence? Some things are too awful to photograph.

And I feel the horror of life at the very end of the rope, having no home, no job, no money, no food and no place to bathe.

Well. At least you, the reader, are presented with this moment and perhaps – just perhaps – you may one day be in a position to do something about this.

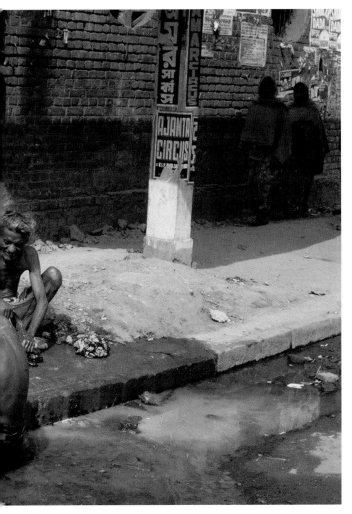

34.3 Building Rice Storage

These villagers in West Bengal, India were preparing to save their harvest from rain, wind, rats, birds and other damage. The storage bin appeared to be temporary. Perhaps they build it only when they have a big surplus to store.

They laid bamboo shafts on top of stones to form the floor joists and then weave the straw left over from husking the rice to form walls. Woven mats are then laid on the floor and thick rope is wound round the walls to hold in the weight of the grain.

Finally, a protective, waterproof roof of straw mats will cover the round rice storage unit.

About 10 percent of India's harvest is lost due to improper storage and handling. Even more may be lost in the fields as rats and other pests consume grains before they are taken.

photo on following page

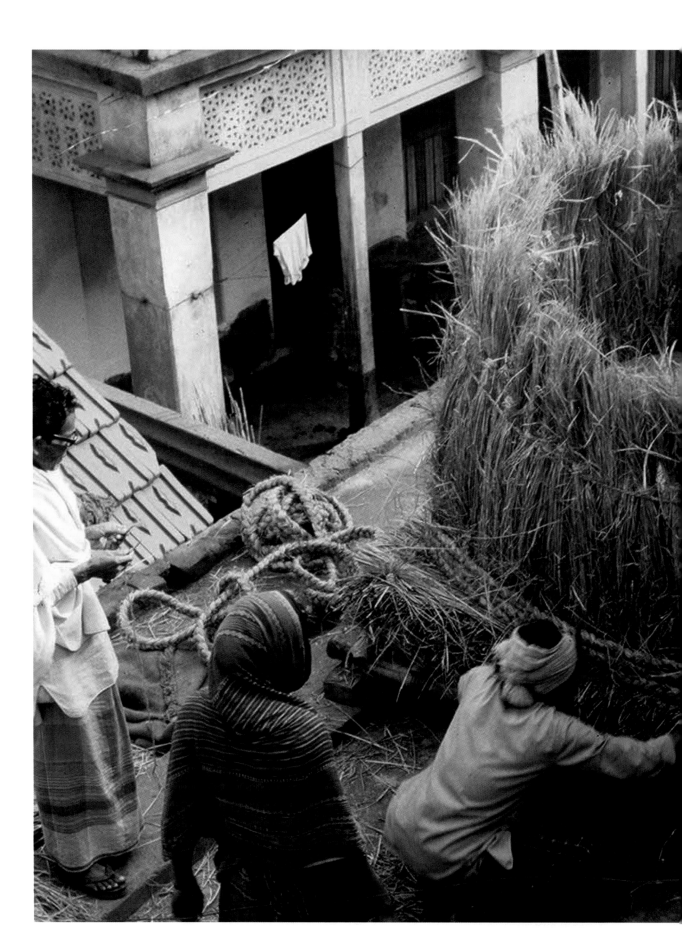

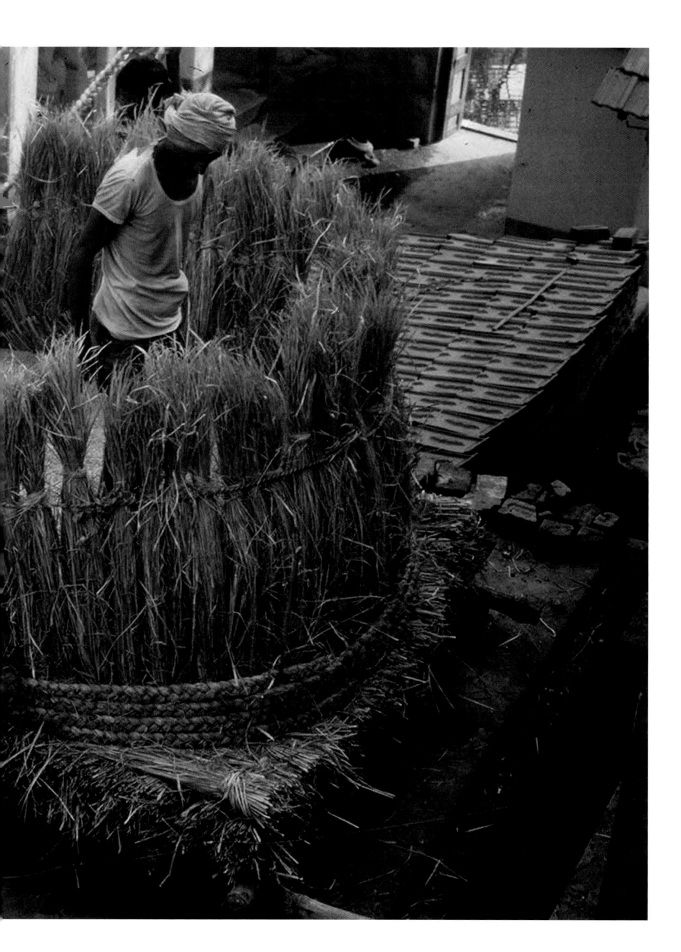

34.4 Young Indian Muslims Arrested After Religious Riots

I took the train from Delhi to Meerut, the teeming city north of the capital where Muslim-Hindu riots are as predictable as the monsoon rains. Police had closed down the roads from the train station and a dusk to dawn curfew was in effect. I stopped a cycle rickshaw driver and for double fare he was persuaded to venture with me into the center of the troubled city.

Uniformed troops checked my press pass before letting me go through their checkpoints. I walked through the winding streets. Shops were shuttered and police with rifles patrolled.

In one small square, the police were arresting and hauling away Muslim youths believed to have engaged in rioting.

I checked into a small hotel and learned that a half dozen people were already dead as the rioting seethed in the sultry city. The local newspapers and radio refused to list the religion of the dead. They know that if they report one group has suffered deaths, the other group will take revenge.

I was told of a Hindu youth who was studying at home with a Muslim school mate when the riots began. A Hindu mob learned the Muslim boy was inside and gathered outside the door, demanding the family turn him over to them – to an almost certain death.

Instead the father shouted to the Hindu mob: "I am a Hindu, as all of you know. You will have to kill me and all of my family before we will let you take our honored guest from our home." It was the sort of endearing cinematic bravado and courage that one sometimes sees in South Asia.

But the story was not over. Tragedy follows honor as the rotting follows the ripest fruits.

The Muslim youth stayed over to study and sleep through the night. The following day the Hindu father sent his son to accompany the friend to the Muslim neighborhood and assure his safe passage through Hindu controlled areas.

Well they got past the Hindu zone but in a no man's land between neighborhoods they stumbled upon a mob of Muslims who snatched the Hindu youth from his friend's grasp and slaughtered him.

India has 1.2 billion people, second only to China, according to the World Fact Book. Some 80 percent are Hindu and 14 percent are Muslim. That makes about 170 million Muslims, more than any Muslim country except Indonesia.

Although Indian Muslims have achieved high status in business and government – even attaining the presidency – they sometimes face discrimination, earn less on average than Hindus and have sometimes

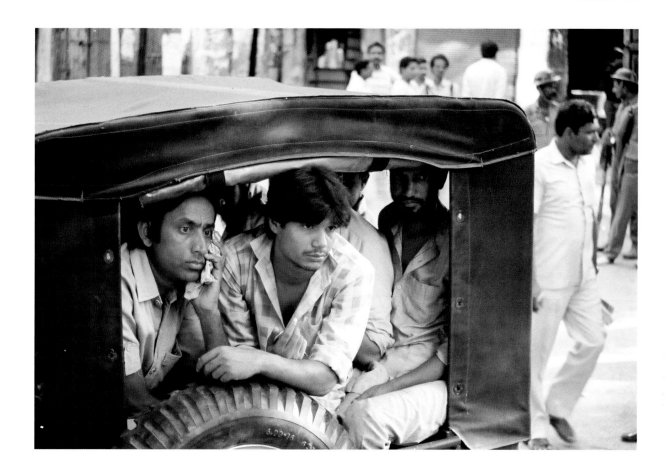

been attacked by ultra-right wing Hindus. Often
poverty sets the communities against each other as
they compete for land, jobs, seats in universities,
and economic advantage.

In 1989, a rightist Hindu party launched a campaign
encouraging Hindu devotees from across India each
to bring a brick from their villages to Ayodhya, site
of a 400 year old mosque they said was built on an
ancient Hindu temple. In 1992 Hindu mobs destroyed
the mosque. Rioting the following week left 1,700
dead around the country – most of them believed to
be Muslims. In 1993 further Muslim-Hindu violence
killed hundreds more; and then bombings of the
Bombay stock exchange, believed set off by Muslim
criminals, killed 200 more.

The film "Gandhi" shows graphically how Muslims and
Hindus killed each other as Britain ended colonial
rule in 1947 and British India was divided into
mainly-Hindu India and mainly-Muslim Pakistan.

Yet India's Muslims have not fled to Pakistan and
they appear to consider that living as a minority in
a democratic nation is better than becoming an
exile in Pakistan which has for most of its life been
ruled by military dictators.

35.
She Sewed

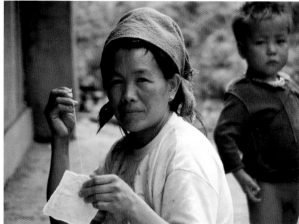

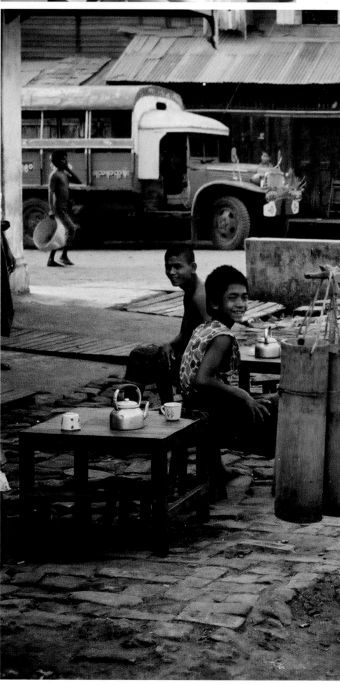

I went to a Hmong village in the hills of northern Laos to ask if they were persecuted by the communists. The Hmong refugees in America insisted they were. So said their leader, General Vang Pao, and others who fought with the U.S. CIA in the Vietnam War.

In the village, I sat near this women who sewed a piece of a quilt to be sold to American Hmong. She said little but continued to sew. Several men and a few women gathered around. Their complaints:

The government wants us to stop growing opium. They want us to stop burning the forest to make fields for our corn. They want us to leave the mountains and move to the lowlands and grow rice.

It's mainly European environmentalists that want the Hmong off the mountain slopes to prevent erosion.

But the Lao government also wants to get rid of the Hmong to log the trees and build hydro dams so it can sell power to Thailand.

The woman kept on sewing, her eyes focused and determined.

Then they spoke of the bombs in the soil and the lack of schools and the way the ethnic Lao treat them like country bumpkins. They spoke of the children's diseases— skin sores, malnutrition and bronchitis. The clinic in the district capital Xieng Khouang is too far to walk and the bus is costly. They reported no persecution by the communists.

36.
Bamboo
Bottles

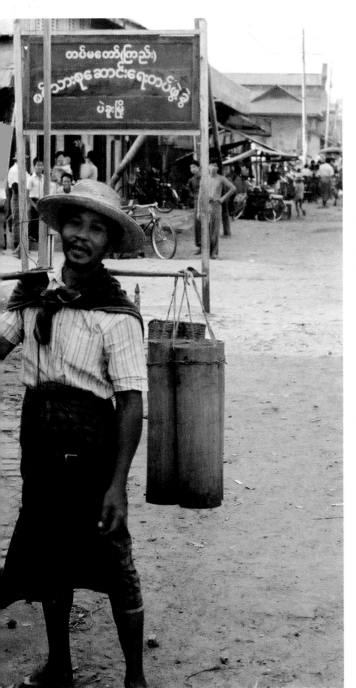

In Burma's countryside grow giant bamboo stalks so huge they can be cut just below each segment wall to form open containers. Smaller bamboo poles are cut into smaller segments that are filled with rice and water and thrown into a fire, cooking the rice as the bamboo is burned.

These huge bamboo stalks are used to carry palm toddy. The fermenting smell was strong enough to make me decline a taste when offered.

The town is Pegu, where I went to interview students who had been shot and jailed a week earlier as the 1988 democracy movement began to grow.

That day, back in the capital Rangoon (now called Yangon), a British diplomat told me he'd found a note nailed to the embassy door. It said "Help us. We are in hell."

Unfortunately, U.S. and British governments encouraged the democracy movement. But when thousands rose up and came to the front of the U.S. embassy August 8, 1988, (the mystically chosen 8-8-88 date), U.S. diplomats wept at the windows as the Burmese army mowed them down with machine guns on armored cars.

37.
Worried
Journalists

These journalists in Guinea had never been able to question the country's dictator Lansana Conte. Now they were about to enter their first press conference with him. They were scared.

I'd been in the capital Conakry a week, teaching them journalism techniques — writing style, balance, objectivity, use of quotes, research, interviewing, etc. — under a U.S. Information Agency grant.

Now would be the acid test. The press conference would be broadcast live on television and radio.

The first question was a super soft ball. Something like: "Mr. President. Can you tell us how did you get the wonderful ideas that have improved the country so much in the past year?"

These journalists are not stupid. They must have felt intense shame at such a question when the streets of the capital are awash with poverty, open sewers, illiteracy, underdevelopment and need.

My colleague from America then asked a question: "How do you plan to alleviate the intense poverty of your people?"

After a moment of bruising silence, Conte showed himself to be a skilled master of spin, assuring us all would be handled in time.

Next day a taxi driver turned around to ask my colleague: "Didn't you ask that question about poverty? Everyone is talking about it."

But nothing changed.

38.
Jury Rigged

In Africa, keeping an automobile engine running requires lots of skill and ingenuity. This man is blowing through the fuel filter to see if gasoline is getting through to the carburetor. He's already sucked a mouthful of gas from the other end of the fuel line.

Cars are bound together with rope and tape and wire and anything that can serve the purpose. Buying parts is not often an option.

When the leaf spring of a Land Rover broke its end shackle in the Sahara Desert in 1982, the Polisario guerrillas I rode with lashed it in place with hemp rope. But they refused to let me photograph the jury-rigging of their car. Perhaps it was an industrial or military secret they needed to hide from the Moroccan Army.

This African man saw no need to conceal his impromptu roadside repairs.

39.
Slum Dad

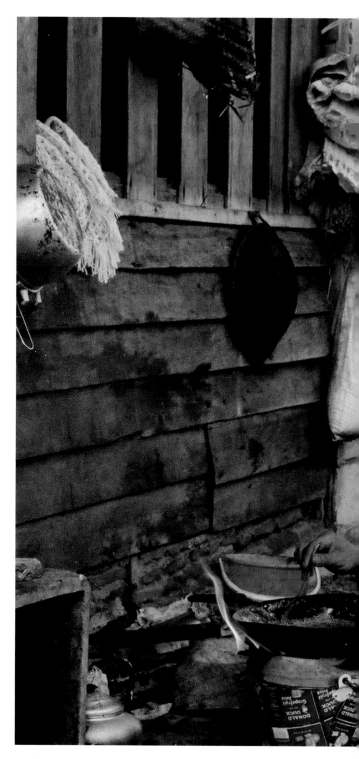

In the slums of Bangkok, this young father cradled his child as he squatted over a skillet cooking food. Like many men from the villages, he's wearing tattoos, and his muscled arms suggest a laborer or possibly a motorcycle taxi driver.

He cooks over a wood fire in a tin-covered, efficient cook stove promoted in Thailand by environmentalists to reduce fuel waste. The tin once held Donald Duck grapefruit juice.

Many Thais cook outside to keep the smoke, heat and odor away.

What I have loved about this picture since I took it in 1982 was that a tough, young man squatting in a hardcore Bangkok slum would use one hand to control a hot frying pan and fire yet use his other arm to gently cradle his child.

The child, whose red-handled toy bike mimics the man's motorcycle, responds to the man with complete faith. This is the face of love.

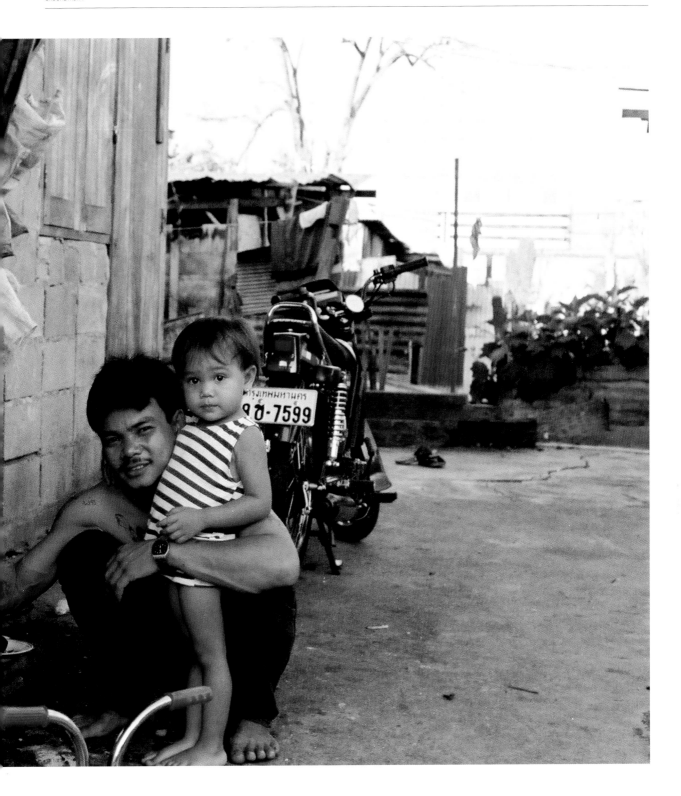

40.
Thai Monk Must Not Touch Woman

A Thai Buddhist monk cannot touch a woman.

So when he gives her a sacred thread to tie around her wrist, he has to drop it into her open hands.

When monks board crowded Bangkok busses, women move away so the saffron-clad men can sit without bumping up against women.

A senior monk in Bangkok told me that for most Thais, Buddhism is a form of devotion and superstition. They know nothing about meditation or the Thai version of the Hindu bible, the Ramayana, or Buddhist scriptures and principles. They know Buddhism says they should not kill or steal and if they are bad they may be reborn to an unhappy fate.

The Thai believe strongly in the existence of phi or spirits and keep what looks like a child's doll house at the corner of their property. This spirit house, often adorned with fresh fruit, incense and flowers, is meant to placate the phi and give them a place to hang out. A Thai school principal I met in the city of Korat, who had lived in America with her U.S. military officer husband for many years, told me the phi had vanished when she lived in America. But as soon as she returned to Thailand, she felt their presence again.

Young men used to become monks for three months around the time they would graduate from high school. These days they become a monk for two weeks or even a long weekend – mostly to satisfy their parents. As monks, they shave their heads and go out each morning with a bowl to collect donations.

Thai monks do not consider this begging. Rather, it is giving an opportunity to the people to make merit. Some people buy a package at a Buddhist shop to give a monk– wrapped in cellophane is saffron cloth for a monk's robe, a towel, soap, toothbrush and bags of rice and sugar.

Buddhism is different in each country and region.

While on a fellowship in Hawaii some years ago, I found an item in the local newspaper saying that large waves had washed out to sea a Buddhist priest from California who was on vacation with his wife, staying in a luxury hotel, and had been fishing off the rocks. A Thai woman who saw this article told me she was horrified, but not by the man's fate. In Thailand, a Buddhist priest or monk cannot have a wife, cannot take a vacation, cannot stay in a luxury hotel and cannot kill any fish or animal.

However there are in Thailand the same sorts of scandal found in every other religion around the world. Some monks have girlfriends, father children, become wealthy, or violate other rules.

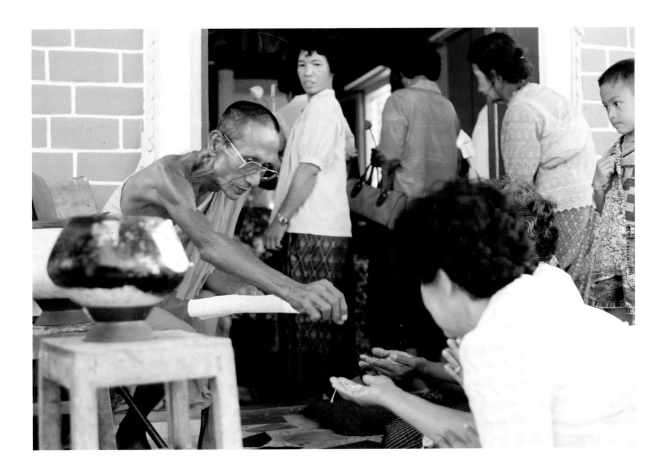

41.
Bagel
Heaven

It was dirt poor and very, very cold in Guiyang, China in 1982. I was one of the first Westerners allowed to visit the city which was among about 50 places opened up as rigid communist rule eased.

This man's bagel-shaped breads were selling like hotcakes under a propaganda poster displaying the communist Chinese view of heaven. His smile – and those of so many Chinese I'd met that month – were a triumph of the human spirit. Everyone shivered, their hands and lips split with the cold. No one had heat. Coal pellets were hauled in carts by bony, poorly-dressed men. Delivered to Communist Party offices. The only vehicles were trucks driven by soldiers. The crowds silently pedaled bicycles in a ceaseless human wave.

One young man pushing his bicycle drew up next to me and spoke in halting, simple English. He scarcely moved his lips and stared straight ahead. "Tell the world about us. We are trapped in this place. I can't speak to anyone. Not even my own mother."

Then he mounted his bicycle and rode off into the crowd.

In more recent years, China's economy has grown and lifted millions from poverty. But fear remains and total control of media, assembly, speech, and thought remains in place.

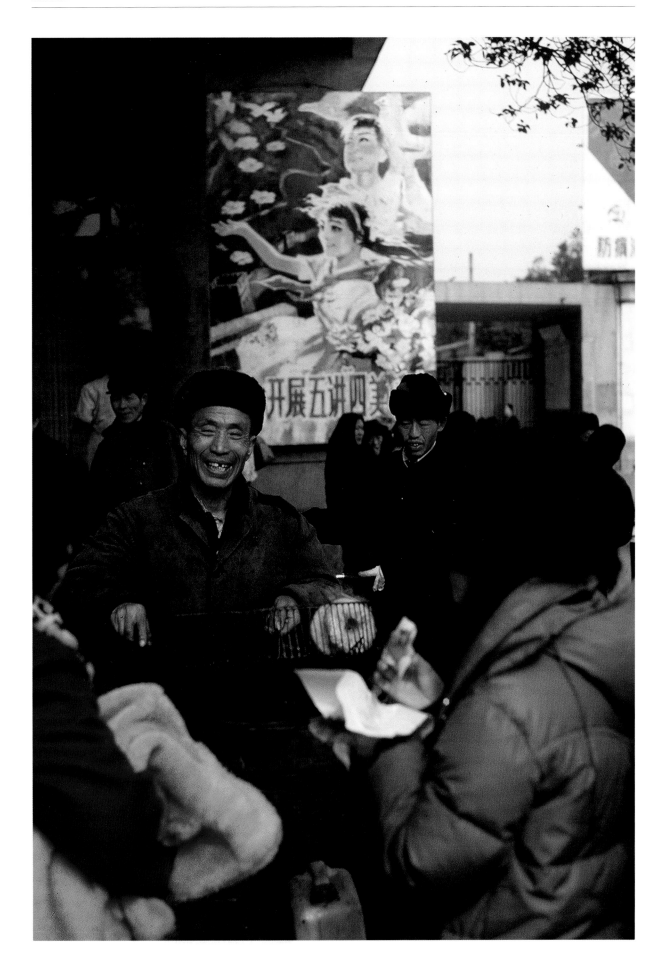

41.1
A Street in
Old China

This street in a central Chinese city is tightly packed with people and activity.

The man at left carries two types of pails on a shoulder pole – one appears to be traditional wood and the other is metal.

While most people wear drab blue or gray clothing, a bright red sweater hangs out to dry—signaling the change of modernization about to sweep China.

There are six bicycles in the scene, some of them brand new with hand brakes and gears. But one woman still hauls a hand cart.

The buildings are very old, possibly more than 100 years old, but at the end of the scene we see a modern cement building.

Above all – there is no sense of privacy. This is a very close society, with many people and little chance to keep your secrets.

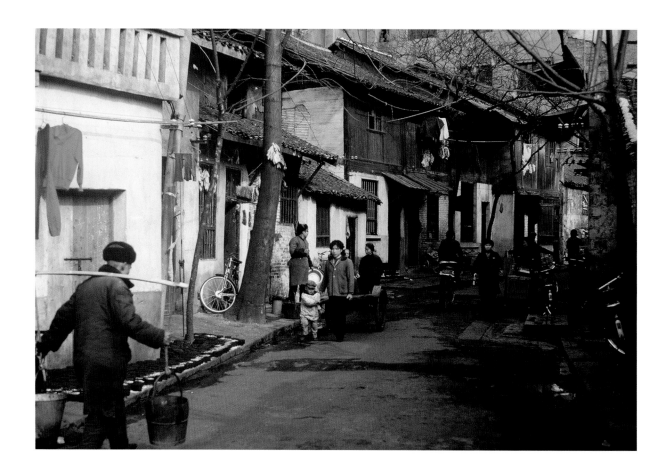

41.2 Cement Mao Rules Over Shivering Guiyang

The grim reality of communist Chinese rule in 1982 – just a few years after the Cultural Revolution – meant ranks of shivering people walking along the sides of wide, paved streets where government trucks rolled by with privileged party cadres standing up in the open backs.

There were no real shops and the few places with open doors selling food were doing little business. A deep, abiding sense of submission and control and helplessness seemed to pervade the scene. I felt I had awakened into a horrifying brave new world. All the oxygen of my life – free thought, information, the ability to speak honestly – had been sucked out of the air.

The cement statue of Chairman Mao Zedong epitomized the cold, soulless grip the party had on every action and thought.

After several hours I made my way to the train station. I had to get away. As I walked, out of the steady stream of bicycles emerged a young man. He stared straight ahead and walked beside me for no more than 30 seconds. Speaking in halting English he told me: "We are in hell. Please tell the world the truth. This is hell."

Then he disappeared rapidly into the crowd.

41.3 Nanjing Road in Shanghai

Nanjing Road in Shanghai is one of the busiest shopping streets in the world.

The thousands of people swarming before me as I shot photos from an overpass left me stunned. This was really the teeming orient as I had dreamed when I was a child.

It was already the year 2000 and the great economic liberalization had begun. Dozens of 60-story buildings were under construction, their reinforced cement frames surrounded by spiders' webs of bamboo scaffolding.

The narrow, intimate streets of Old China were being knocked down one by one as the 10 percent growth rate – fueled by exports to the United States, Europe and the rest of the world – swept the past aside.

However the culture and the character of China seemed to survive these architectural changes. People were well dressed and had some money to spend as they wandered Nanjing Road. But freedom to speak and think was not part of their future.

In a Starbucks, I sat by the window shooting photos of young people passing by – until the manager came over and told me it was not permitted.

At a bar, the disc jockey told me that the four young men in leather jackets sprawled across their chairs were all police. They came and drank each night and never paid.

A pregnant woman told me she stood online for hours at a public clinic that day, waiting endlessly to be examined by a doctor or nurse who treated her as if she was an animal.

The surface success, glamour and wealth on display in Nanjing Road is not all that it seems.

42.
Laughing
Thai
Schoolgirls

These laughing Thai schoolgirls with their bright, clean uniforms, their motorbike with its two mirrors and a cargo basket in front, all celebrate success in a region that was plagued with defeat.

The green tropical jungles around their city, Nan, were only five years earlier a bloody battlefield as communist guerrillas stalked the mountains.

But Thai King Bumibol Adulyadej and his government rejected U.S. offers to bomb the hills and fight another war. That strategy failed in Vietnam, Laos and Cambodia which fell to communists in 1975, moving the frontline to Thailand's neglected hill tribe region.

Instead, Thailand sent the U.S. military home. It built roads, schools and clinics. Trucks brought their cabbages, pigs and embroidery to markets in Bangkok.

"We were wrong—my 10 years with the communists was a waste of time," pig farmer Lao Pao Saesson, 40, told me in 1985. "If I want to improve my life now I know it depends on my own self."

The Domino Theory predicted Thailand would fall after its neighbors fell.But communism halted at the Thai border.

The confidence, happiness and hope for the future seen in these schoolgirls was both the cause and the product of Thailand's victory.

photo on following page

43. Charcoal Children

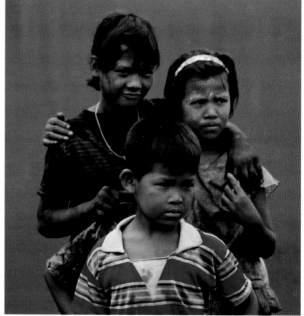

These Burmese children are in Thailand as illegal immigrants. Instead of going to school, they work long hours making charcoal.

Wood cutters chop down the mangrove trees in Phang An Bay, the lovely Indian Ocean region where James Bond once fought evil film villains hidden in steep, wooded islands rising from the bay.

The mangroves, which are vital to preserve the corals and the fish breeding and spawning grounds, are delivered to these children who stack them inside brick kilns 15 feet tall. They are ignited and smolder for a week. Before they are really cool, the children crawl into the hot, dark interior to remove the charcoal.

The only thing worse than this life must be what remains back home in Burma.

44.
Bengali
Child

I was visiting the ancestral village of a friend, a journalist from Calcutta's venerable newspaper, The Statesman, when I photographed this child.

You see in the background the rounded aluminum pot Indians love to use because they balance on three stones of an open fire. And they easily tilt at an angle to allow mixing and serving the food from the side without getting burned.

Beside her arm rises a sturdy bamboo post supporting the roof of the verandah.

She wears a shawl over her bright blue dress.

And her eyes are open wide with appreciation of this moment. She's the center of attention but also amused by it all.

The wonderful quality of her eyes, her slight smile, her busy but relaxed fingers bespeak the way in which this moment arrived. I came with her cousin from Calcutta to the village. I was brought straight into the heart of the family. She looks at me not as a foreign photographer, not as a visitor or a tourist or a stranger. She looks with humor and confidence at me as a playmate, a friend, a relative, a human being.

She made me feel at home.

45. Calcutta Street Children

This may be as close as one gets to the bottom of the human barrel —living on the streets of Calcutta.

Some families live for years, for generations, occupying the same few square yards of sidewalk.

Many send their kids to school each day and hold down jobs sweeping or washing clothes.

But thousands live in rags, eating from garbage and begging for scraps outside the restaurants and markets. They wash in the open drains, they defecate in the alleys and in the cold night they smoke the cigarette butts they scavange off the sidewalk. They cough and die on the pavement.

Sometimes, the city loads them on trucks, dumps them in a village and destroys their flimsy shelters.

When Bombay bulldozed street settlements in 1982 – the same week that the film Gandhi opened in the movie theatres— the newspapers reported that the mayor lost two of his safari suits because his washerman was among those bulldozed.

Of course, the pavement dwellers always return. They or those like them, fleeing the crowded land in search of a job and a full stomach.

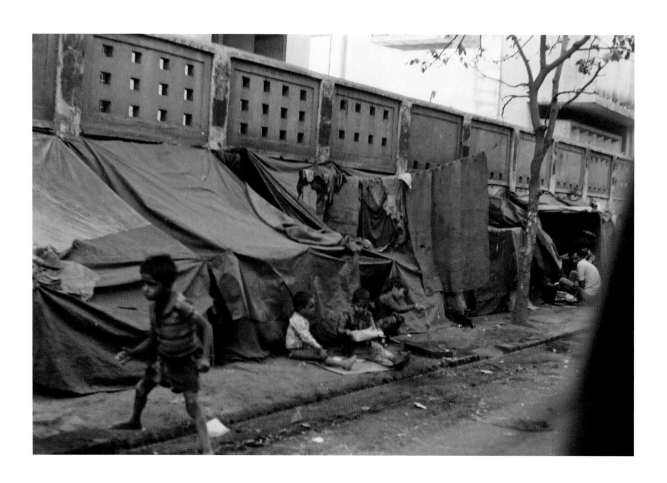

46.
Burmese
Reading

She's squatting effortlessly in a Rangoon street reading a cartoon newspaper while a boy reads the other side of the paper.

Their cheeks are dusted with a powder meant to protect the skin in the tropical heat.

Behind them another market woman looks over with concern. Why is a foreigner taking a photo?

For 20 years after this shot was taken, Burma remained firmly in the grip of military dictators. They allowed absolutely no dissent. They shut the universities for years to quiet students. They kept Nobel Peace Laureate Aung San Suu Kyi under house arrest.

But since 2010, she was set free, press freedom was permitted, political prisoners have been freed, the military rulers stepped aside and multi party elections were held. President Barack Obama and Secretary of State Hillary Clinton visited the former pariah state and U.S. sanctions were eased.

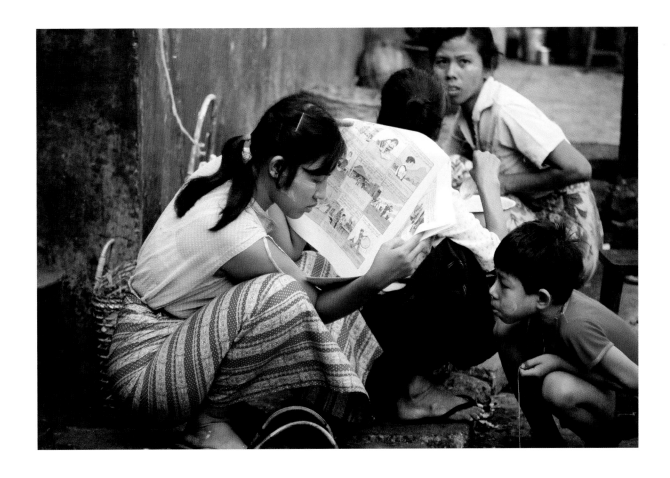

47. Renting Comics

These Chinese children are so poor they pay a few cents to rent the comics they are reading at this street library.

They live in a country drenched in propaganda. Television and radio have been harnessed by the Party and dole out stentorian admonitions to "work harder" and "be vigilant."

The children are thirsty for knowledge, for new voices, even those coming through comic book adventures.

48.
Dad's
Bicycle

This proud father in Saigon was about to cycle off into the dense traffic of the city. His kid's bicycle seat caught my attention.

I've always been disappointed with American kid seats on bicycles because the children are stuck in back and can't see or be seen. It's even hard to talk to them.

So I was fascinated by this child's wicker seat with a safety rail. It put the child up front.

Naturally, the kid prefers to hold Daddy's solid handlebars rather than the thin wicker railing on his child seat. The kid seems pretty safe there.

And what more could words say about this man that his expression does not already spell out? It's a feeling I know so well. To be protecting the child of one's heart as it sets forth discovering the world we have brought them into.

Our children give us a new mission in life. Serving them is the greatest joy.

49.
Christians in Pakistan

When these Christian women gathered to pray in Pakistan, they raised their voices to God. But their thoughts and words to each other after prayers ended were full of deep worry.

Pakistan was once part of British India. The Anglican Church still stands where the British built it when they ruled, on the main street of downtown Lahore.

But Pakistan has become an Islamic state, and many of its 150 million Muslims – frustrated by inescapable poverty – have little tolerance for infidels.

The bishop told me in 1998 that the million or two Christians in Pakistan were ok for the moment. But any Muslim can accuse them of insulting Islam – blasphemy — which is a criminal offense. Christian girls are sometimes kidnapped and forced to convert and marry a Muslim man. If they try to go back to their family and religion, they are accused of apostasy, another criminal offense.

Sharing prayers with them in a small Christian island of a sometimes stormy Muslim sea, I felt what it is to be a persecuted minority. Jews of Poland, the early Christians of Rome, the Tutsis of Rwanda.

50.
Overloaded

The license reads "AJK" for Azad Jamu Kashmir, the Pakistan-held portion of Kashmir. How many passengers does this jeep carry? I count about 20 on the outside. Maybe another five or ten inside.

In America, such a vehicle carries one person to the store for some groceries. In Pakistan and the rest of the Third World – home to five of the seven billion people sharing this planet – each car or van provides transport to hundreds of families.

Most of these vehicles are beefed up with extra leaf springs to bear loads far beyond the designer's intent.

I was riding in a Pakistani army truck heading for the Indian border or Line of Control when we came around a sharp bend and saw this sight. We squeezed around each other with the rocky cliffs on one side and a sharp drop 2,000 feet to the rapids of the Neelam River on the other side.

photo on following page

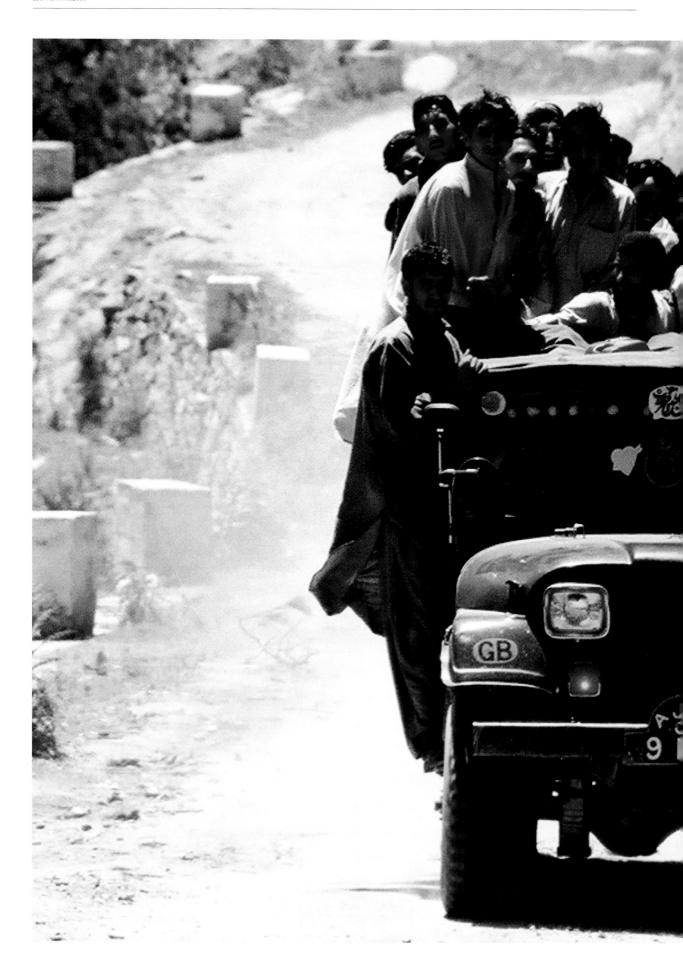

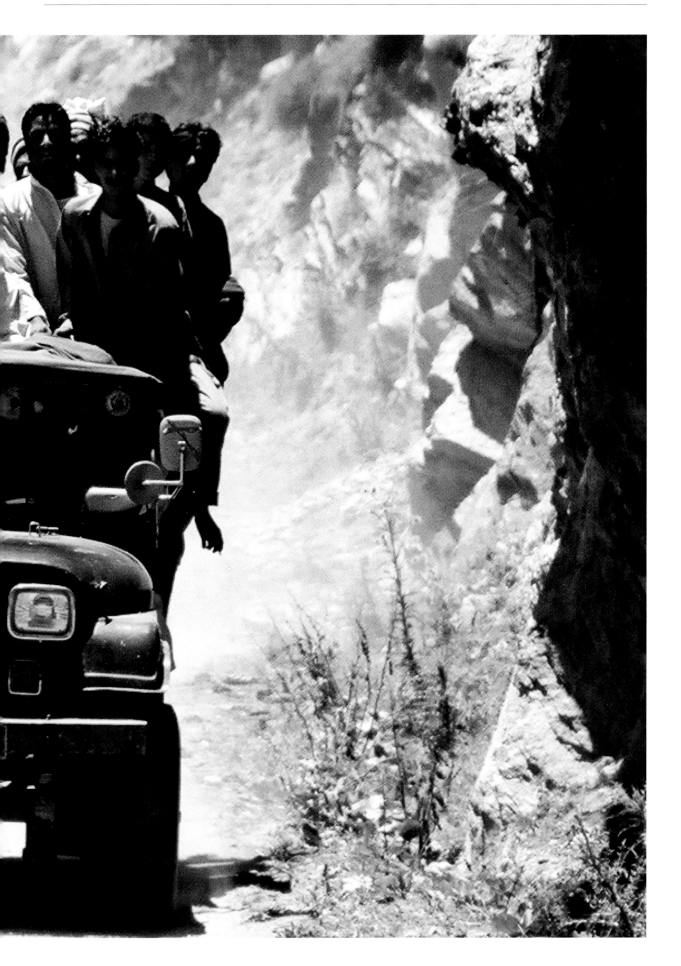

51.
Hanoi Rain

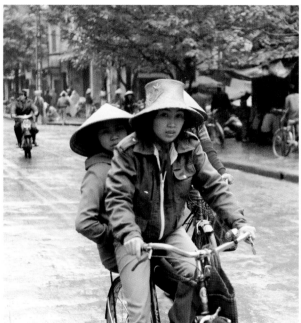

Hanoi was a city of few cars but many bicycles back in 1988 when it opened up to foreign reporters for the first time since the end of the Vietnam War.

These young women rode in the rain on a cold winter day exactly 20 years after the Tet attacks in South Vietnam that helped turn U.S. public opinion against the war.

Tet is the Vietnamese New Year and many people had tied traditional miniature orange trees to their bicycle racks to bring them home for the holiday.

At night, with no traffic lights or street lamps, hundreds of cyclists crossed paths at busy intersections and there were frequent crashes.

Several times one of the fallen riders got up from the street and slapped the face of the other. The feisty, aggressive nature of the northern Vietnamese was showing through. Little wonder they overran the more easygoing south Vietnamese.

Hanoi was so poor that people celebrated Tet with only a cup of thin, unsweetened green tea and a few slices of candied carrot. They were thin and their clothing was drab and worn. I shivered alongside them with my tea warming my hands.

52.
Maldives
Capital

This whole country is expected to vanish if global warming melts enough ice to raise sea levels.

This is Male, the capital of the Maldives. It is built on a coral island only about two or three feet above the level of the Indian Ocean. The 1,200 Maldives' islands are mostly uninhabited. The rest have a few hundred families each, clustered on pieces of land the size of a couple of city blocks.

Around each island is a circular lagoon of shallow tropical water and beyond that the sea crashes on a reef where you can see brilliant corals and fish go down through crystal clear water for up to 200 feet.

When the 2004 Asian Tsunami reached the Maldives it barely encountered an obstacle to slow it down and make it rise into a big tidal wave. The water rose only three or four feet and passed over the islands while villagers clung to their boats.

The round building in front is the mosque.

To protect the conservative traditional Muslim villagers from Western sex, drugs and alcohol, tourists are not allowed to visit the inhabited islands, and they can only stay on islands developed as resorts.

53.
Triple Motor Trishaw

On the right you see the bicycle rickshaws of Dhaka, Bangladesh. Thin men in dhotis and undershirts stand on the pedals as they use their weight to power their passengers through the city. One man can haul up to four or more passengers at a time, or boxes of goods tied in staggering loads.

In the center you see the new generation of transport – the motor trishaw. Powered by a small, two-stroke motor-scooter engine, these can travel twice as fast as the cycle rickshaws, 20 to 30 miles per hour.

Seated on the springy bench in the back, one clings to the metal frame as the trishaw bounces into and every pothole and the screaming engine vibrates every bone in your body. Clouds of smoke pour from the engines which burn oil mixed with gasoline, and when caught in traffic behind other trishaws the smoke is nauseating.

But unpleasant as it sounds, at least one does not have to sit in back of a cycle rickshaw, listening to the driver grunt and pant, watching the sweat pour off his thin body. I know they want the work but how hard it is to sit and let them use their life this way.

54. House of Sticks and Mud

In a village near Gagnoa, in the West African country of Ivory Coast, a man is finishing his new home. It's made of mud and wattle: sticks tied together into a frame that is plugged with clumps of mud.

The final layer is thin mud smeared on by hand to seal the walls from wind, sun, rain and animals.

You can see the builder's finger marks on the completed portion of the wall.

The roof is split bamboo woven into mats and should shed the rain nicely.

He's building his new home because his old one was burned down in ethnic fighting a few months earlier that year, 1997. The village of about 400 houses is divided into the three main groups of Ivory Coast:

— the mainly Christian Baoule who dominate in the south and control the government;

— the mainly Muslim Malinke or Mande who dominate in the north but run commerce across West Africa;

— and the Bete of the western woodlands near Gagnoa.

Christian-Muslim animosity grew so fierce after my visit that in 2003 the country was divided by a civil war into a Muslim north and Christian south.

55.
Bomb
Planter

This woman in north central Laos stands under a planter she has made from a U.S. cluster bomb. The markings are still visible on the side.

It was dropped by U.S. aviators on Laos during the Vietnam War from 1961 to 1975. While falling, the bomb would split open and release hundreds of bomblets, each about the size of a baseball. These would explode when they landed. But a large percentage would simply bury themselves in the ground without going off. The lethal bomblets ould remain for years waiting for some farmer's hoe or a child's hand to set them off.

This woman is an ethnic Hmong – part of the study hill tribe that sided with the United States in the Vietnam War and have remained poor and isolated. They use the bomb casings to grow vegetables and as troughs to water their farm animals.

56.
Hmong
Educator

Although most Hmong in Laos are poor and uneducated, Somechai had reached a senior position in the government – senior for a Hmong.

Somechai Mouawangyang is education director for Xiangkhoang Province. After bouncing around rutted roads in an old jeep all day he invited me to his home in Phonsavan to meet his family. He had been attending meetings to set up the school curriculum for the coming year, 1998.

"Hmong have a lower position than others—I work very hard but don't get advanced," he said as we ate green vegetable soup and rice. "We must stay below the Lao Loum" – the mainly Buddhist ethnic Lao who dominate the wealthy, rice-rich lowlands.

His children sat on the cement floor watching black and white cartoons on a fuzzy television. It was cold and there was no heat. We sat on cracked plastic couches and the dishes were set on a cracked glass coffee table.

This intelligent, educated, confident man represented the hope for Laos – especially its long-neglected Hmong people – for education and economic development.

57.
Burmese
Bus

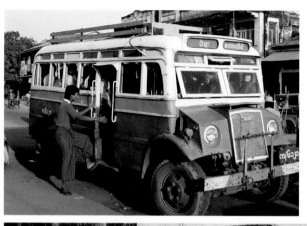

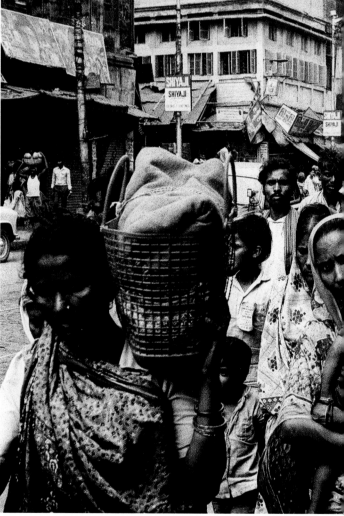

This bus was made in 1939 in Canada and shipped to Burma as the British Commonwealth prepared to defend its colonies – Burma was one of them – from Japan's wide-ranging military.

Nearly 50 years later, in 1988, I shot this photo of the bus, still running albeit on bald, bald tires.

Through the front windscreen you can see a monk wearing a dark maroon robe. The Buddhist monks get special seating because they not allowed to touch women.

This photo was shot just a few weeks before a massive democracy movement took to the streets and up to 3,000 people were mowed down by the army.

Some 22 years later, in 2010, the army abandoned its brutal control of society and turned government over to civilian leaders.

58.
Calcutta
Procession

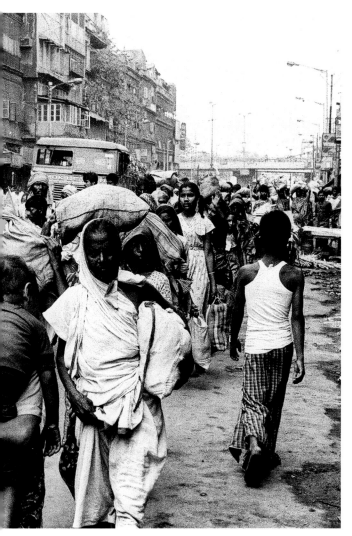

I was on the streets of Calcutta in 1983 when I saw this procession of thousands of silent villagers, mainly women with their children, walking in a long file. It was a protest, but either I never learned the details or else I forgot them.

The Indian state of West Bengal and its surrounding states are frequently riven by movements to provide land or rights or water or temples or education to various groups of people. The Indians are divided by caste and history and language.

But India is a truly democratic country and even the landless, the poor, the illiterate and the homeless believe in their right to march. Mahatma Gandhi showed them how to march. He led thousands to collect salt from the sea in violation of British law. They filled the jails and covered front pages of newspapers from Delhi to London to New York. And today Indians are still marching.

What struck me about these people was the earnest intent written upon their faces. Not one was laughing or vacant or bantering. It was as if a holy silence had descended upon them. They carried food with them in sacks, as if they were prepared to carry on for many days.

Such people have power that touches all who encounter them.

58.1
The Grand Bazaar of Tehran

Iran was called Persia for thousands of years until 1935. It has 77 million people and life expectancy is 70 years.

Barely 51 percent of its people are Persian. Some 24 percent are Azari – linked to the people of Azerbaijan. And seven percent are Kurds – linked to about 25 million other Kurds in Turkey, Syria and Iraq.

Since 1989, Iran's Supreme Leader has been Ayatollah Ali Hoseini Khamenei. Under the religious system of government known as "rule of the jurisprudent", he holds the ultimate say over everything in the country.

U.S. relations with Iran have been severed since militants took 53 American diplomats and others hostage in the American Embassy in Tehran in 1979, holding them for 444 days. The militants, spurred on by Ayatollah Khomeini, called America "the great Satan" and vowed revenge for a history of U.S. intervention in Iranian affairs, backing the Shah and helping overthrow a previous, democratically elected leader.

Iran's hard line Shiite leaders also intend to show the 90 percent of the world's billion-plus Muslims — who are Sunni — that the Shiites are more aggressive in their faith, more supportive of the Palestinians against Israel and more opposed to America's questionable moral and economic leadership in the modern world.

Many experts believe Iran's nuclear enrichment program is aimed at building nuclear weapons.

The Grand Bazaar in Tehran is one of the largest covered markets in the world – with perhaps 10 kilometers of alleyways.

You enter into a densely-packed sea of humanity, women as well as men, and shops clustered according to their goods. For example, in the carpet section, merchants lie barefoot on thick piles of ruby red hand woven rugs, waiting for their customers.

Other sections include hardware, tools, gems, watches, foods, clothing, textiles, furniture, etc.

Iran's bazaars date back to 4,000 BC but most of the Tehran Grand Bazaar's stone and brick walls and roofs date back no more than 400 years.

The bazaar, long a center for conservative thought, proved decisive when it supported the Ayatollah Ruhollah Khomeini and his Iranian Revolution in 1979 against the Shah Mohammad Reza Pahlavi. The shah had been moving to industrialize the country and this undermined the power of the bazaaris – who are essentially merchants.

Later on, several prominent merchants married their sons and daughters to the children of powerful ayatollahs, cementing that relationship between the bazaar and the mosque.

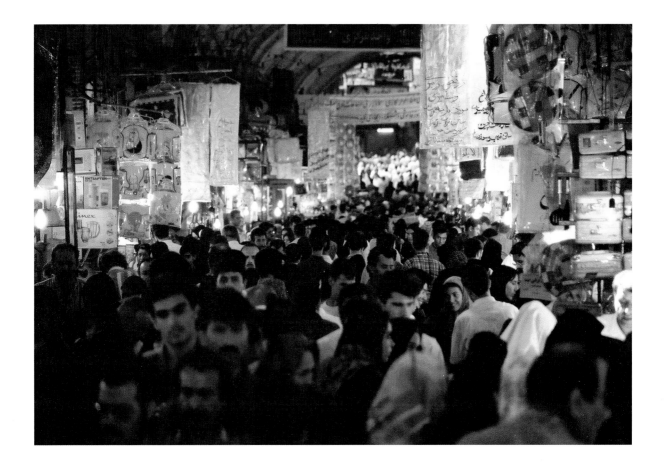

58.2 Bangladesh River Ferry

Perhaps no country in the world is so criss-crossed with mighty rivers as Bangladesh, the South Asian nation where waterways surge across flat land the size of Wisconsin and 150 million people perch – sometimes just above the waves.

To get from the capital Dhaka to a city just 40 miles away one must go by bus or car to a ferry crossing and load onto a boat that looks like this one. Trucks, buses, cars, freight, motorcycles, rickshaws and hundreds of men, women and children crowd the deck of the ferry. It inches its way into the thick, muddy current pushing us downstream, down towards the Bay of Bengal.

The chugging of the engine is the slim sound that leads us to expect we'll reach the other shore. Each year, thousands die when ferry boats overturn in rough water. The boats are always described as "overcrowded." This whole country is overcrowded so why not the ferries?

Tragically, few people in Bangladesh and in many other Third World countries, learn to swim. At home in America and Europe we learn in swim class and make sure our children are taught. Without such lessons, it's unlikely many of us would figure out on our own how to stay afloat and to reach safety in deep water.

And for a non-swimmer, a ferry boat capsizing is bound to be fatal.

The bitter irony is that the flood waters that seasonally overwhelm the rivers here also bring nutrients and rich soil washed off the Himalayan slopes by the monsoon rains each year.

These pour into the giant Ganges and Brahmaputra Rivers which cross Bangladesh and flow into the Bay. They bring fertility but also tragedy through floods as well as the ferry accidents.

Bangladesh ferry accidents claimed more than 4,000 lives between 1971 and 2005, according to the Alliance for Safe River Routes which issued a report on the risky method of transport in 2005, the BBC reported.

Some 500 ferries were involved in the accidents that caused the deaths.

"Overcrowded and unsafe" the BBC called the river ferries. The ones I rode certainly lacked life preservers and any other safety equipment.

About half the 20,000 cargo and passenger ferries operating in the country were unsafe, the report said.

photo on following page

59.
Warrior
and Angel

A Thai soldier stands guard beside a stone angel at the corner of King Bhumibol's palace in Bangkok – Chitralada Palace.

The magical stone carving is indifferent to the snapping mouths of dragons or serpents. The angel's hands are raised in a traditional Buddhist mudra or gesture meaning she is enlightened and stopping the cycle of rebirth and illusion.

The soldiers are always scattered around the palace wall although they seem few in number and more symbolic than anything.

The firm beauty of the angel and the cautionary vigilance of the soldier create a telling postcard of Thailand. Gentle worship of beauty, sensuality and Buddhist renunciation go hand in hand with aggressive defense of their king and country.

60.
Cambodian Land Mine Victim

This man was in a small clinic near Battambang in Western Cambodia – the site of some of the most vicious fighting and violence during the civil war, the Khmer Rouge repression and the Vietnamese occupation.

He had stepped on one of the millions of land mines sown in the fields and forest of the region.

For him and for the others who survived the blast and the loss of a limb, life was a bleak horizon. Unlike the West, where people with disabilities are helped to live as normal a life as possible, Cambodians have tended to see such people as cursed by fate – perhaps because of some evil they committed in a previous life.

Western non-governmental organizations such as Handicap International set up shop in Cambodia and helped many victims to receive prosthetic limbs and assistance in starting some business or craft that could help them make a living.

But this man, who told me he was injured collecting firewood in the forest, would no longer be able to collect wood or to farm.

Aside from assisting the disabled and working to change the mindset of rejection shown to many of the disabled, Western NGOs such as the British HALO group also operated extensive mine-clearing operations. They cleared many fields in the 1990s once the Paris peace pact ended guerrilla war by the Khmer Rouge and other Khmer groups against the Vietnamese army.

But each year the heavy monsoon rains and floods hit Cambodia, shifting mines around and re-contaminating some fields that were already cleared.

With 40,000 amputees among its 12 million people, Cambodia has one amputee per 290 people, one of the highest rates in the world, according to a 2003 BBC report.

Some of them sell post cards and trinkets in the markets in Phnom Penh but say they are treated as outcasts by the other merchants and even the police, who drive them away from main roads.

The Mines Advisory Group reported that 40 percent of Cambodia's villages had landmines – which the Khmer Rouge dictator Pol Pot called "perfect soldiers."

The Cambodian Mine Action Center estimated in 2000 that there could be from four million to six million landmines still active in Cambodia.

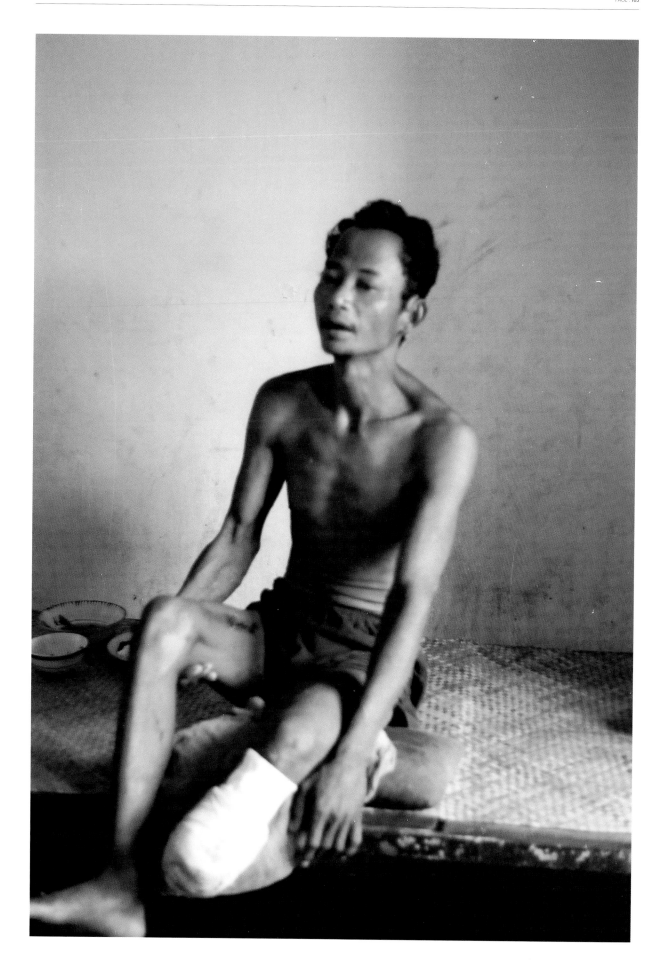

61.
Khmer Rouge

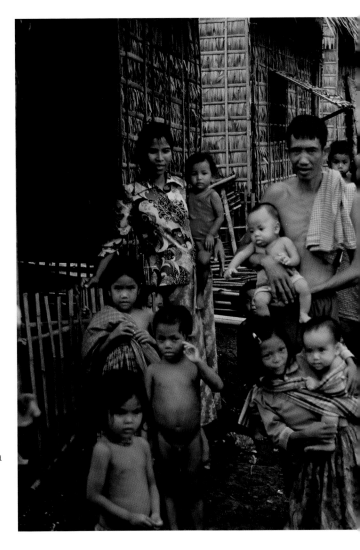

This is a refugee camp in Thailand for Khmer Rouge Cambodians, led by Pol Pot, who slaughtered a million people in the "killing fields" from 1975 to 1979.

Vietnam's army drove them out in 1979 and occupied Cambodia until 1988, when I visited this border camp.

The Khmer Rouge told me not to publish a picture showing the mountain in back of the camp because it might help Vietnamese artillery zoom in on them. During my visit, the rumble of artillery was audible in the east.

Although the Khmer Rouge killed so many – especially doctors, intellectuals, monks, minorities, teachers – they were never brought to justice.

Safe and amply fed in their Thai camp, they denied the Khmer Rouge killed anyone. "What killing fields?" they scoffed in French. "Must have been Vietnamese agents who did any killing."

Many refugees slipped back across the border into Cambodia to fight the Vietnamese. The United States supported the Khmer Rouge diplomatically and with food aid while China gave them weapons. Even if they were blood thirsty killers, they were now killing Vietnamese. It was pay back for the U.S. and Chinese loses against Vietnam.

The birthrate in the camp was astronomical.

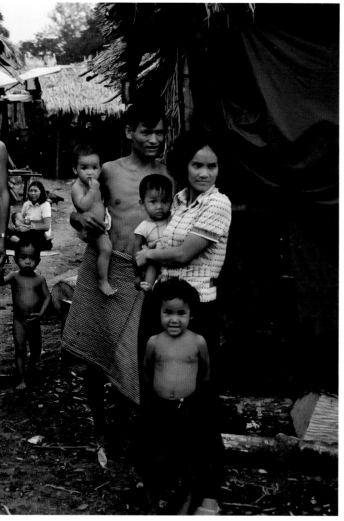

61.1
Refuge for
Killers

This camp just inside the Thai border is a refugee to those who gave no refuge to others. It shelters in safety the bloody Khmer Rouge, who gave no safety to the hundreds of thousands they killed from 1975 to 1979.

I was able to visit the camp when the United Nations and Thai authorities gave me permission. When Pol Pot's Khmer Rouge held power, they killed all the western journalists they could get hold of.

Now they were smiling and inviting me in, knowing that American money paid for their food and Thai soldiers protected them from the Vietnamese army just across the border who had taken over Cambodia.

For any journalist, it is a horrible moment to shake the hands of killers. You meet Nazis and torturers and communists who keep innocent people in the cellars beneath their offices. Yet you cannot avoid meeting them as they are part of the story of modern human history.

Pol Pot's Khmer rouge came to power when American-backed governments were over run – not just in Cambodia but in South Vietnam and Laos as well. But in the other two countries, repression and re-education camps meted out terror to a small number of former leaders and fighters. Cambodia handed out death and hardship wholesale.

The Khmer Rouge did ask me not to take a photo that showed the distinctive stone spire you see in the background. They said that Vietnamese artillery beyond that mountain could use it to sight their artillery pieces on the camp. So I never published this photo.

Now, 20 years later on, the refugees are all returned to Cambodia under a peace agreement. And Vietnam's troops no longer patrol Cambodia. So the photo can be shown.

62.
China's
Kids

This street scene in Changsha, a major Chinese city, shows how lively and loved these kids were. It was 1982 and most Chinese cities were still very poor and isolated. But the children were easier to befriend than adults who had a great fear of foreigners and fear of being seen talking to one. The Cultural Revolution was still a terrifying though fading presence in the land.

Children are free of such fears. A smile and a gesture can break the ice and make friends.

The faces may be unwashed but the children wear wearing warm clothing. Their cheeks are round and one child is eating a bowl of rice.

The wicker cage behind them is for transporting chickens. This photo is a prelude to the rapid progress China made since it was taken.

63.
13 Years in Prison Ends

This defeated South Vietnamese colonel had just been told to pack up and go home. It was 1988. He'd just spent 13 years in the Ba Sao communist re-education camp near Hanoi.

The 161 former officers and government officials climbed onto trucks. Many were psy-ops or psychological operations officers. "The communists were afraid of these men," said one official. You can look in their eyes and see their strength. We were afraid of them until now. This means the war is really over."

In French, away from the communist minders, they told me they were not tortured. But they had to work in the fields and write self-criticisms admitting their mistake in backing the Republic of South Vietnam.

"We learned to write what they wanted," said one man, who had been trained at U.S. army posts in the U.S. Once a year their families took the long train journey north to see them.

In Saigon a week later, one of the released men was back home, surrounded by his wife and kids. He showed me photos from his brother who had escaped in April 1975 and lived in a California suburb.

That was fate. Some fled to new lives. Some remained and coped with the communist rule. These men fought for their country and were caught and punished for being patriots. "We did not want to run away and be deserters," said former Brig. Gen. Le Trung Truc.

During the Vietnam War from 1969 to 1975, the death toll was 1,921,000 Vietnamese, 200,000 Cambodians, 100,000 Laotians, 58,135 American soldiers and 35,000 U.S. civilian non-combatants.

About one out of five Indochinese was made a refugee.

Source: Reese Williams, ed. Unwinding the Vietnam War: From War into Peace (Seattle: Real Comet Press, 1987)

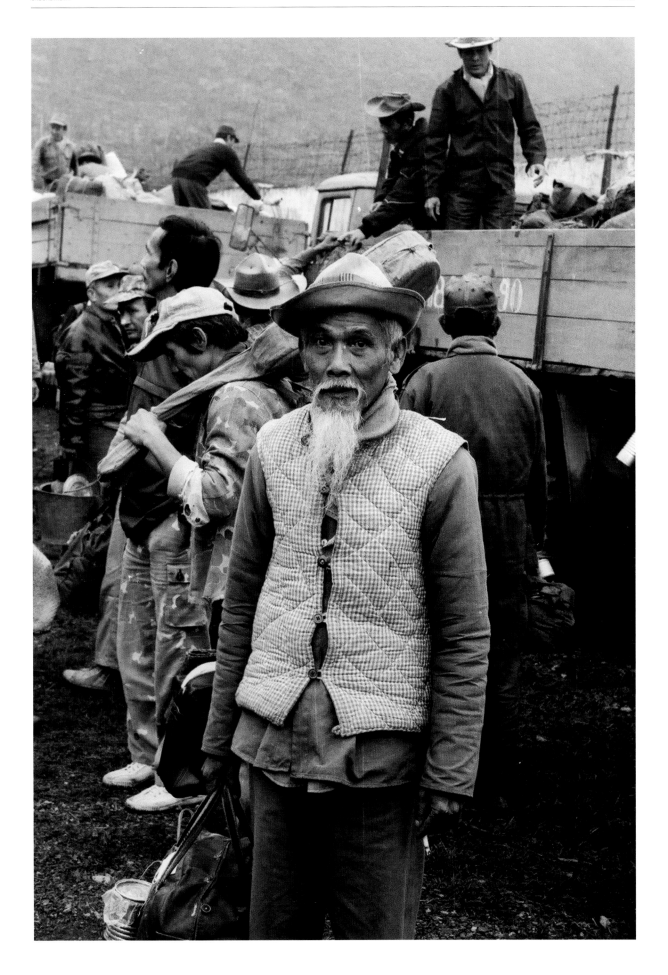

64.
War
Orphan

I saw this boy riding his bicycle in a Vietnamese village and asked if I could follow him to his home.

His mother was Vietnamese and his father was an American soldier—an African-American soldier.

He is one of a few black AmerAsians born from liaisons between Vietnamese women and black U.S. soldiers during the Vietnam War.

White AmerAsian kids faced a lot of prejudice and were called "dust of the erarth."

But Black AmerAsians faced even greater prejudice. Many hung around Saigon and became drug addicts, hustlers and prostitutes.

But this boy was lucky. He ended up with a kindly old couple who raised him like their own flesh and blood.

In 1988, when this photo was taken, the U.S. government opened its doors to all such children and brought about 20,000 of them along with close family members to the United States.

Then these kids became popular as tickets to a better life.

The old couple wept when they talked about him going away to America. They said they were too old to go on to a strange new country with their adopted son. For them it was too late to make such a journey.

65. Crossing the Sahara with Polisario Guerrillas

Sahara – also called Western Sahara — just below Morocco on the Atlantic Coast and running inland as far as Algeria where the Polisario have their base.

I met them at Harvard when two Polisario observers to the United Nations came to Boston for a conference. They invited me to visit their rebel movement.

When I landed in Algiers some months later, and called to ask for Mahmoud, I was brought down to Tindouf and taken into the desert.

In 1976, some Sahrawis started an independence movement they called called Polisario. But when the Spanish pulled out, instead of the Polisario taking over, Morocco's King Hassan II launched a mass movement which simply occupied and annexed the Western Sahara.

Some 75,000 Sahrawis fled to Tindouf , Algeria and launched a guerrilla war. But the Moroccans, aided by U.S. weapons, kept control over the region. They did so by building a berm of sand and rock some six to 10 feet high and more than 1,600 miles long in the desert. High-tech sensors and radars were placed atop the berm and triggerd alarms whenever the Polisario tried to cross. The F5s then flew over and blasted anything moving in the desert.

Each time we halted to sleep or cook or fix the cars, we hid under thorny bushes and scattered apart so we would not all be killed by one bomb.

We had been whipping across the Sahara Desert for four days already, fearful that Moroccan warplanes would spot us and attack.

Ironically, the jets we fear are F-5s, made by my own country and sold to the Moroccan government.

The Polisario guerrillas I'm with have added a huge second gas tank to the back of each Land Rover so we were able to drive 1,000 miles without refueling. They knew where to find water in the desert.

I am sitting in the front seat on the left. My head and face are wrapped in a filthy cloth loaned to me by one of the guerrillas. I think I got TB from that cloth. After that trip I tested positive. But the TB remains inactive.

When we rode across the desert at 50 miles per hour, day and night – traveling by the stars at times – a bitter cold wind blew in my face. The windshield had been lowered onto the hood to assure it would not break from small stones flying up from the tires. So I borrowed the cloth from the rebels to cut the wind.

The Polisario guerrillas are Sahrawi people, Berber camel herders who live in the former Spanish

A total of 14 F-5s were shot down by the Polisario in the 1980s during the heart of the fighting. The Polisario was aligned with the leftist nations such as Algeria, Cuba and other Soviet bloc countries which supplied the rebel group with anti-aircraft missiles.

Algeria's backing for the Polisario was thought to be linked to its desire to control a land route to the Atlantic that did not need to cross Morocco. Thirty years after my visit to Tindouf, perhaps 75,000 Sahrawi civilians remain trapped in refugee tents pitched in the desert – apparently prevented from leaving the camps and returning to their homes by the Polisario.

photo on following page

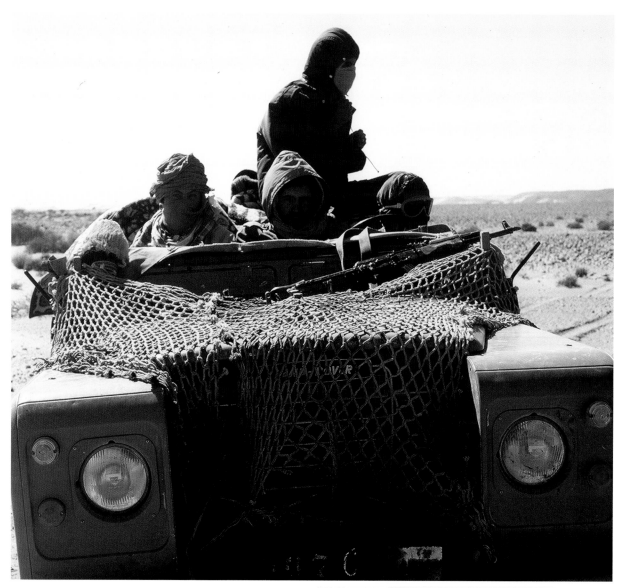

65.1 Fixing Land Rover Spring in Sahara

I had been bouncing for three days along the wadis – dried up river beds that flood once a year when it rains in the Sahara – and marveling at the sturdy British-made Land rovers the Polisario guerrillas used to navigate the trackless waste.

Suddenly there was a halt. The lead car was stuck in the sand. Even with four wheel drive the tires simply spun without purchase and the chassis was already embedded in the sand.

That was why they always left a few hundred yards between the two vehicles. If one got stuck or hit a mine, the other could pull it out and continue the mission. We unraveled a long winch cable from our car and another one from the lead car. They were hooked together and our car pulled out the stuck vehicle.

They told me not to take a photo of the freeing of the stuck car. Perhaps they feared it would appear in the newspapers and be seen by the Moroccans, giving them some intelligence about the rebel movement.

A few hours later, after a quick lunch and a snooze under the thorny trees out of sight of the Moroccan jets, our car broke down with a loud bang. It was the steel pin that held the leaf springs onto the chassis. Shattered.

We were about 500 miles away from the nearest garage. My map showed we had crossed from Algeria into the Western Sahara and then to Mauretania. It was all desert and there were no border markers or fences.

The guerrillas sent out searchers to find a large flat stone so they could jack up the car body. You can't set a jack in the sand. Then they used one inch diameter woven nylon rope to lash the end of the spring to the body. It was a masterful jury rig. Two men put the maximum force onto the rope and then managed to tie it off.

I got off one photo before the guerrillas told me "do not take a photo of this." I had already taken the photo. But I didn't publish it for 29 years until now.

The guerrillas basically lost the war against Morocco in the 1990s. But the fighters and perhaps 75,000 civilians are still stuck in refugee camps in Tindouf, Algeria. They are awaiting a political agreement on who will vote in a referendum in the Western Sahara on whether to join Morocco or become independent.

Thirty years in a desert refugee camp is a crime against humanity.

65.2 Deadly Mines at Guelta Zemour

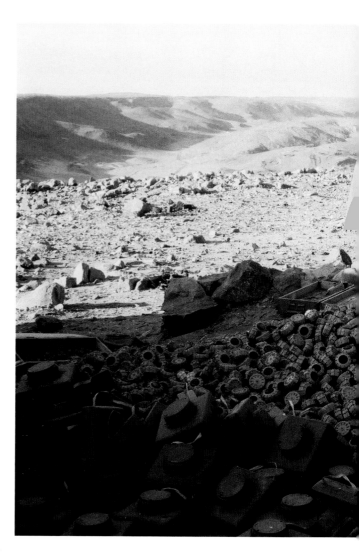

After three days of hard traveling in the desert we reached Guelta Zemour, a shattered row of stone and mud shops that had been thoroughly bombed by the Moroccans. Even the ancient water hole had been poisoned, my rebel guides told me.

If you look on a world map at the point of the Sahara where Algeria, Western Sahara and Mauretania meet, you often see Guelta Zemour printed – as if it was as important as some major cities of the world. In fact it was on the map because it was the only human habitation in a vast area.

The rebels showed me the wreckage of a Moroccan F-5 fighter plane they said they had shot down. They said this was the site of their greatest victory.

I however saw the completely abandoned and shattered town – where perhaps 100 people might have lived in its heyday, as a completely worthless achievement. They denied it to the Moroccans but had driven out the locals and could not even spend a few hours there without risking annihilation.

Atop a small ridge, they showed me hundreds of land mines left by the Moroccan army before it pulled out, unable to secure this outpost surrounded by hundreds of miles of barren desert. The small mines are for blowing legs off foot soldiers (and hapless civilians). The big ones are for cars and trucks.

The fighters in the photo are bundled up against the cold February winds that blow in the Sahara.

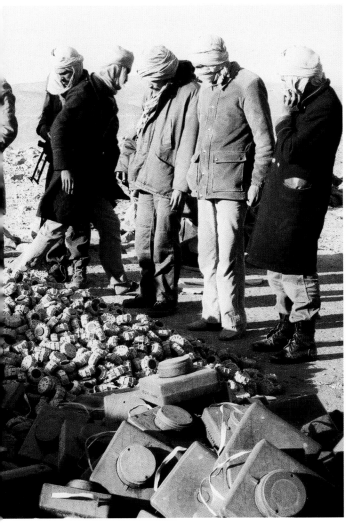

66.
Skulls of Cambodans Killed by the Khmer Rouge

A Cambodian man views all that remains of some of the million people slaughtered by the Khmer Rouge from 1975 to 1979. They were killed because they spoke French or were Buddhist monks or wore eyeglasses or failed to mimic their masters' enthusiasm for the return to a primitive ant colony existence as slaves to the leaders.

The whole intellectual leadership of society was butchered. The brave and creative and outspoken above all they cut down.

Only two people were ever prosecuted for this slaughter. Thousands more of the killers remain living among their victims.

photo on following page

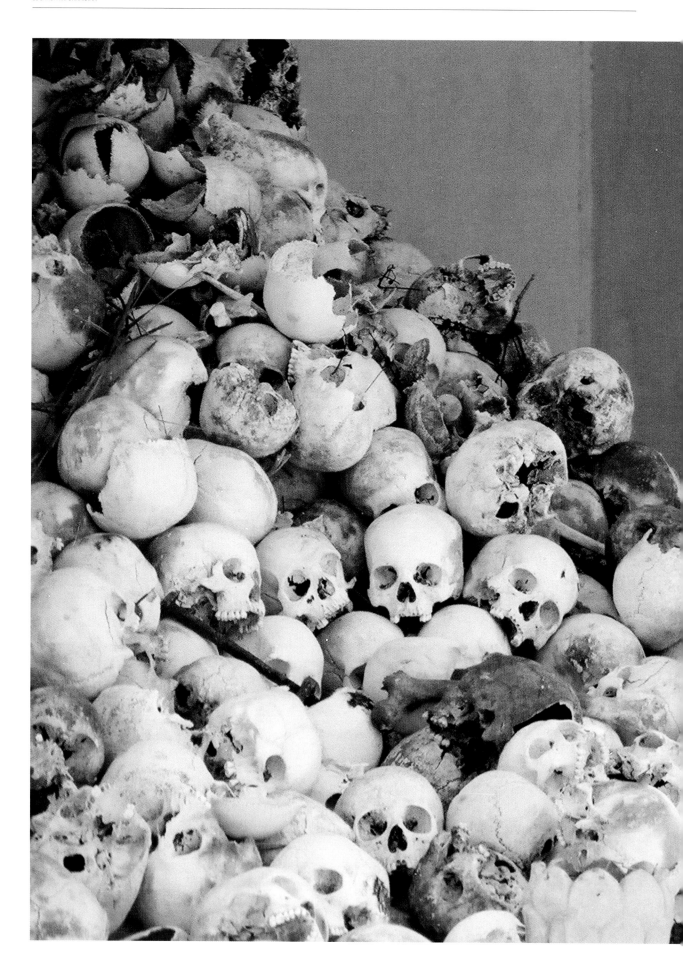

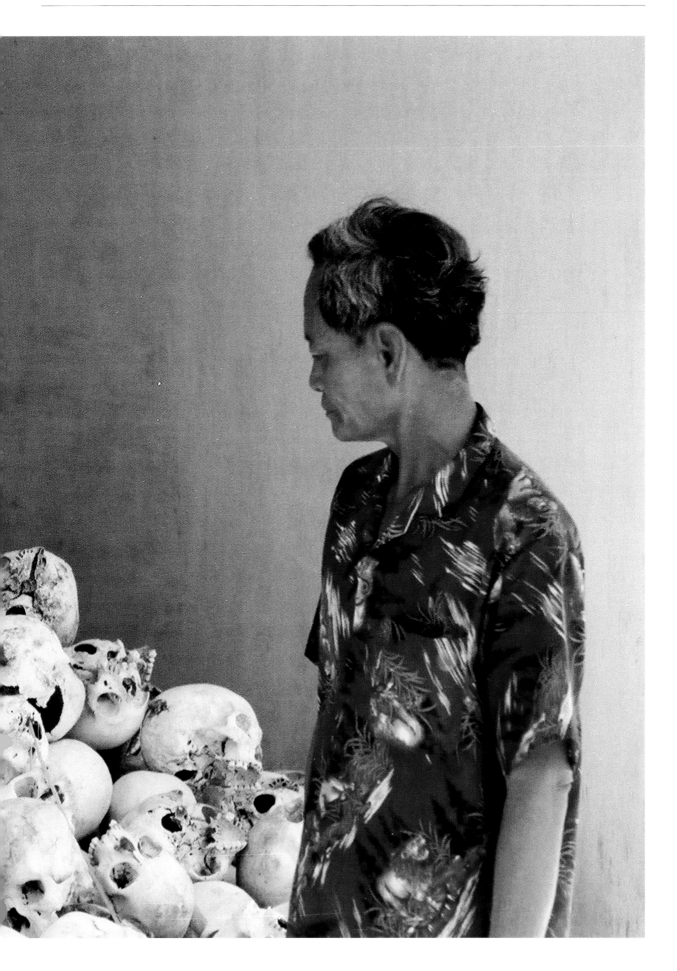

67.
Los
Ranchos of
Caracas

More than a million Venezuelans live in these slum hillsides above Caracas called "los ranchos."

For several days I had failed to find anyone willing to come with me into the ranchos to interview people there. Even the police are unwilling to go there. Criminal gangs provide whatever law and order exists. Finally, I went alone, my camera hidden in a plastic shopping bag and looking very much like some vegetables from the market.

The land belongs to no one, but someone charges rent. The houses are built on steep clay slopes where the heavy rains undermine the houses sending dozens plunging into the ravines each year. Many of the victims are buried alive and never recovered.

And if you build a house in an open space one year, in a few more years new houses are built alongside – there is no zoning law. The new houses block your windows, leaving you in the damp shadows that nurture malaria and TB.

I reached the foot of the steep hillsides around 9 am and watched a river of humanity flowing down from the ranchos towards the buses and trains to downtown offices. Fresh-faced young women with high school education walked carefully in high heels and tight skirts down the steep streets towards their jobs in banks and government offices. The young men went to their jobs in construction or rubbish removal or security guards at the university.

One woman invited me into her home and showed me the heavy iron door with its multiple locks, the iron bars over the windows. "After seven o'clock at night, no one goes out," she said. "We are all at home, locked in and afraid."

Water, electricity, sewage and garbage removal are all jury rigged by the residents. Sometimes the government provides a pipeline running down the hill and residents tap into it.

Despite the vast income provided by Venezuelan oil exports and the populist promises of socialist President Hugo Chavez, neither the past regimes nor the present one has provided safe, healthy and affordable housing to replace or improve the ranchos. They remain a wild west, beyond the law, where dozens of young men are murdered each weekend.

68.
The Potala Palace in Lhasa, Tibet

Lhasa was once the inaccessible roof of the world, isolated by the Himalayas to the south and the foreboding emptiness of the Chinese steppes and deserts to the north.

When I walked along its streets and looked up at the Potala, where the Dali Lamas had lived and ruled for many centuries, the whole scene seemed like an abandoned prop from a Hollywood film about Tibet. The Potala is an architectural and cultural treasure with 13 stories, 1,000 rooms, 10,000 shrines and 200,000 statues. But it is empty of power.

Tens of thousands of Han Chinese from the lowlands have moved up to the 12,000 foot high Lhasa to do business – and they are changing the ethnic and cultural feel.

And since my visit in 2000, a new high altitude railway links China with Tibet, adding to the demographic and economic shift of power from Tibetans to the Han.

I'd met Tibetan refugees in Northern India and Nepal just eight years after they fled the 1959 military crackdown on the Dali Lama – sending him and thousands of followers on foot over 20,000 foot mountain passes to safety in northern India, pursued by Chinese soldiers.

Back in 1967, in the Tibetan refugee school in Mussoorie, north of New Delhi, the refugees had just begun what has become a long exile. The Dali Lama, himself a refugee in Dharamsala, Northern India, has offered to make peace with China and not seek independence for Tibet – but he has been rebuffed by the fiercely chauvinistic Chinese who insist he is a "splittist" because he wants some sort of autonomy.

The Potala is painted half in red and half in white to symbolize the two functions of the palace – red for religion and white for living quarters.

Inside, you walk from one dark and mysterious room to the next, with the walls painted with garish scenes of religious events seen by flickering butter lamps.

One day I took a cab to the still functioning Sera monastery, a few miles from the center of the city. I decided to climb the rocky hill next to the monastery, panting in the thin air. I was delighted by hundreds of furry animals looking like prairie dogs or marmots, living in a dense web of holes dug into the earth.

Looking down on the monastery, I saw about 40 young men and women performing a dance on the roof. They chanted a lovely melody and held sticks that ended in flat stones which they thumped against the earthen roof, perhaps tamping it down to make it weatherproof. The rhythmic dance, the thumping and their song was the loveliest thing I have seen in many years.

Then a horrible noise erupted from the hills, drowning
out the Tibetans. The Chinese had placed a military
base next to the monastery. Loudspeakers atop its
barbed wire fences blared out a strident woman's
voice. Military music bounced off the hillsides as the
firm, awful voice probably warned of the dangers
of disobeying the voice of the people's army. The
Tibetan dance continued despite the military music.

69.
Vietnam Army Leaves Cambodia

The officer on the left is the head of Vietnam's army of occupation in Cambodia. The officer on the right is the Cambodian army chief. They are celebrating the end of Vietnam's occupation of Cambodia.

I was one of about a dozen Western reporters living in Bangkok who had been waiting for years for a visa to visit Cambodia. In 1988 it finally came. Vietnam, which had occupied the country since 1979 when it ended the bloody rule of Pol Pot's Khmer Rouge, wanted us to come and report its withdrawal.

Even before the ceremonial withdrawal parade, I went out to the country side and saw buses loaded with Vietnamese soldiers – some riding on the roof – wailing down the road heading home. The occupation had cost Vietnam 55,000 dead – ironically equal to U.S. deaths in the Vietnam War. Most died of malaria in the jungles near the Thai border where the Khmer Rouge and other Cambodian groups launched a guerrilla war out of refugee camps.

After the parade in Phnom Penh, the Vietnamese army leaders mounted helicopters and flew off. Naturally, we reporters were skeptical about the whole dog and pony show and we wondered if the helicopters were merely flying off a few miles to some Vietnamese army camp.

So to remove our skepticism, Vietnamese officials herded us onto a plane and flew us to Saigon – renamed Ho Chi Minh City. There, at the airport, we saw those same helicopters that had lifted off from Phnom Penh two hours earlier. They landed and discharged the senior Vietnamese army officials.

Of course they could have flown back to Cambodia the next day. But this was a turning point in history. Vietnam, deeply impoverished and isolated, had decided to try and seek normal relations with the rest of the world, beginning with its own neighborhood. So it ended its occupation of Cambodia. Next Vietnam would open up to international trade and investment, allow its farmers to sell rice to the open world market, invite American experts to recover remains of U.S. Vietnam War soldiers, and eventually normalize relations with its former enemy, the United States.

Cambodia has 15 million people and average life span is 62 years.

Average income is $2,100, making it 189[th] in the world.

In 2011, Cambodia fought a brief border skirmish with Thailand over an ancient Khmer Buddhist temple along their common border.

Vietnam has 90 million people and average life span is 72 years.

Average income is $3,100. In 2011 Vietnam was engaged in a dispute over thousands of miles of the South China Sea surrounding the Paracel and Spratly Islands, said to hold oil and gas. China claims the sea and islands as do Vietnam, the Philippines, Taiwan and Malaysia.

70.
A Child Washes a Younger Child

In this courtyard, a young girl washes a younger child. It symbolizes a vast area of the globe where the children do not spend their days in school and their weekends at the swimming pool. Instead, by the age of five they are working in the home and in the fields.

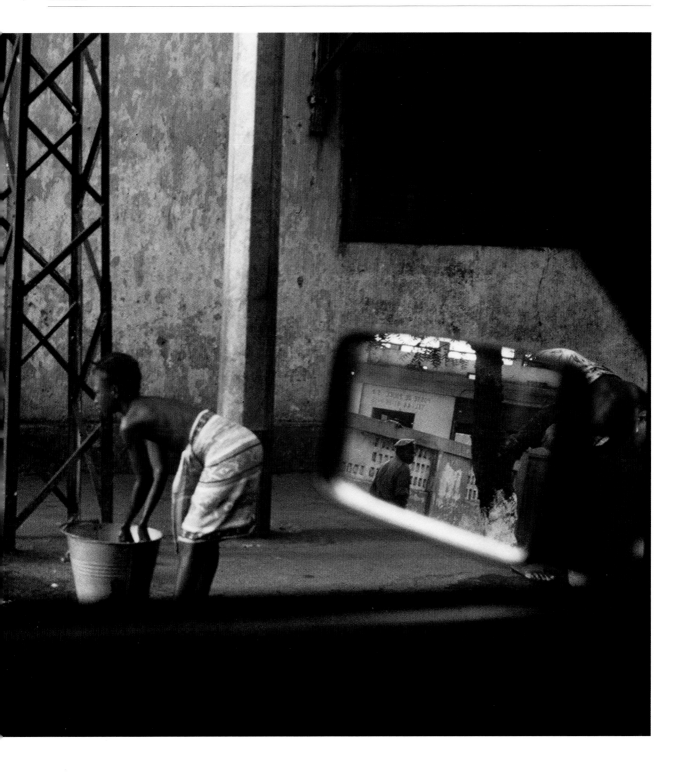

71.
Cambodian Mother and Child

This beautiful Cambodian mother with her child smiled at me as I walked towards a display of military power by the new Cambodian army.

It was in 1988 and the country was still reeling from the murder of up to 1.7 million people by the Khmer Rouge. Vietnamese troops still ran the country and a new authoritarian regime by Hun Sen – who rules today, some 24 years later – was training troops for a new security force.

Amid the gloom of poverty, Khmer rouge rebel attacks, thousands of amputees from landmines and the loss of so many skilled and educated people, the optimism and glow of motherhood seemed to give hope for the future.

I particularly liked the notched and lashed steps of the ladder next to her. Like many people in Southeast Asia, the Cambodians often lived off the ground in houses built on log poles, using the ground floor to store animals and tools; or a space to work at cooking and crafts.

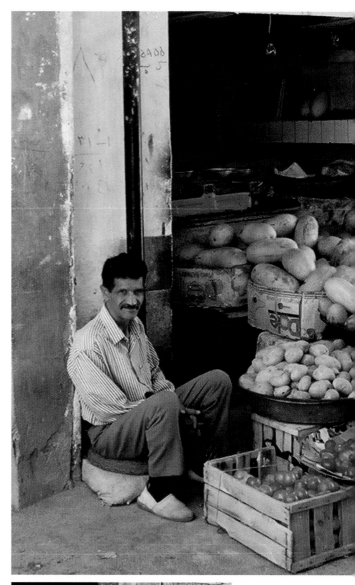

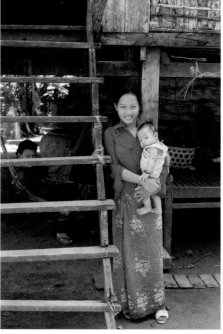

72. Jewish Merchant in Iran

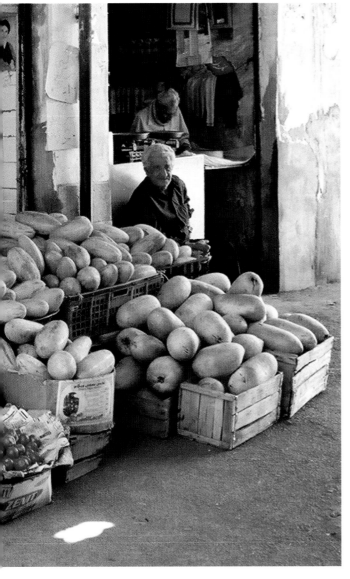

If you look carefully at the wall of this fruit and vegetable seller in Shiraz, Iran, you can see – next to the photo of the Ayatollah Khomeini— some Hebrew prayers.

The merchant is one of about 5,000 Jews who were still living in Shiraz, some 500 miles south of Tehran, when I visited in 2000. They are descendants of the first Jewish exile which came to Babylon and Persia in the 6th century BC – about 1,000 years before Islam was born.

The Iranian Jewish community was protected and prosperous under the former Shah, who had good relations with Israel. Even under the Islamic Revolution they have been able to worship in their synagogues and engage in public business. One Jew served in the parliament. However they are banned from any contact with Israel, where many have relatives, and their numbers have shrunk from 100,000 in 1979 to 25,000 in 2000.

This man in particular was worried because his son was in prison – one of 13 Iranian Jews accused of spying for Israel. All were eventually released.

73. Tibetan Lady with Prayer Wheel

She was crossing the main road in Lhasa when I saw her, dressed as if for another century. The cars and trucks veered around her as she made her way towards the main Buddhist Temple.

In her hand she held a portable prayer wheel, whirling it round and round continually so the powerful mantra inscribed within – Om Mani Padme Hum – would continually revolve. That way she gets credit for having said the prayer over and over.

Her traditional Tibetan costume is rapidly disappearing in Lhasa these days as ethnic Han Chinese from the lowlands arrive in great numbers and dominate the roads and markets. Even younger Tibetans tend to dress in Western-style clothing. This woman is part of the past.

"Om Mani Padme Hum cannot really be translated into a simple phrase or even a few sentences," according to Dharma Haven, a Tibetan Buddhist website.

"All of the Dharma [religious teaching] is based on Buddha's discovery that suffering is unnecessary: Like a disease — once we really face the fact that suffering exists, we can look more deeply and discover its cause; and when we discover that the cause is dependent on certain conditions, we can explore the possibility of removing those conditions.

"Buddha taught many very different methods for removing the cause of suffering, methods appropriate for the very different types and conditions and aptitudes of suffering beings. For those who had the capacity to understand it, he taught the most powerful method of all, a method based on the practice of compassion. It is known as the Mahayana, or Great Vehicle, because practicing it benefits all beings, without partiality. It is likened to a vast boat that carries all the beings in the universe across the sea of suffering."

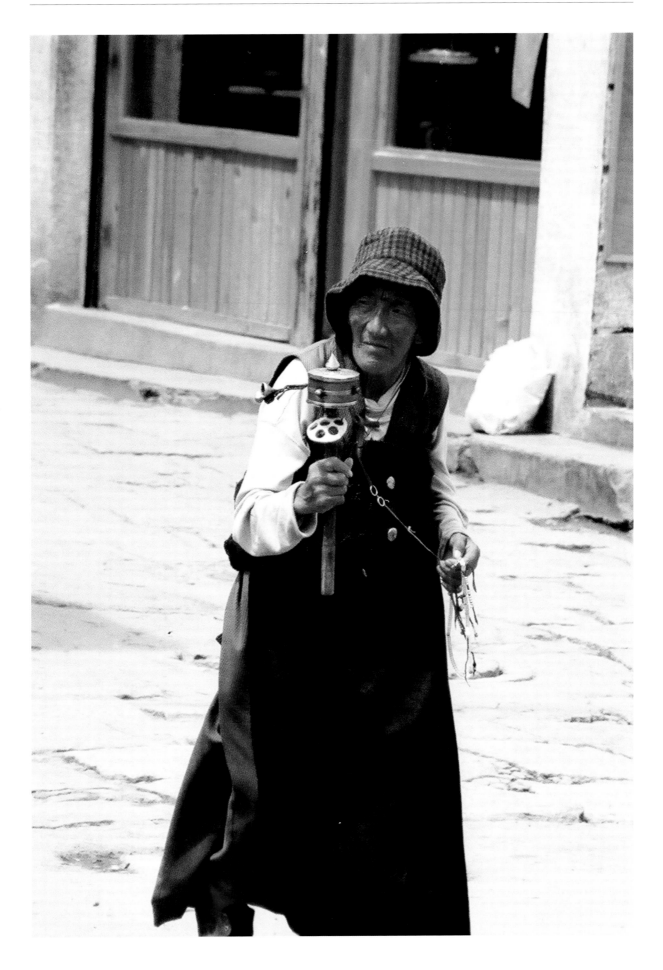

73.1
Tunisian
Woman
and Child

This woman and child in Tunisia remind me of the special place that Tunisia – alone in the Arab World – gave to its women. Her face is curious, serene, confident and bemused as she holds the hand of the child.

In many places from Rabat to Sanaa, I had to sneak photos of women as it was forbidden to take their photos. Or they were hidden behind veils and high walls of compounds and homes. But Tunisia prided itself that since independence in 1956 it was the leader in the Arab world in granting full rights to women.

Tunisian dictator Zine El-Abidine Ben Ali, who fled to Saudi Arabia on Jan. 14, 2011, at the start of the Arab Spring uprisings, used to boast that his national airline was the only one in the Arab world with a woman pilot. Tunisian women were also among the first Arab women to vote – although elections were rigged for many decades. They also had abortion rights and proportionately more seats in parliament than do French women. Tunisia also bans polygamy. And women had the highest literacy rate in the Arab world.

Some of this is beginning to change as the Islamist Ennahda party came to power in 2012 and Islamist extremists have sought to censor media and films and enforce religious rules on a liberal populace. Islamist groups have shouted at women to return to the kitchen where they belong and also demanded that all women wear the veil. They have hounded some female professors off of university campuses.

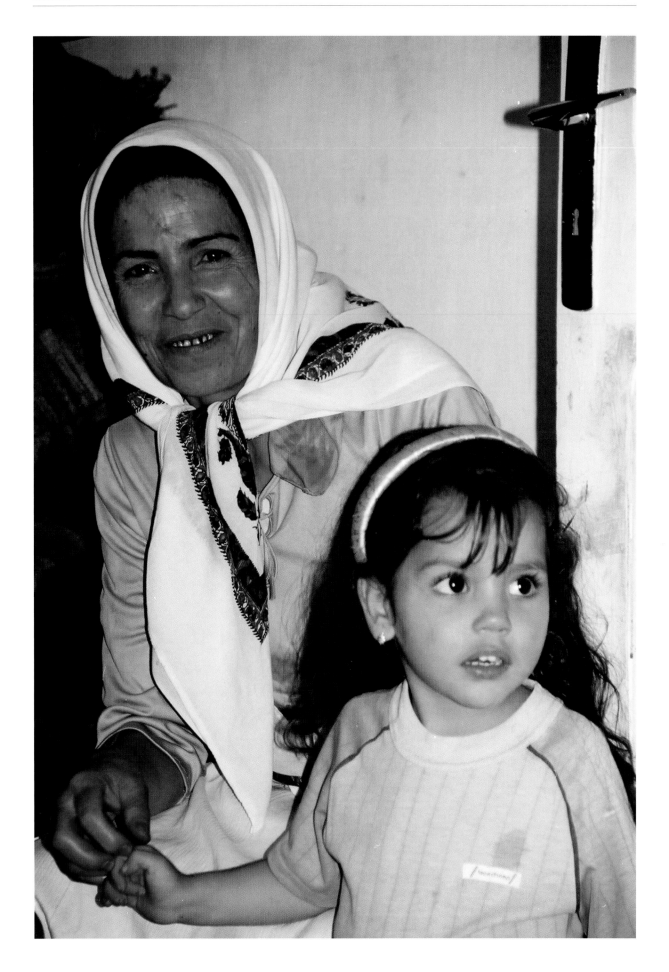

74.
Cuban
Coffee

This old man holding a tiny cup of extremely powerful Cuban coffee was standing at the window of a coffee bar on Calle Ocho – Eighth Street in Miami — heart of the million-strong Cuban-American community.

You might think that small hit of coffee in the thimble-sized cup would be too little to have any effect. But it gives such a jolt that afterwards my hands would tremble.

When I covered demonstrations, shootouts, robberies and other events for USA TODAY, and I hung out with the cops, they would send one guy out for coffee. He came back with a single Styrofoam cup of black caffeine-rich Cuban coffee and a half dozen little cups like the one in this photo.

To avoid the jitters, I used to order instead a cortadito which has milk and tastes like the café crème I used to order when I lived in Paris.

This man's weathered face reveals he surely was born in Cuba long before the Castro revolution in 1959 sent waves of refugees heading for South Florida. At first it was the professional classes, fleeing socialism and repression. Twenty years later when I moved to Miami, it was chock-a-block with Cuban pharmacists, doctors, dentists, merchants, land owners, journalists, judges, police officers and other professionals. Many of them never were able to learn enough English to practice law, medicine, accounting and other highly skilled professions. But they were sure to push their children to achieve high levels in society – not mere doctors but specialists.

Later, in 1980, a second wave of refugees came to Miami in small boats in the Mariel boatlift – but this time Castro dealt a subtle blow at his hated bourgeois enemies in Miami. He unleashed thousands of criminals from the jails and insisted that boats sent from Miami for middle and upper class uncles and aunts first load up with lower class murderers and thieves. These criminals – many of them dark skinned – unleashed a crime wave in South Florida immortalized in the Scarface movie and the Miami Vice television series.

They also tarnished the image the Cuban-Americans had of being a cut above – In terms of income and education – immigrants from Mexico and Central America.

Every time I return to Miami I visit Calle Ocho, if not for coffee then for fried bananas, tongue, yucca, plantains and the rice and beans they call Moros y Christos which stands for Moors (dark beans) and Christians (white rice). It's not just Osama bin Laden who remembered that for hundreds of years before the 1400s, Spain was ruled by the Muslim Moors.

Ironically, although Castro did win total control of Cuba in part by ridding his island of the middle and upper classes, in Miami the refugees became kingmakers. Their votes determined which way Florida's huge bloc of electoral votes would go. This meant that they were able to lobby every U.S. administration – Republicans and Democrats – to assure the embargo on Cuba remained in place for the past 50 years.

Today there are 1,240,000 Cuban-Americans with the lion's share – 820,000 – living in Miami. In the 1960s, when they arrived, they were assisted by the Catholic Church as well as the U.S. Cuban Adjustment Act and Cuban Refugee Program which delivered $1.3 billion in aid. Some of it enabled Cubans to start small businesses where even those who spoke no English might find work. They also were eligible for public assistance, Medicare, free English courses, scholarships and low interest student loans.

Before 1980, all Cubans were eligible for political refugee status and aid whether they were discovered at sea or crossed the border from Mexico. Since then, only those who reach U.S. soil are accepted as refugees. And 20,000 come legally as immigrants.

75.
Kashmir
Motor-
Rickshaw
Driver

This Kashmiri rickshaw driver struck such a proud pose when I asked to shoot his photo that it came to symbolize much more than a single young man and his rickshaw.

First it showed the power that comes to those who adapt new technologies. No more bicycle-rickshaw for him. No more sweating as he pedals around Srinagar, the capital of Indian-held portions of Kashmir. No more horse carriage either, maintaining a smelly, sweaty animal needing food and cleaning so it can haul passenger and freight.

He's the man of the hour these days. With the small 150 cc engine suitable for a Vespa motor scooter, he's able to tool around town, out to the airport, past the suburbs and into the hills at about 25 miles per hour.

He's also a symbol of the failure of a decade of guerrilla warfare – sponsored by neighboring Pakistan – to undermine the will to live, work and be happy and proud. Some 60,000 people died since 1990 when Pakistan urged Islamist jihadi fighters to try and bleed India and win by force control over Kashmir.

These fighters, many of them seasoned by fighting the Soviet army in Afghanistan and inspired by the belief that Islam had triumphed over the communist empire, now were told they could also defeat giant India.

Pakistani-supported groups such as Hizbul Mujahideen and Lashkar-i-Taiyba sent a steady stream of trained and indoctrinated killers over the mountainous border where they rapidly drove out all 200,000 Hindu Kashmiris. India sent in 500,000 troops to fight the jihadis. But thousands of innocent civilians were killed because they refused to join the jihadis, were caught in firefights or were suspected of working for the rebels.

By the time I got there in 1999, people told me they did not want to join Pakistan and wanted independence.

This young man seemed to stand for those who simply wanted to advance, earn a good living and play a useful role in society.

Now if only he and other motor-rickshaw drivers can figure out how to replace their polluting two-stroke engines which burn oil with the gasoline and leave a blue cloud of pollution behind them wherever they go. Efficient, four stroke engines would clear the air.

About four million people live in Indian-controlled Kashmir. Another 2.4 million live in Pakistan-controlled portion of Kashmir called Azad Kashmir. Both populations are over 95 percent Muslim.

The Vale of Kashmir, as the valley was called, had long been a cool resting place for British colonial families and tourists seeking to escape the torrid heat of the summer in the plains of India. But since the anti-Indian fighting began, the houseboats on Lake Dal remain empty of the tourists from India and elsewhere.

The streets of Srinagar were marked by Indian soldiers on patrol, looking very uncomfortable and fearful. At major intersections they stayed inside bunkers made of earth, tarps, wire and wood, as if they were out camping in the middle of a city. But trucks loaded with apples, pears and other fruits still headed south into India's plains.

photo on following page

76.
Haitian Street Music

Did the people around him since he was a child tell him his music came from God?

There was no school to take him in and teach him composition and piano and violin. No way for an illiterate man from the country to step up from that sidewalk.

This photo shows another musician playing on home-made percussion boxes and cans in Port au Prince. He was good. But the one I heard that evening long ago was a voice direct from the spheres, from the inner heart of mankind. It might have been too dark to shoot his photo. Or I may not have had the camera with me. But it's also possible his music was so powerful it drove out of my mind all thought of preserving his image for posterity.

When you hear such music, listen. You may live 50 more years and never hear it again.

I was walking at sunset along a busy street in Port au Prince, Haiti some years ago, baffled by the crowds and blinded by the dust rising from thousands of feet and thrown up by passing buses, overloaded till they tilted over so far their fenders scraped the ground at every pothole.

Then I heard this strange music. A rhythmic tap tap tapping and a humming and almost human twanging.

That's when I looked down and saw on the sidewalk by the busiest intersection possibly in all of Haiti was a small man playing music on a bunch of empty tins and cigar boxes – some of them wrapped together with rubber bands.

Using a couple of bamboo sticks to strike the boxes and the rubber bands, the man was making music. MUSIC. Music from the soul, from the heart and from the inner mind.

About 20 people had stopped and we didn't look at him for fear we'd be shamed into forking over some money. But the traffic light changed and then changed again and still we stood there, looking off into the dying orange glow of the sunset through the dusty haze, and hoping this music would never end.

How was it this Mozart, this Johnny Cash, this Beethoven was born so poor he had to make his own instrument from trash? How was it he knew he could move people with his sounds? Did he turn down a family farm on the rough hillsides somewhere inland or some other work because he felt an inner calling?

77.
Kashmiri
Children
Cooking

Why are these children so beautiful and why are their smiles so brilliant and moving?

By all American standards, they should be miserable. They are cooking chepatis, unleavened bread, over an open fire set between three stones.

Instead of feeling miserable at not having all the conveniences they lack – refrigerator, running water, pantry full of foods, clean dishes and silverware, dish soap, gas or electric cook stove – they are simply beautiful as they prepare their meal.

Are they homeless people fleeing the guerrilla war in the village? Have their parents been killed in the war? Are they simply waiting while their father works on a construction site?

Why are they there?

Next time I return to Srinagar I will ask. And since these children will by now be grown and possibly have their own families, I will ask whatever children I find living or cooking on the sidewalk. Of one thing I am sure. There will always be such children in India.

India has the world's largest number of street children – UNICEF estimates them to total 11 million but others say it is as high as 18 million. Egypt, Pakistan and Kenya follow in the numbers of homeless children. Worldwide, homeless or street children have been estimated by UNICEF to be 100 million. But really firm numbers are impossible to obtain.

A study in 2007 reported that 65 percent of homeless children in India lived with their parents on sidewalks, under bridges and in other public sites.

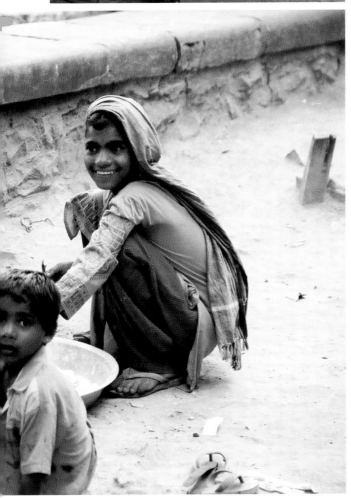

78.
Guarding
Gate to the
Mosque

The two men sitting on either side of the mosque gate are not happy to see a foreigner, especially one with a camera.

These men are squeezed.

This is one of the oldest mosques in the Kashmiri capital Srinagar. But while it had been for many years a welcoming place for worshippers as well as visitors, these days it is a pressure point in what some are calling "the long war" against Islamist terrorism.

On the one hand the Kashmiri Muslims have long been moderates – the women are not veiled and can work outside the family compound. The majority Muslims also had good relations for centuries with a large Hindu minority – the Pandits.

And when thousands of British colonial families came up each summer to escape the heat in the plains, they were safe and welcome.

But now that Pakistan has trained, funded and unleashed thousands of Islamist fighters across the border, the Pandits have fled to safer parts of India and few tourists venture into Kashmir.

In addition, the shadow of conflict has fallen on every individual. Just as George W. Bush asked after 9/11, every Kashmiri is asked by militants and Indians: "are you with us or against us?"

The wrong answer could cost you your life.

When I asked these guys for their opinion of the conflict, they simply waved me off. And I sympathize.

If they tell me they approve of the struggle against Indian troops, the Indian security forces are likely to pay them a visit and perhaps even incarcerate them in highly unpleasant – if not inhumane – circumstances.

But if they say they are against the Islamist militants, denouncing them as the source of violence and division and terror, guess who will soon be visiting their homes? The terrorists.

And even if you could explain to them in a credible manner that you would not use their names in print, the very fact they are seen talking to a foreign or a local reporter means both sides could suspect them.

So I walk on by, shoot a quick photo, and hope that one day wisdom and compassion will replace the bitter hatred of our time.

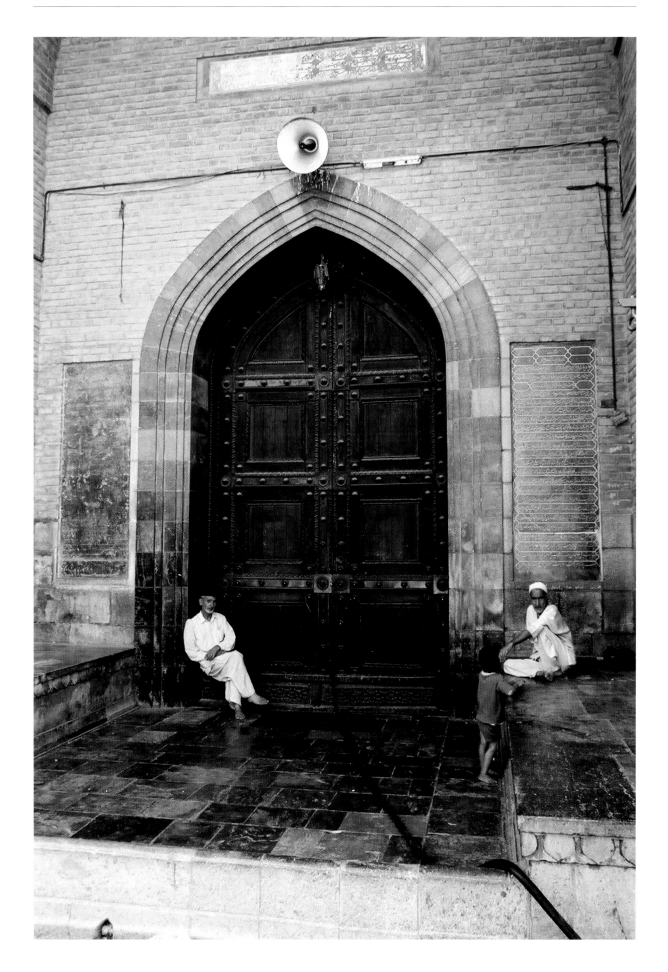

78.1
Kashmir Police – Running Scared

I was riding in a taxi when I noticed the man with a gun in the truck in front of me.

The painted letters stand for Jamu Kashmir Police.

Kashmir's capital city Srinagar was a tinderbox at the time. Gunfights and bombs went off every few days. Tens of thousands of Indian troops were making house to house searches looking for jihadi guerrilla fighters. They would gather in a square as people hurried out of their way. Then they cordoned off a block of housing and shops, searching every room for weapons and suspects.

I'd noted previously that the Indian soldiers looked uncomfortable and scared. They knew that the local people did not want them there and were afraid of them. Some human rights groups had reported that the Indians had killed suspects without trials. One detainee with the Islamic militant group Hizbul Mujahideen told me in a jailhouse interview that he had been tortured. His wrists and ankles were covered with red welts. So being a solider or a policeman was to be a target.

The man with the gun was inside an armored vehicle, holding the door open just enough so he could observe and, if necessary, fire his weapon. But he was protected from being picked off by the heavy metal doors.

This defensive stance in the midst of downtown traffic showed a lack of confidence and a recognition of the ever-present danger posed by the Islamist rebels.

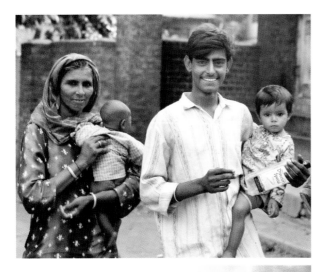

78.2 Simple Joy in a Troubled Kashmir

This smiling family in Srinagar, the war-torn capital of Kashmir, was perfectly happy to let me take their photo. You never know what troubles they may have at home. But here for the moment they were together and safe, dressed up nicely, perhaps on a visit to relatives or for shopping in the market.

When I look at their faces I ask myself how they can display such radiant happiness. They cannot have the wealth of the average American or European. Their city is patrolled by Indian troops ensconced behind sandbags and wire bunkers thrown up in the center of major streets and squares.

Years ago I had studied Yoga and mysticism from teachers who loved to restate the old saw: "You Westerners are never happy because you never satisfied and always want more than you have. But in the East, we have learned to be satisfied with whatever we have."

The smiles on this Kashmiri family seemed to prove that.

79.
Hmong Boy Feeds His Buffalo

I was walking along a dirt path in a Hmong village in central Laos when I came across this boy feeding his buffalo. Despite the bloody history of the Vietnam War – this region was the most heavily bombed place since World War II – the children I met seemed universally happy, friendly and undaunted. They made their tasks seem like play. And it is always impressive to see someone half my size stand without fear or uncertainty next to a huge animal such as a buffalo capable of doing terrible damage but also terrific labor in the fields.

Small tractors have replaced the buffalo in many parts of neighboring Thailand. But Laos remained poor and undeveloped. There was a symbiosis – the buffalo needed that boy to provide fresh green fodder; and the boy's family needed the buffalo to till the soil.

Would that all labor was accomplished with such brilliant smiles.

79.1 Smiling Laotian Girl Carries Firewood

This girl in the central Laos highlands is hauling a load of firewood, not the school books and computer most girls her age in America would carry in their backpacks.

Yet her smile is so lovely and brilliant, her posture is one of good cheer and enthusiasm. Maybe she is thinking that this wood will help her mother cook their dinner and warm her family in the cool night?

She hauls the wood on a wooden frame similar to the aluminum frames we buy in U.S. stores to carry sleeping bags and tents when we go camping. Once again it seems that life in the Third World resembles a return to the summer camp of our youth. And we who live in posh America with our cars, electricity and air conditioning have to seek out the physical exercise, hiking, bike riding and diets that are facts of life in the Third World.

But of course one also thinks that this girl should be in school. And we hope she is.

Yet when I see her shoes, obviously meant for someone with much larger feet, I wonder if her family has enough money to let their daughter study instead of working.

The UN Children's Fund UNICEF estimates that 158 million children aged 5-14 are engaged in child labor. That is one sixth of the world's children in that age group. Many work in mines and other unsafe occupations or as servants behind closed doors where they may be treated as little more than slaves. Those who work 28 or more hours per week in domestic work at home, such as this girl appears to be doing, are considered child laborers as well.

80.
Children of
the Dust

This woman is one of 25,000 AmerAsian children left behind in Vietnam after their American soldier fathers returned home at the end of the war.

She holds her own baby — who has a Vietnamese father and is therefore one quarter American. The child holds a photo of her American grandfather in his military uniform together with her grandmother.

Many of these children grew up in loving homes with their mothers and other relatives. I met one girl about 16 who was learning piano and lived in with educated middle class relatives. But many were rejected by Vietnamese society as being illegitimate offspring, or else simply impure racially – especially those with Black American fathers. They were called "children of the dust" and I met gangs of them hustling on Saigon's streets, looking for handouts and sometimes wanting to hang out with visitors from America.

By 1988, the United States was shamed into accepting all of the AmerAsian children – by then they were from 13 years old to their mid 20s—for settlement in the United States. And they were allowed to take with them close family members.

In the early 1990s, 25,000 Vietnamese AmerAsians came to the United States with about 50,000 of their relatives. A survey by Ohio State University showed that 76 percent wanted to meet their fathers in America but only 30 percent knew the names of the fathers.

And perhaps due to fear they might be held responsible for the care of their children, or fear to disrupt their current marriages and lives, only three percent of fathers actually made contact with their children, the Ohio State survey said.

Aid

JOYOUS SHOWER AMID WRECKAGE

This happy Indonesian child is doing what my children and millions of others do on a hot day when the sun is shining and schools are closed – getting cooled off under a stream of fresh water.

But in this case she is living proof of the resilience of the human spirit.

This is – or was — the town of Calang, on the west coast of Sumatra Island. Since the undersea quake that launched the Great Tsunami hit a few miles off this coast, it was probably the first place hit by the waves, which surged as high as 100 feet as they rushed against the nearby hills.

In the background you can see the ruins of the town strewn between the palm trees which were so thin the waters passed between them and left them intact.

The powerful Tsunami also reshaped the coastline, filling in channels once used for shipping and fishing, but cutting open new channels. Volunteers from Thailand took a sailboat along the damaged coastline in the weeks following the Tsunami, took fresh soundings to map all new channels and presented to the United Nations a report including brand new nautical charts to enable relief and reconstruction supplies to be delivered by boat.

In the far distance the sun shines on a tropical bay, a vision of tranquility that belies the Biblical scale of the disaster that hit a few weeks earlier.

Helicopters – the only way to reach the West coast after the roads were washed away – deliver food, water and even school books as aid groups moved to restart schools in steamy tents. But everyone has lost friends and relatives. It is the youngest ones, living in the moment, who seem to be ready to begin life once more.

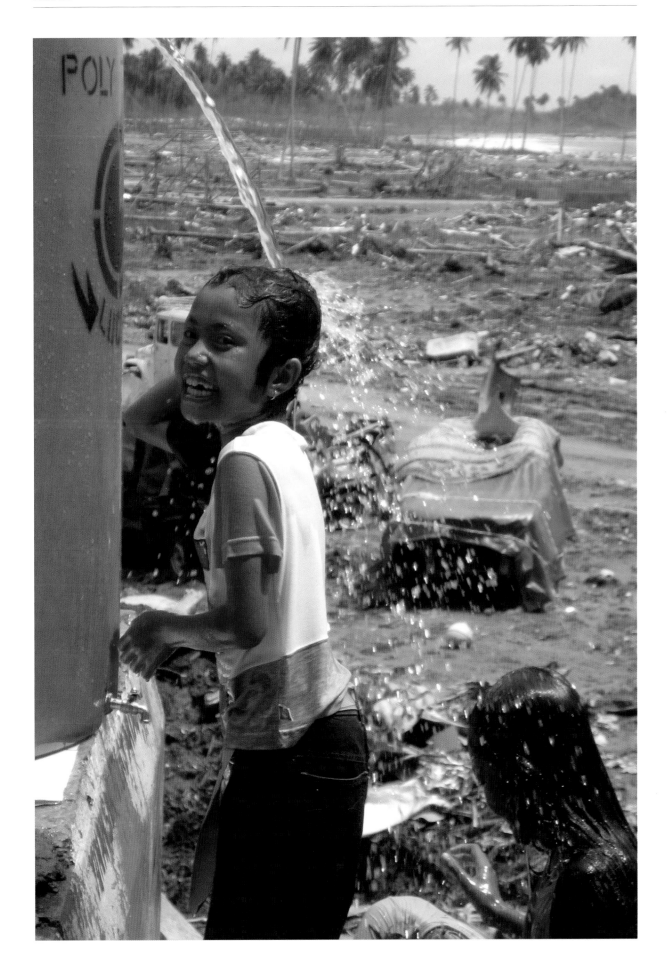

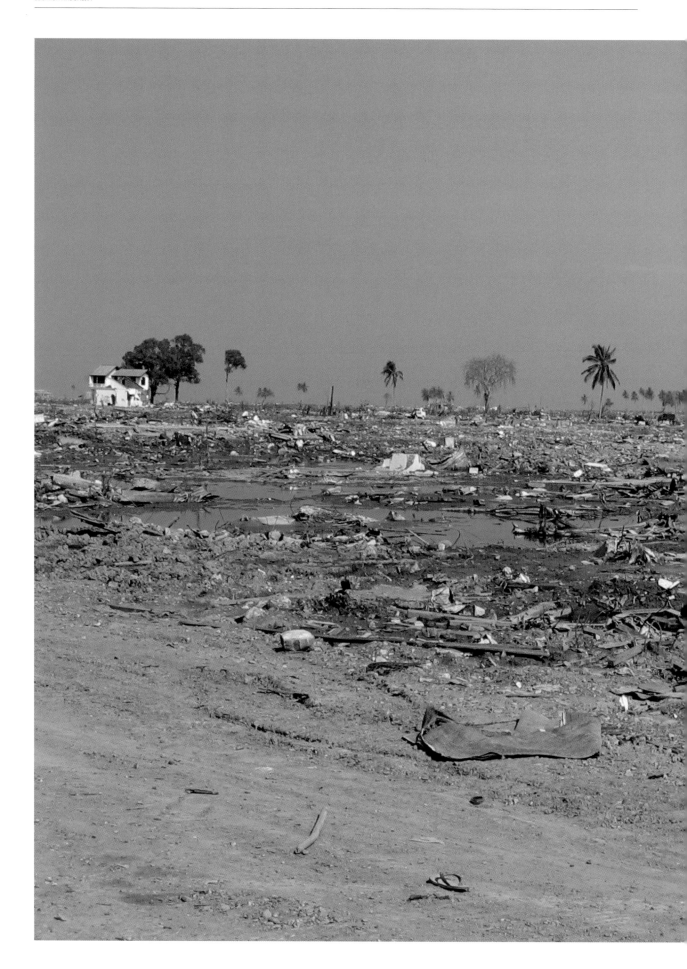

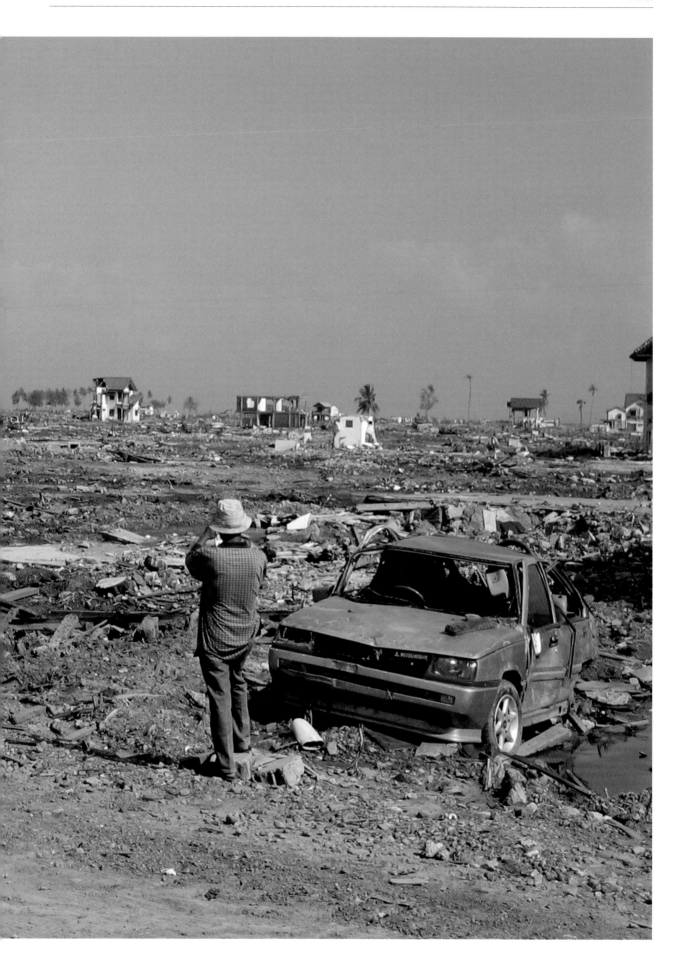

THIS WAS BANDA ACEH, A CITY OF 219,000

This was once an Indonesian city of 219,000 people until the Great Tsunami struck the day after Christmas, 2004.

A massive wall of water 30 feet high swept in from the beach, killing perhaps 150,000 people. When I arrived a few weeks later, Zainal Abidin, 49, told me how he ran for his life as the water chased behind him. "People were being sucked into the water and asking for help," he recalled. "I heard the sound of the houses sucked under the water. Half a minute later I couldn't see them."

He pointed out the cement floor that was all that remained of his house and his wife and children. And he wept. "That is the grave of my family," he said.

The Tsunami was spawned by the world's second largest recorded earthquake, measuring 9.3, which struck off the coast of Sumatra, Indonesia. The Tsunami swept across the Indian Ocean, killing 35,000 in Sri Lanka and thousands more in Thailand, India and even distant Somalia.

I saw the health workers pulling bodies from the splintered wreckage of the city – they were still finding 1,000 bodies every day.

This man walked to the swath of total destruction – running up to three miles inland – and took his photo of the wreckage.

Foreign aid was rushed to help. The captain of an American aircraft carrier, the Lincoln, had raced from Singapore to Aceh and his helicopters were flying food and clean water to isolated survivors; and flying the injured out to hospitals. The governments and world organizations pledged $6 billion in aid.

Survivors were collected in relief camps where psychologists trained teachers and camp leaders to recognize depression and other post traumatic stress disorders.

Scenes of the destruction were so graphic that they staggered the mind. For example, a huge barge with an electric generator on board was carried three miles inland by the water and dropped on top of houses full of people. The barge was so massive – standing 70 feet tall—that it seemed impossible to imagine getting it back to the sea once more.

One benefit from the Tsunami: A long separatist conflict in Aceh between army troops and Islamic rebels was ended peacefully. Both sides laid down their weapons and fair elections took place. The winners were the former rebels in the Free Aceh Movement.

Within hours of the Tsunami, the U.S. Agency for International Development (USAID) began sending food, water, plastic sheeting and medicine, according to an April, 2005 USAID report: "Tsunami Relief." The swift response by U.S. and other aid groups prevented outbreaks of disease among the one million people left homeless in Indonesia, Sri Lanka, India, Thailand and Somalia.

Aid groups hired thousands of local people to shovel away mud, clean streets, remove wreckage and get public services running.

Clean water produced by desalination plants on U.S. warships was flown into relief camps. Trained psychiatric counselors from several countries worked with Indonesian Ministry of Health psychiatrists and Muslim clerics to help counsel thousands of orphans and grieving, terrified children.

photo on previous page

5 MILLION AFGHANS JOIN WORLD'S LARGEST REFUGEE RETURN

They came up from the steamy lowlands of Pakistan where they had lived in mud-walled refugee camps for up to 20 years.

Millions of them came, riding high in the painted trucks hauling their children and their goats, their clothing and the roof beams of their refugee huts.

The trucks rolled with a jangling noise as they entered the UN compound in Kabul, a Biblical exodus of an entire people. Children yelled and mothers herded them into the lines for vaccinations and training on land mine recognition.

Finally each family head got $100 plus a small amount more for each child; bags of rice, flour, sugar and salt; and cash to pay off the truckers, waiting with their engine running to complete the epic journey.

Soon they yelled goodbye to their fellow refugees on other trucks and headed off in a cloud of dust towards their distant villages.

The UN High Commissioner for Refugees said it helped 3.69 million Afghan refugees return home, calling it "the largest assisted return operation in its history."

Another 1.1 million returned on their own, without UN help.

After the Soviet Union invaded in 1979, 5 million Afghans fled to Pakistan and 2 million to Iran. In 1989 the Russians left and the mujahideen fighters turned on each other in a bloody civil war that ended in 1996 when Pakistan helped the religious students known as Taliban seize power.

Still the refugees waited. They started small businesses and looked for work in Karachi and other cities. They drove taxis and trucks, they wove carpets and worked at many jobs. But they remained Afghans, foreigners. Pakistan was generous and never forced them to remain in fenced in camps like Palestinian refugees in Lebanon and Cambodians in Thailand. And UN assistance gave them food, clinics and education.

But when the Americans drove out the Taliban in 2002, the Afghans decided to finally go home. First they sent one family member to determine if it was safe and whether their house and land were still there. Then the rest of the family followed.

Although this was the largest voluntary return of refugees in UN history – perhaps in world history – newspapers ignored it. This was a good news story. Boring. Even the New York Times ran an article about 50,000 refugees in tents in Kabul who "might" face hunger and cold in winter. The Times said in paragraph eight or nine that the Afghans were part of a wave of 2 million returning refugees and then went back to speculating on those in tents. But it failed to say what happened to the other 1,950,000 returning refugees.

I asked my fellow reporters to write about this mass return. And no one did. Bad news is news. Good news is boring. Or so the editors think.

The United Nations High Commissioner for Refugees (UNHCR) has helped 3.69 million Afghan refugees return to Afghanistan since March 2002, marking the largest assisted return operation in its history," according to a January, 2007 report by the U.S. Congressional Research Service – Afghan Refugees: Current Status and Future Prospects.

"In addition, more than 1.11 million refugees have returned to Afghanistan without availing themselves of UNHCR's assistance, bringing the total number of returnees to at least 4.8 million. Despite the massive returns, possibly 3.5 million registered and unregistered Afghans still remain in these two countries of asylum — up to 2.46 million in Pakistan and more than 900,000 in Iran — making Afghans the second-largest refugee population in the world.

"These numbers are far greater than the initial working assumption in 2002 of 3.5 million refugees; in fact, the total is believed to be more than 8 million. The United States spent approximately $332.37 million between FY 2002 and FY 2005 on humanitarian assistance to Afghan refugees and returnees..."

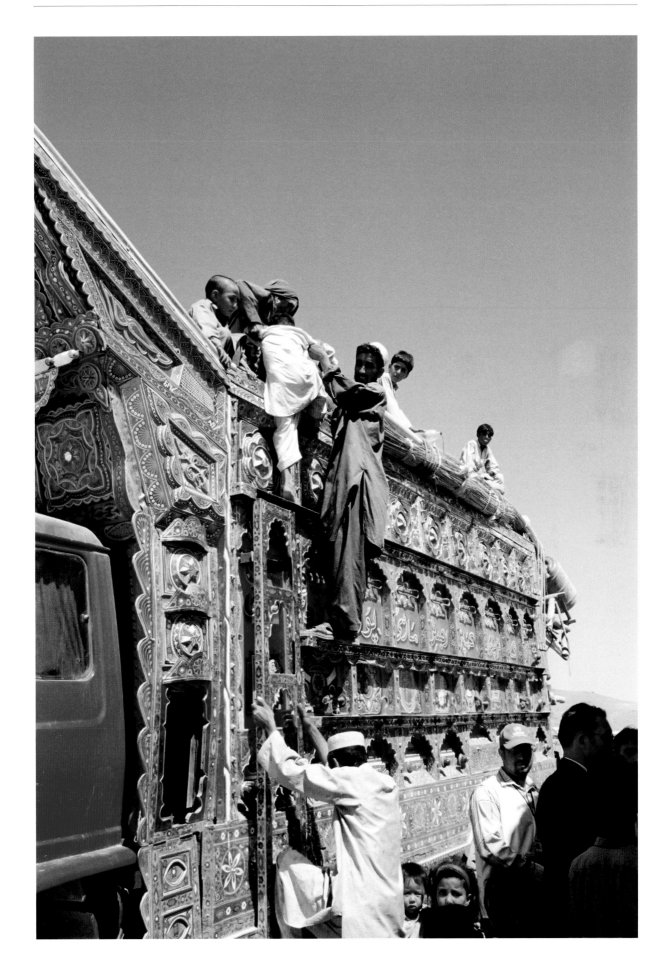

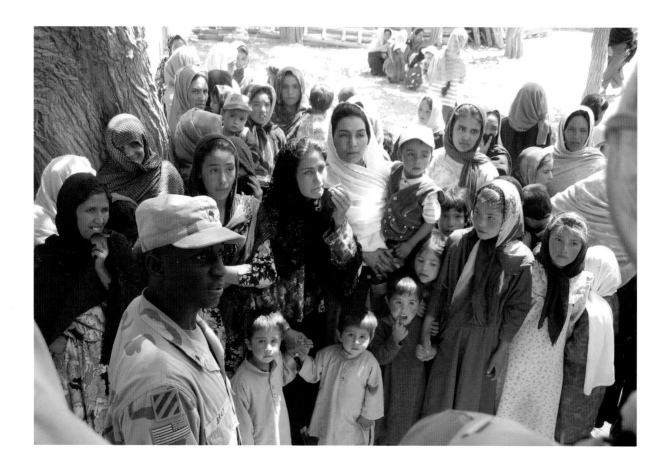

AFGHAN WOMEN WAIT TO SEE DOCTOR

These Afghan women in Tormay, a village outside Ghazni City south of Kabul, waited anxiously as the day went by. They had come with their children to be seen by the U.S. military doctors who set up an all day clinic in a girls' high school.

I rode out that morning with the doctors in a dozen armored vehicles as they left the fortified compound they call the Provincial Reconstruction Team – a desert outpost with about 100 soldiers, three civilian aid workers and plenty of radios to call for air support if a heavy attack by the Taliban was underway. It was one of about 25 PRTs across Afghanistan.

These women are mainly ethnic Hazaras who form about 20 percent of the Afghan population. They do not require their women to wear the all encom- passing burka or be shut up in the home compound, like the Pashtus.

When we got to the village, Army Col. Steve Jones, a heart surgeon from Ft. Campbell, Kentucky told the elders he wanted to set up a day-long free clinic. The elders offered use of a school which was closed due to summer vacation. They also sent out riders on motor- bikes to tell adjacent villages about the free clinic.

With a translator for each doctor, the patients were rapidly assessed and given medication if needed. Women were treated by female medical personnel and lined up on a separate side of the building.

Some 800 patients were seen that day with everything from high blood pressure to infections to intestinal problems. Some difficult cases were referred to the hospital in Ghazni.

The great thing about this clinic is that so many people got medical care. The problem is there were no x-rays, no blood tests and no follow up.

Was this only an effort to win hearts and minds? If so — so what? Many men, women and children got help reducing their pain and suffering and improving their health.

Other U.S. aid programs built 600 clinics across the country, providing daily access to care for millions.

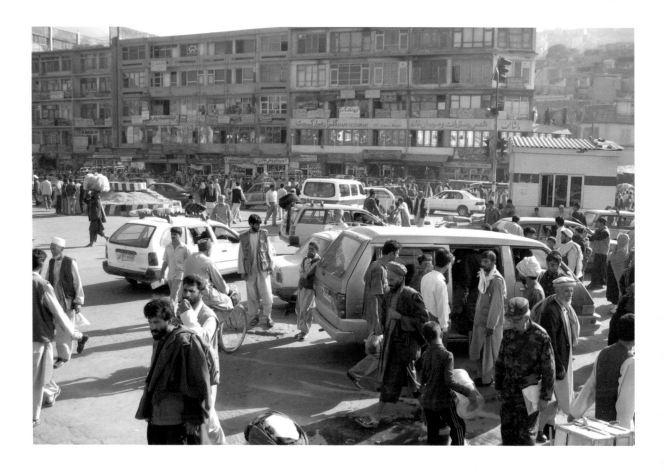

CENTER OF KABUL AT NOON

The bustling, seemingly-chaotic scene here is the daily downtown hodge-podge at the center of Afghan economic life.

A boy pours clean water from a plastic jug. A man tries to entice passengers into a mini-van. One man balances on his head his goods wrapped in a cloth while others board yellow taxis.

Some men wear traditional Afghan hats: the flat, rolled wool pakul hat, turbans, small caps and the lambskin hats President Karzai favors. They also wear the thin wool blanket over one shoulder, the vest they call "waistcoat," and the knee-length cotton shirt. Others wear western-style trousers and shirts.

There are very few women on the streets.

On the left above the cement office building rises one of the huge mountains that ring the city. On the right climb new housing settlements built as the population rose from one million to five million after the end of Taliban rule.

On the far side of this open square are restaurants, guest houses, pharmacies, lawyers and other commercial activity.

There are no guns to be seen.

In 2010, six years after this photo was taken, I would return to Kabul and find the city in the middle of a building boom. Every street had a hardware store selling cement bags, hammers, saws, levels, nails and other building equipment. Every few yards I'd run into piles of sand and stone on the sidewalks as homeowners built extra rooms. And all around the city rose new blocks of apartments and offices, or giant wedding halls.

Yet the only thing one sees in American newspapers or on television are explosions and war in Afghanistan.

Well, on the ground the truth was quite different. The people with money in Kabul were voting with their cement and sand that the country will not descend into war again.

But that was not a story that a reporter could even pitch to an editor. When five million people have really dug into the earth itself, to rebuild an ancient nation, that's not news. But when a single motorcycle bomber blows himself up at a clinic – that's what they want to put in the paper.

THEIR CHILDREN SHALL TEACH THEM

Shogla, 19, teaches former mujahideen fighters more than twice her age how to use computers.

In a country where women have long been kept ignorant and excluded from the ranks of power, she treated these elderly ex-fighters like small boys.

"Mohammad, have you not been able to underline the Dari script and make it larger as asked?" she told one student.

Embarrassed, the grey-bearded man humbly admits before his classmates that he's been unable to complete the assignment.

"Who can show him how to do this?" she prods the class. Several men shoot up their hands and she assigns one of them to assist the stymied ex-fighter.

The men told me that all the years of fighting brought only death and destruction to Afghanistan. They fought the Soviets, they fought each other and they fought the Taliban.

Now, with thousands of U.S. and NATO troops stopping the fighting in Kabul and most of the rest of the country – aside from intermittent terrorist-like attacks – they need to retool.

This U.S. program is teaching them how to use the computer, write and edit documents in Dari, Pashtu or English, surf the Internet in Dari and Pashtu, and prepare for jobs in the peace-time economy.

The aid program is part of what aid experts call DDR – Disarmament, Demobilization and Reintegration. Under Disarmament, thousands of light and heavy weapons were handed over to UN forces. Under Demobilization, about 60,000 ex-fighters left their mujahideen groups to return home. And under Reintegration thousands of them were taught carpentry, metal work, mechanics, construction and other skills to reintegrate into the economy. Without such skills they may once more resort to force to earn money and intimidate competitors.

What was most striking to me was to see that these older ex-fighters – who for years ruled by force and kept women locked away as chattel or second-class citizens – were now at the mercy of a young woman endowed with the ultimate tools for modern life – education and computer skills.

In 2012, according to the CIA World Fact Book, 43 percent of Afghan boys and men can read; but only 12 percent of girls and women were literate.

CROSSING THE AFGHAN DESERT

Getting out of the village in Ghazni province after 10 hours of holding a free medical clinic was not as easy as driving in that day.

We'd rolled through Ghazni City that morning, a dozen armored jeeps and Humvees with machine gunners standing up in the roof turrets, creating a lot of attention. Any bad guys would have surely taken note and even sent someone off on a motorbike to follow us to the village of Tormay.

So returning back down the same road was out of the question. It could have been mined or an ambush set up. Instead, we snaked a path between the village houses and backyards into the desert, and headed back to the base across flint rock shoulders cut by trails and rocky roads.

We rode strung out so that if one of us hit a mine – the army calls it an Improvised Explosive Device – it would not disable more than one vehicle.

We made it back to the Provincial Reconstruction Team compound by dusk. The next day I rode with the medical team on a Chinook helicopter to Bagram Air Base near Kabul. We sat along the walls of the chopper and boxes of rockets and bullets filled the center aisle. We flew low to the ground at maybe 500 or 1,000 feet altitude. That way, people on the ground barely got to see us before we flew over them and were gone. There was no chance for them to try and shoot at us.

The medical team would go out in a few days to some other village to treat hundreds more people.

LISTENING FOR PNEUMONIA

The clinic was just a stone and timber room with tin roof and mud stucco walls crumbling at the corners. A tin wood stove in the center threw off bright waves of warmth so long as the fuel lasted. Against one wall was a sheet of plastic to keep the dust away from the examination bench.

This health care worker is examining a small boy brought in by his completely-veiled mother. She is using her stethoscope to listen for congestion in the boy's lungs.

She explained that she is able to treat many major illnesses in the small clinic – she had a powerful collection of antibiotics, pain killers, antiseptics and other medication in a locker. The medication and treatment are provided to patients free of change under a U.S. funded aid program.

"Many children die of pneumonia," I said. "How will you know if the child has it?"

"The rate of breathing goes up," she said. "When the child – even at rest – is breathing very rapidly, it indicates pneumonia."

With a powerful dose of antibiotics, she has a good chance to cure pneumonia. In some cases, she sends very sick patients, or those with illnesses she cannot identify, to the district hospital a few kilometers away where there are advanced diagnostic tools such as blood tests and x-rays.

Thirty yards from the clinic is a brand new clinic nearing completion that will replace the current one. It is one of 600 built with U.S. aid funds since the end of Taliban rule. The new clinic has six examination rooms, each with sanitary tiled floors and walls, electric lights, sinks, running water and a vented wood stove.

The Americanaid health program has cut the infant mortality rate, saving 85,000 children per year according to a study by the Johns Hopkins School of Public Health. Before the U.S. began, only 15 percent of Afghans had access to medical care. Now 85 percent of Afghans do.

However in winter, with deep snow on the ground, access to health care remains limited for the majority of Afghans living in remote villages.

MAN PLANING WOOD

These men in the northern city of Mazar-i-Sharif are learning carpentry. They use an ancient wood block plane that was replaced by metal planes about 200 years ago in the west. The classes are part of a U.S. aid program that helps former combatants learn a useful and peaceful trade.

Teaching the carpentry, weaving, tailoring, metal work and literacy helps them to prepare to find jobs in the new economy after the fighting ends. It's better than having them go back to the use of weapons to get food and money for their families. The program even advances them small sums of cash and provides bicycles so they can get to the training classes.

One man whose name is Mirwais (many Afghans use only one name) was learning to read. "I am done with fighting," he told me. "I personally could not find any benefit from the fighting except looting and destruction. I fought for 12 years. Most of my friends disappeared."

photo on following page

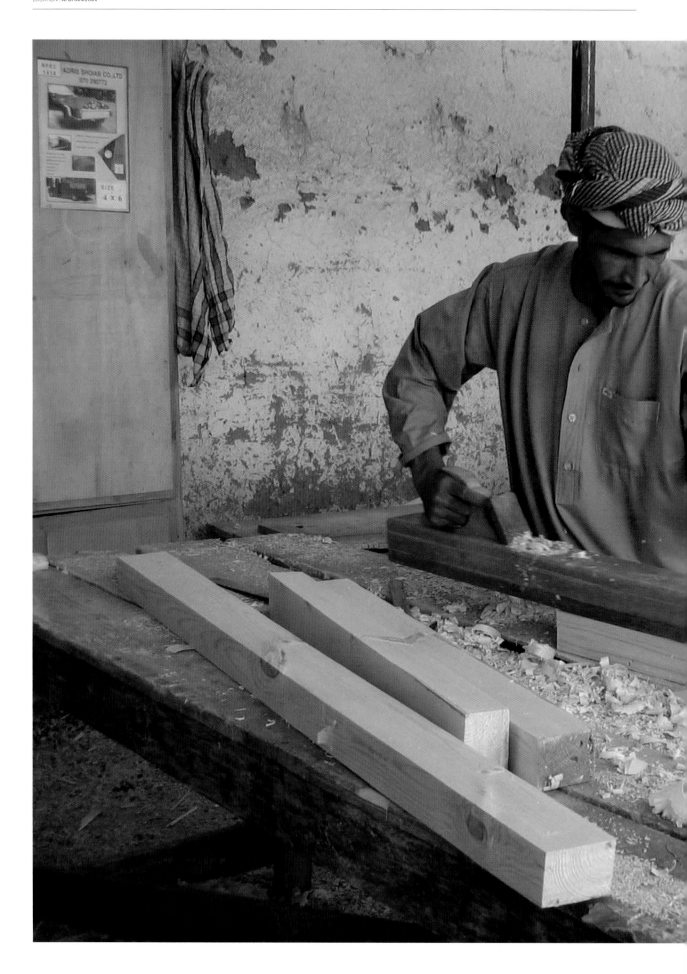

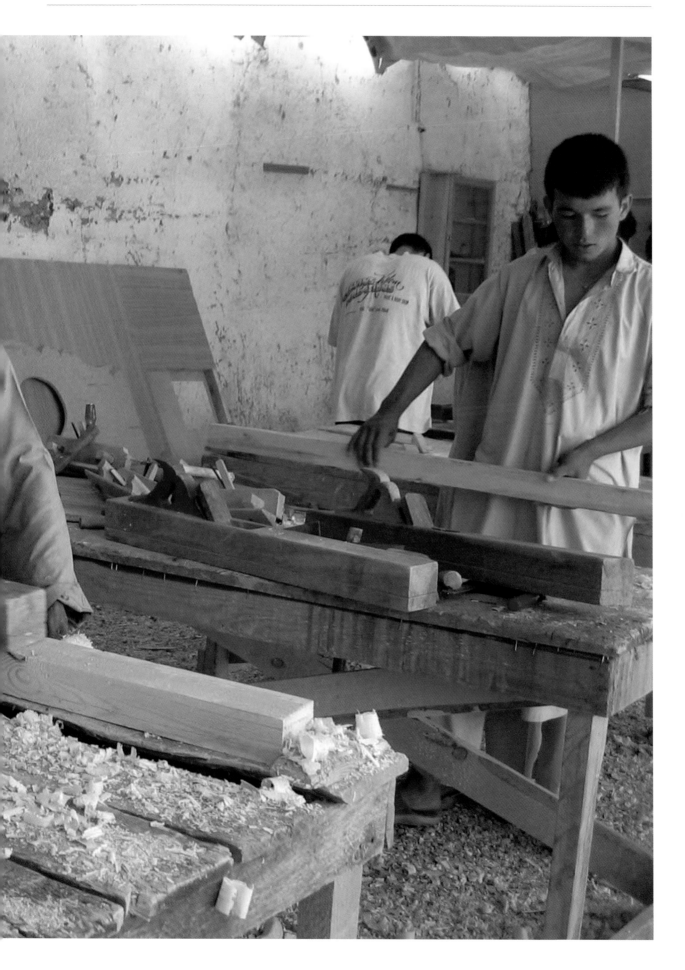

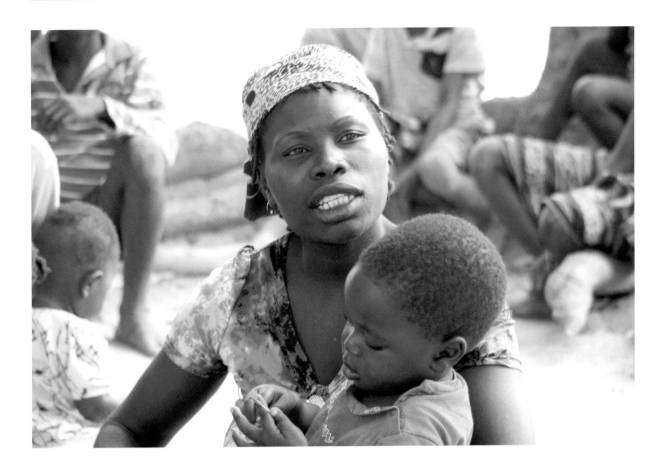

SHE WALKS 12 KM EACH DAY FOR WATER

This woman in the northern Mozambique village of Ampivini near Nampula is filled with indignation. And strength.

While tourist cars and buses speed down the paved road next to the village, heading for the coral reefs and beaches of the Indian Ocean coast, her village has no clean water to drink. She sends a child running off to bring me a glass of murky, slimy water which is all they can draw from the exhausted, polluted village well. It's not even good to wash clothes.

"Where do you get drinking and washing water?" I asked.

"Six kilometers from here," she asserts.

I could not believe it. We had just eaten sandwiches with bottled sodas at a small cafe on the main road, perhaps 100 yards from the village courtyard where the woman told her story.

"Will you take us to see this water?" I asked.

We brought her plus her plastic water container in our jeep and I noted the odometer reading. Sure enough, after 30 minutes churning across sandy paths among scattered houses we reached a cement tube well. We'd gone six kilometers.

And she would have to walk back home each day another six kilometers carrying a jug that weighed perhaps 50 pounds. We gave her a ride home that day.

The long walk for water is draining the energy of African and other women – it is mainly women who carry water. What is most discouraging is that her village is right on a main road. It would be so easy for a tank truck to deliver water a couple of times a week to people living along that asphalt road. Mozambique has vast resources and recently signed a multi-billion dollar deal with Brazilian multinational corporations to dig and export coal. But little of that money trickles down to this village.

The one hope is in the children who show me their Portuguese language school books.

Mozambique snapshot:

There are only 600 doctors for 21 million people and most doctors live in the cities.

Some 85 percent of the country's arable land has not yet been farmed.

The country is twice the size of California and has 1,500 miles of Indian Ocean beaches.

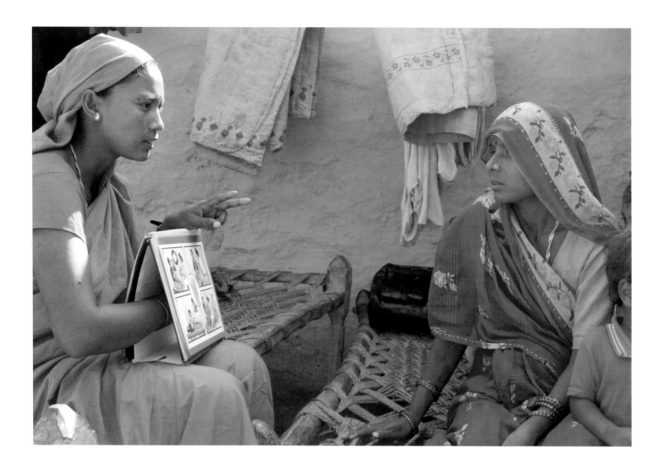

NEPALI HEALTH WORKER

Sarada Yadav is pregnant with her fifth child and watches intently as a volunteer health worker tells her about sanitation, health, and preparation for delivery.

Sita Yadav, one of 50,000 female health volunteers trained in Nepal by a U.S. aid program, turns the pages of a display book to show the pregnant woman how to assure a healthy delivery.

"She will need iron tablets at the sixth month. She needs antenatal checkups and a tetanus injection," said Sita. "We talk about food, bathing, rest, and keeping away from all alcohol. I tell her about danger signs— headaches, convulsion, lower abdominal pain."

She also advises Sarada to save a bit of money each month so she has enough for an ambulance to the hospital and blood donors if needed.

In case she waits too long to go there, and she goes into labor in her village, Kamdi, in Banke District, the volunteer shows her the safe delivery kit she will get. It has a sterile blade to cut the umbilical cord, sterile thread to tie the cord off, a plastic sheet to lie on, and soap. The pages she turns show pictures of all these activities— many women in the village cannot read.

The volunteer also talks about spacing of births through birth control.

Sita Yadav has been a volunteer for eight years, getting only 100 rupees (less than U.S. $2) per month from the local government. She covers 90 households in this agricultural village where buffalo carts and flocks of goats compete with bicycles and horse carts in the dusty lanes.

Since 1951 the United States has given more than $1 billion in aid to Nepal, helping fight malaria, improve health, train medical workers, build roads, improve agriculture, develop tourism and preserve its forests. This led to a doubling of life expectancy to 65. Nevertheless, Nepal remains one of the world's poorest nations – despite its breathtaking Himalayan views and thousands of Westerners who trek to Mt. Everest's flanks each year.

Sixty percent of Nepal's 28 million people earn less than $1.25 per day according to the World Bank. Some 40 percent of children are under weight.

In 2008, after several years of a communist insurgency, the 240-year old Hindu monarchy was dissolved and elections took place. However the new government has been paralyzed by disputes over what to do with several thousand communist rebels living in UN- supervised camps.

Thousands of Nepalese escape poverty by seeking jobs in India as well as in Britain and Persian Gulf countries.

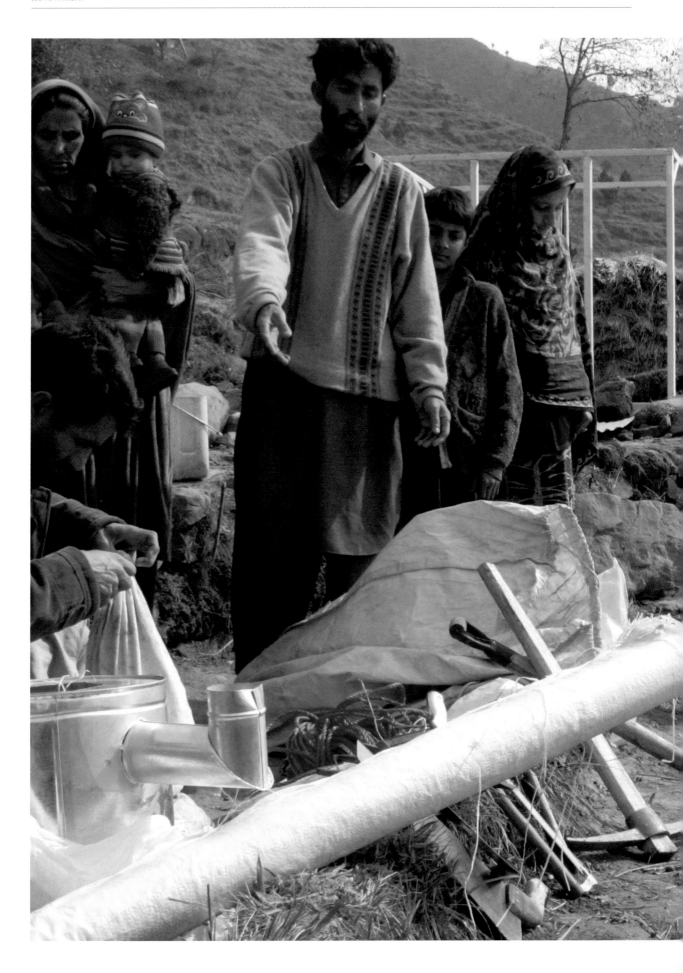

REBUILDING AFTER QUAKE KILLED 75,000

This family in the Pakistani village of Langla has just received a U.S. kit worth $1,000 to rebuild their home — one of millions destroyed by a huge 7.6 earthquake that hit Northern Pakistan in 2005.

The man is showing what he was given by U.S. aid workers: corrugated metal roofing panels, a roll of felt for carpeting and ceiling insulation, plastic sheeting to go under the floor, wire fencing to strengthen foundation walls, a metal wood stove with smoke pipe, shovel, pick, saw, and other basic tools.

Behind the family is a new frame for a temporary house they have built out of the fallen roof beams. Helping the two million people left homeless by the quake has meant changing the way they build their houses.

When the quake hit northern Pakistan, it killed 75,000 and left 2.8 million homeless.

It was often the roof beams that killed those inside. In these mountains near Kashmir and in sight of the Karakoram Range, people traditionally sawed tall trees into eight inch by eight inch beams which they laid side by side on mud brick walls and covered with layers of straw and earth. When the walls crumbled in the quake, the roof beams crashed down.

Aid workers held classes to show people how to use a motorized band saw to slice each of their eight by eight impossibly heavy roof beams into eight, light-weight two-by four building studs. These are used to make a frame and a peaked roof to be covered with thin metal panels. If the new roof were to collapse,

it's not heavy enough to kill anyone inside.

The survivors also were given U.S. flour and other aid delivered by about 25 giant Chinooks, U.S. army helicopters flown over from the battlefield of Afghanistan. All day long the choppers flew into Muzaffarabad, gateway to the damaged region. They hovered briefly to hook into nets loaded with flour bags, and lifted them up over the crushed roads into remote villages where survivors had nothing left to eat.

"They are angels of mercy," said one officer in the Pakistan army which was using mules to deliver food to areas where trucks and jeeps could not reach.

Donor nations pledged $6.2 billion in relief after the quake, plus $100 million from U.S. corporations and private citizens.

Thousands of local men were hired to clear roads and towns of rubble and to repair irrigation channels.

The World Health Organization at first predicted that hundreds of thousands who survived the quake might die that winter of disease, hunger and exposure to the weather. Instead, a vast health effort reached survivors with vaccines, medicine, food and shelter. No post-quake death spike was reported.

Tens of thousands came down from the high mountains for the winter and lived in a relief camps in a bend of the Indus River. There, many children were enrolled in schools for the first time in their lives. Young women school teachers came to the camp school from nearby Pakistani cities, along with one of their fathers to protect their honor in conservative Muslim culture.

photo on previous page

YEMEN CAMEL CART

The camel seemed rather small as it pulled the cart through the rough streets of Aden, Yemen's southern port on the Arabian Sea. Two boys getting a ride seemed stunned that anyone wanted a photo of what to them must be an everyday occurrence.

U.S. foreign aid had built a new covered market nearby and business was brisk in the neighborhood. Cars and pedestrians flocked to buy and sell the fresh fish, meat, fruits and vegetables sold in the shady, clean market with plenty of clean water to wash the produce, the counters and the floors.

I'd seen camels grazing on the few plants growing among the flint rocks of the desert in Marib Province north of the capital Sanaa. But I never got used to the novelty of seeing a camel pulling a cart in downtown traffic.

Later, in the Arab Spring of 2011, Islamic militants would seize major cities just east of Aden, sending thousands of refugees into the city and raising fears that the prolonged protest movement against the government would lead to civil war. One has to wonder whether the clean market would survive in a time of disorder and whether the peaceful boys on the camel cart could avoid taking sides in a future conflict.

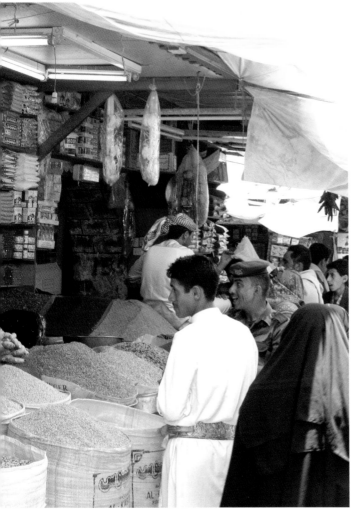

MARKET IN YEMEN

I was wandering in the old city in Yemen's capital Sanaa when I saw this scene in a shop. The shopkeeper, with his big traditional Yemeni dagger sticking out of his waistband, was smiling and listening to an equally smiling soldier.

The scene was one of relaxed joy and pleasure. Interaction far beyond the simple customer – shopkeeper business relationship.

When I see this scene I try to compare it with the day to day encounters at my local Safeway or Giant supermarkets. People are friendly here too. But it seems that this glimpse of a moment in Sanaa shows a world that has vanished in the West. We are even encouraged to use automatic checkout in which we scan our items and pay without speaking to a human being.

This moment in Sanaa—taken five years before the Arab Spring led to mass protests against the Yemen government – take us back to a time when personal relationships and encounters are given the value they deserve – these moment are the ones that cement us together as a human family, as a people and as a civilization.

UNDER THE VEIL

These two young women in Yemen's Marib governorate have true sparkle in their eyes and spoke with such passion and dedication about their work that I had to show their photo to the world.

We sometimes imagine that all women who wear the veil are uneducated and repressed. So it comes as a shock when one actually speaks to a veiled woman who is taking a leading role in developing her own country.

Sana Al Towayty, 26, (left), a former teacher, helps get parents involved in schools through mothers' councils.

"I worked with the imam [cleric] at the mosque who favors women getting education," said Al Towayty in an interview at a hotel in Marib. Her father sat nearby - he accompanies her on all her social work projects to protect her honor. As an unaccompanied woman she would find it difficult to get around on her own in the conservative Muslim society.

Imams tell the community during sermons that "woman is the sister of man and has a right to get an education," she said. They then encourage parents to meet with social workers to form councils.

When a group of seven to 10 mothers meets at someone's home, Al Towayty or other social workers lead discussions on: renovating schools, mixing boys and girls in the schools, the lack of female teachers, the lack of latrines or proper classrooms, and the benefits of an education. Mothers councils also raise money for poor students as well as carry out literacy and small projects such as sewing and weaving."

"Here women are very tough - if mothers decide to do something it will happen," Al Towayty said with a humorous twinkle in her eyes.

SELLING QAT IN YEMEN

These dealers are bundling and selling the daily handful of Qat leaves that Yemeni men chew each afternoon to get high.

Sometimes even the president of the country would appear on television giving a speech and his cheek would be puffed out with Qat.

In the market place in Sanaa, the capital, people selling bread and other items were simultaneously chewing Qat.

I was invited to the home of a government official who had weekly gatherings of friends involved in banking, business and foreign policy. We sat around on cushions and it felt very much like a bull session in grad school when we thought we had the answers to the problems of the world.

Most of them chewed Qat and drank tea. I tried chewing a bit but I did not like the taste and did not chew enough to notice any affect on my mental condition. But the others seemed to loosen up and talk more freely. Qat is said to be a mildly narcotic stimulant that keeps you awake in the torrid afternoons of Yemen. It's perhaps in between two or three cups of strong coffee and a small doze of amphetamine.

The tragedy of Qat is that up to 40 percent of the water used in agriculture in the country goes to Qat plantations. The tall, green trees are grown in the midst of a starkly, barren desert covered with sharp rocks. This is a country that could use more food and less Qat. But some say the chewing of Qat and the free-wheeling discussions it provokes act as a safety valve, allowing people to vent their feelings in a country controlled for decades by a single man and his family.

The tragedy is compounded since poor people are spending as much on a daily hit of Qat as they do on food for their families.

photo on following page

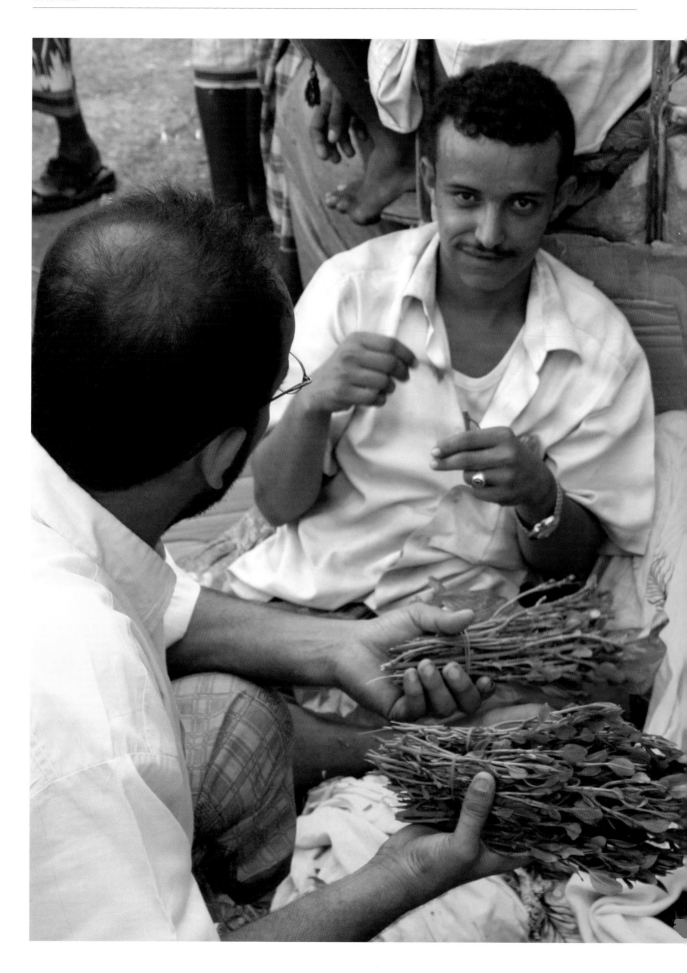

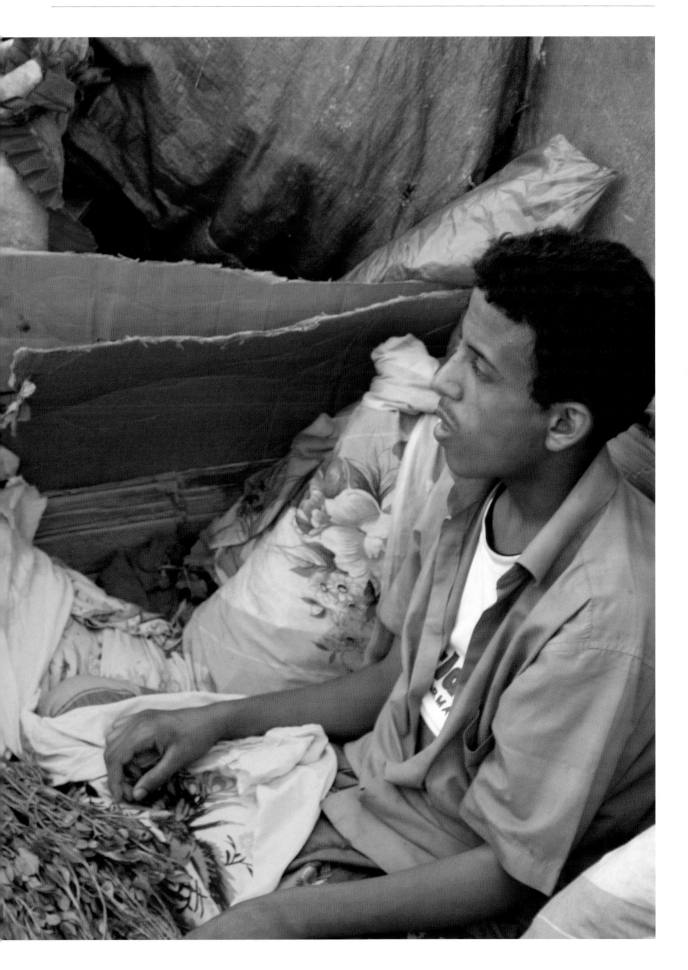

A TOUGH JOB

I was walking around the frozen streets of Faizabad, in northern Afghanistan near the Tajikistan border. It was 2006 and I was able to walk around the city without an armed guard, a helmet or a heavy bullet-proof vest.

Faizabad and the entire province of Badakshan was considered to be "permissive" at the time. Foreign aid workers and reporters could visit without fear of being attacked. Years later, ten medical workers would be slain in a remote district as if to prove no place is absolutely safe in Afghanistan.

The area was mainly ethnic Tajik and was always against the mainly Pashtu Taliban – who ruled nearly all of Afghanistan but never controlled this area. These people have been very happy for U.S. intervention and the end of the Taliban.

I saw this man in the street, hauling firewood for sale. It was bitterly cold and the streets were covered in thick ice and snow. He had no gloves, his torn clothing seemed inadequate and he wore thin rubber boots – possibly with rags or straw inside for insulation.

What got to me was that he was about to sell the very material that could have given him warmth – the wood slung over his shoulder. Heat was a luxury for this man and millions of other poor Afghans. Food was the only necessity.

His face and his eyes showed me a map of human suffering in Afghanistan. But they also showed me that he had triumphed over his fate. He was out there in the market, struggling against the forces of cold and hunger. There seemed to be a mixture of wisdom and acceptance in his face. He looked at me as I took his photo with supreme acceptance. "Here am I," he seems to say. "This is my life. I am shouldering not just some wood but decades of war and struggle that have left my country poor and wrecked. But we are human beings and know how to welcome a stranger."

I look often at this photo to remind myself how difficult life can be in the Third World and how brave and strong people become as they flow through their years.

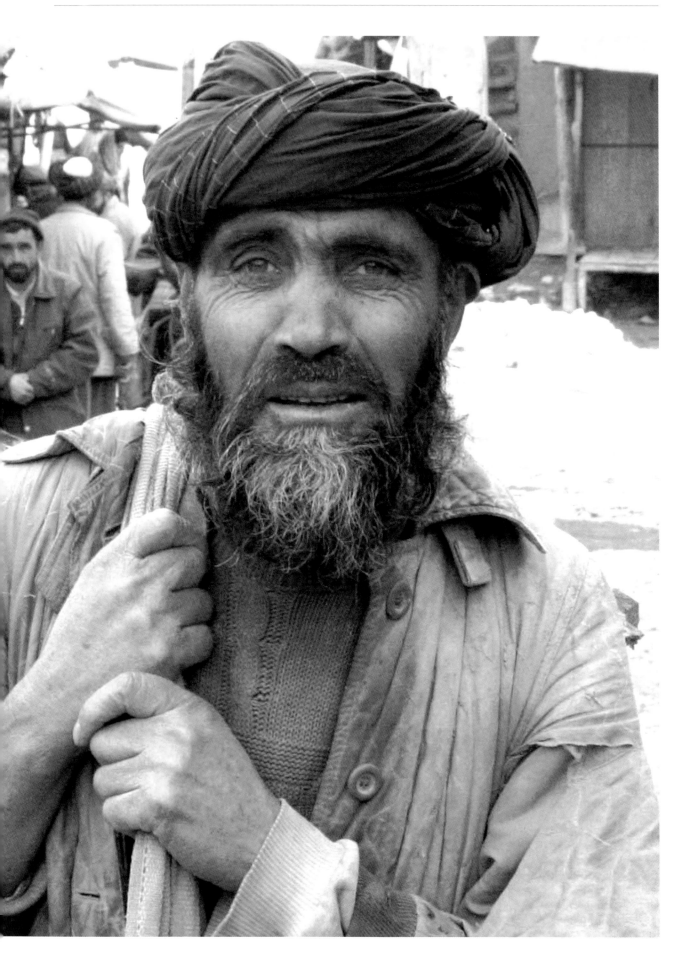